COMPLETE
DIGITALPAINTING
TECHNIQUES

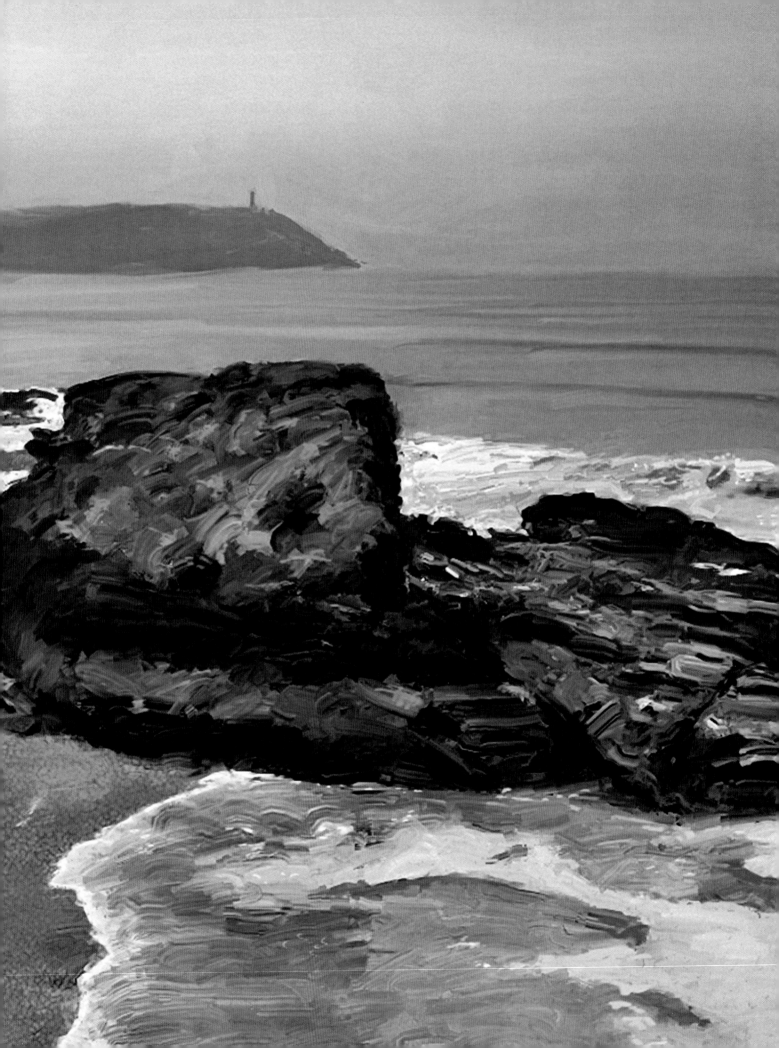

COMPLETE
DIGITALPAINTING
TECHNIQUES

DAVID COLE

NORTH LIGHT BOOKS
CINCINNATI, OHIO
www.artistsnetwork.com

COMPLETE DIGITAL PAINTING TECHNIQUES

This book was conceived, designed, and produced by
The ILEX Press, 210 High Street, Lewes, BN7 2NS, UK
Copyright © 2010 The Ilex Press Limited

ISBN: 978-1-60061-766-9

Other fine North Light Books are available from your local
bookstore, art supply store or online supplier. Also visit our
website at www.fwmedia.com.

FOR ILEX PRESS
Publisher: Alastair Campbell
Creative Director: Peter Bridgewater
Managing Editor: Nick Jones
Assistant Editors: Ellie Wilson & Isheeta Mustafi
Art Director: Julie Weir
Designer: Graham Davis

Printed in China

Color Origination by Ivy Press Reprographics.

13 12 10 11 10 5 4 3 2 1

Contents

In his 2001 book, *Secret Knowledge: Rediscovering the Lost Techniques of the Old Masters*, David Hockney argues that from the middle of the 15th Century, lenses and mirrors greatly helped a number of artists capture their subjects more accurately and more photographically. Such evidence as exists is mainly to be found in the physics of the paintings rather than in written documents, and we may never know if Caravaggio and Ingres used lenses and mirrors in the ways suggested by Hockney. Whether or not he is right about an early and extensive use of optical devices, there is no doubt that artists throughout the ages have been ready to adopt new technologies and processes if they delivered better results—just look at the development of pigments, paint, and painting supports.

And of course, there has been the development of photography and the part it has played in propelling artists toward greater self-expression and creativity. Photography simultaneously freed artists from the need to reproduce exactly what they saw and highlighted the power of the fleeting moment. Drawing on this, artists —one immediately thinks of the Impressionists—created a view of the world that was highly personal and immediate. Today painting and photography work together, and artists use and can draw on—often quite literally—not only photography, but also computer generated and manipulated images, and a mix of the two. If you can visualize it, there will be a way to do it with the computer software available today.

This book is a compendium of methods to achieve digital simulations of natural media painting techniques using computer software on a PC or Mac. *Complete Digital Painting Techniques* mainly covers digital paint application using brushes and other tools, but also touches on software filters and add-on software applications that can help you achieve the effects you want.

To use this book and get value from it, you do not have to be able to paint freehand and by eye—or "eyeballing," as Hockney calls it. Not all of us have the skills to do this to a satisfying degree, and turning photographs into paintings through various cloning methods can be more rewarding. The software covered in this book allows you to paint freehand and to use photographic or other images as starting points for artistic cloning, which means that you will be able to turn a photo into a variety of paintings. Therefore, you do not have to be a trained artist to get value from this book. What style of painting you do—watercolor or oil, Impressionist or Expressionist, brush or palette knife—and the techniques that go with it, are of course up to you. The book shows you how to achieve the techniques you need.

Each of the techniques outlined is accompanied by tables describing the support and brushes used; icons denoting whether a technique has been achieved with a digital brush, pencil, palette knife, sponge, and whether a picture has been painted using a photograph (cloned) or freehand; and footnote references to other relevant sections to make the book as user-friendly as possible. To start you off on your creative path, I have also made available twelve digital photographs to work from (although I recommend you use your own photos too) and a number of customized Painter and Photoshop brushes and patterns. This package can be downloaded at http://web-linked.com/painting/download.zip

The technology of digital painting is always developing, and future editions of this book will reflect these developments. For example, the new brushes in the latest version of Photoshop, CS5, will certainly bear exploring in a subsequent edition. However, you will find that the approach here has been kept as generic as possible, so that the techniques described can be translated to any painting program.

There is, of course, a certain irony in the fact that some Old Master painters used advanced technology to help develop new techniques for painting, while we are using advanced technology such as computer software to simulate, amongst other things, traditional Old Master painting techniques. But the computer will not do all the work for us—and where would the fun be if it did? You still have to make brushstrokes

using your digital pen and tablet and the right creative decisions en route. It is heartening that not only has David Hockney focused attention on the role of technology in traditional, Old Master painting, but that in 2008 he himself started to make digital paintings using, reportedly, Photoshop.

A final thought: in the gentlest way, it is strongly recommended that you supplement the advice in this book by developing some familiarity with the painting style and techniques you want to emulate. Look at real paintings to see how, for example, canvas peeps through oil paint, how impasto brushstrokes appear on board or canvas, how watercolor washes can bleed, and watercolor pigment sediment is deposited on rough paper. Observe these technical things closely in real paintings you love and this will help you hugely with your own painting.

The first section of the book deals with essential tools for digital painting. It then looks at specific brushed techniques, and finally other, non-brushed techniques. Have fun!

David Cole

What is the hardware and software needed to use the digital techniques in this book? This is a natural initial question before getting started with digital painting.

First, if you don't already have one, consider buying a digital tablet and pen tool to input your image data into the computer. For painting, they feel much more natural than a mouse and will allow you to control a number of software functions directly. You will, for example, be able to adjust the size of a brushstroke easily by exerting a downward pressure on the pen tool, or change the applied shape of the brushstroke by tilting your pen tool. The best known tablets are made by Wacom and the Intuos (the latest is the Intuos3) range offers very good features.

The size of the tablet is very much up to you. If you want to draw and paint with lifelike strokes of your wrist and arm you should consider an A4 size tablet. This will give you the sense of working on a life-sized canvas or paper pad. But they are expensive and quite tiring after prolonged use. Many people find the smaller A5 or even A6 sizes give as much control and are more comfortable to use because the hand has to travel shorter distances to make strokes. There are also a number of different pen types to choose from for Intuos3 tablets, though it's probably best to start with the Grip Pen, which is thicker than previous Intuos pens and comes with three different nibs that give different types of pen stroke and pen feel. Throughout this book I will assume that you have a digital tablet and pen tool.

Software

The main graphics software programs to consider are Adobe's Photoshop and Corel's Painter. Photoshop, now at version 12, better known as CS5, is primarily a photo management, retouching, and manipulation tool used by professionals to get the very best out of photographs and to create particular photographic effects. It also has powerful brushing capabilities which take it beyond photo preparation into brushed natural media simulation. There are other more all-purpose and less expensive photo retouching programs such as Corel Paint Shop Pro and Photoshop Elements—a cut down version of Photoshop. You can also find free programs such as Picasa, from Google, and Gimp (GNU Image Manipulation Program), which cover the Photoshop ground to differing extents.

Corel's Painter program, now in version 10 or X, is first and foremost a digital painting program, with a galaxy of brushes of many media types and huge power in the way it can simulate natural media. It is perhaps not as readily capable as Photoshop on photo preparation and less comprehensive in its filters, but the two programs—Painter and Photoshop—complement each other very well and you will be very well prepared if you have both. Painter really stands by itself, although Mac users may consider Synthetik's Studio Artist (which is Mac only). For digital painters who want a painting program that is less expensive, the obvious one to look at is Corel's Painter Essentials—a cut down but very usable version of Painter.

The work in this book was done on the following system:

Hardware:

Homebuilt pc—Intel Core 2 Quad Q9550 cpu; Asus P5K Premium Wifi motherboard; x2 WD Velociraptors 300Gb SATA internal hard drives; Gigabyte 4850 pci-e vga card; Asus Xonar D2X pci-e soundcard; 3Gb DDR2 ram; LG Blu-Ray GGWH20L SATA Disc rewriter. An Antec P182 case and an Enermax Modu82+ 625W power supply. Other equipment was: the display—a NEC 26" 2690WUXi LCD monitor; x2 Lacie 500Gb usb2 external hard drives; Wacom Intuos3 6"x8" digital tablet; Canon 5DII dslr; Panasonic LX3 compact digital camera. Printers were an Epson R2400 inkjet, and a 1400 for less demanding work. Also an Epson Perfection V700 scanner.

Software:

Windows 32bit Vista Ultimate; Photoshop CS4; Painter 10.1; buZZ Pro 3 (dead commercially but still working fine in CS4); LucisArt (the original cut down version—now superseded); PhotoZoom Pro 2; PT Lens; Noiseware; Photomatix Pro 3; Dynamic Photo HDR; Dreamweaver CS3 ; Topaz Adjust and Topaz Simplify.

The programs referred to in this book obviously need computers and operating systems to run on and you should check the System Requirements for any software you are about to buy. If your system is powerful enough to run Photoshop and Painter it should be able to run any other graphics programs, although note that Studio Artist is for the Mac only. Photoshop CS4, the version used in this book, has particular requirements for graphics cards. If you are considering CS4—or indeed CS5—you should check for the latest advice on System Requirements on the Adobe website. Apart from any graphics card requirements, as a general rule, it is a good idea to have as much Ram memory as you can. For Windows 32bit operating systems the practical limit is 3-4Gb of ram, and for 64bit systems as much as 8Gb if your motherboard can cope with this much.

It is also useful to have a decent photo scanner for scanning textures—like real canvas and watercolor paper—to make texture patterns which you can apply to your pictures.

The selection of the Display is a difficult choice made harder by the increasing number of wide color gamut displays now available. This is not the place for a discussion on color management, but it is important to have this in mind when buying a display. Crudely, if your work is for viewing by others on the internet, stick with an sRGB workflow and if you have a wide gamut display make sure it offers an sRGB simulation mode. You may wonder what the point is of buying a wide color gamut display if you are going to run it only in sRGB mode, but there are reasons; around 60% of internet users have Internet Explorer as their browser and this is not yet a color aware application, meaning that the color they see is around sRGB. If you are producing for print and your printer uses the aRGB color space, or if you make pictures for yourself alone, a wide gamut display may be a good choice for you.

CHAPTER ONE

Essential Tools

Brushes are of central importance to the techniques described in this book, so they are at the core of this first chapter on the essential tools of digital painting. Nearly all of the brushed techniques described in Chapter 2 rely on Photoshop or Painter brushes, and even a number of the non-brushed techniques in Chapter 3 (like Smudging, Stippling, and Sponging) are based on a variety of brushed techniques.

It is quite possible to use brushes in Painter and Photoshop without knowing much about brush creation or customization by simply sticking to the default brushes. Having said that, it is a much better idea to broaden the range of techniques available to you by getting to know more about how to create and modify brushes before you start digital painting.

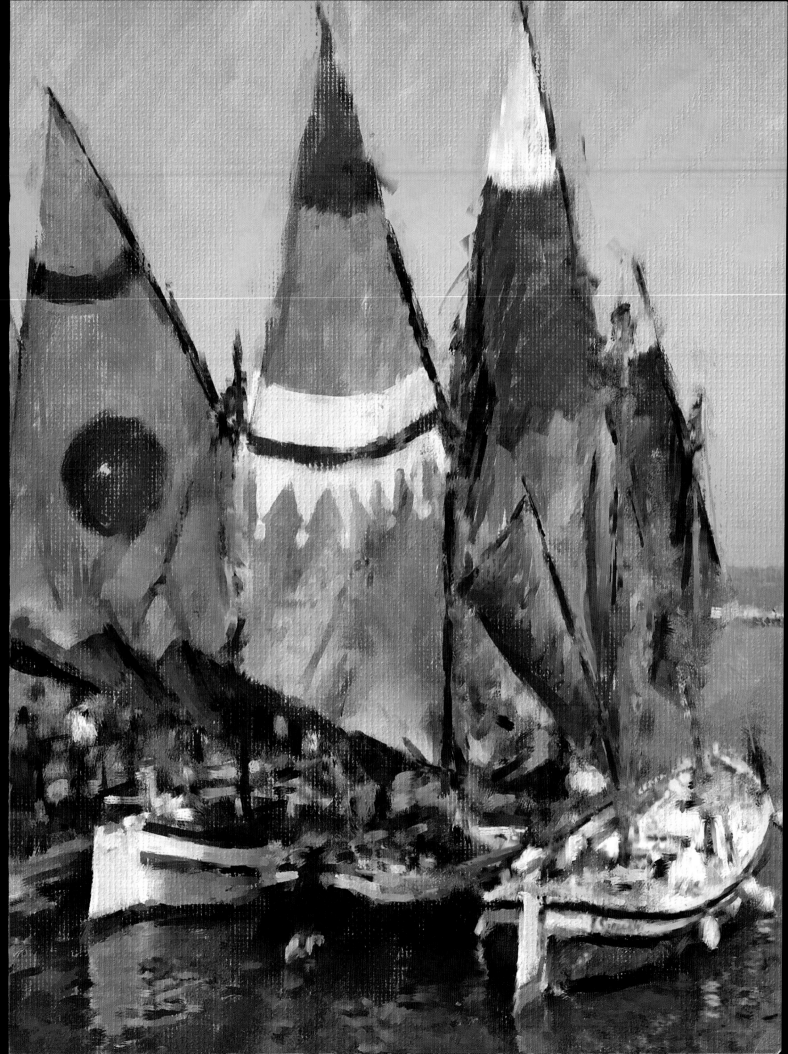

Being able to at least customize brushes enables you to get exactly the effects you want, and it's fun too! Once you get used to creating and changing brushes, you will quickly build up a number of favorites that will give you immediate access to the brushed effect you are looking for. Familiarity will also give you a sense of the strengths and limitations of the various brushes in both Painter and Photoshop. Digital brushes—particularly some Painter brushes—have become increasingly sophisticated, and though this guide is a good starting point, there is no substitute for spending time experimenting with the various options available. The aim of this chapter is to provide an introduction to the sort of effects that can be achieved with various brushes.

Brushes operate in very different ways across Photoshop and Painter, and taken together, there is a huge range of effects that can be achieved. Painter offers a number of fundamentally different brushes (such as the Artist and Watercolor brushes) and an initially intimidating range of brush parameters to play with. Photoshop, not being primarily a painting program, offers a narrower range of brushes, but still provides a wide array of powerful options. This chapter will cover brush attributes, brush customization, and brush creation in both programs.

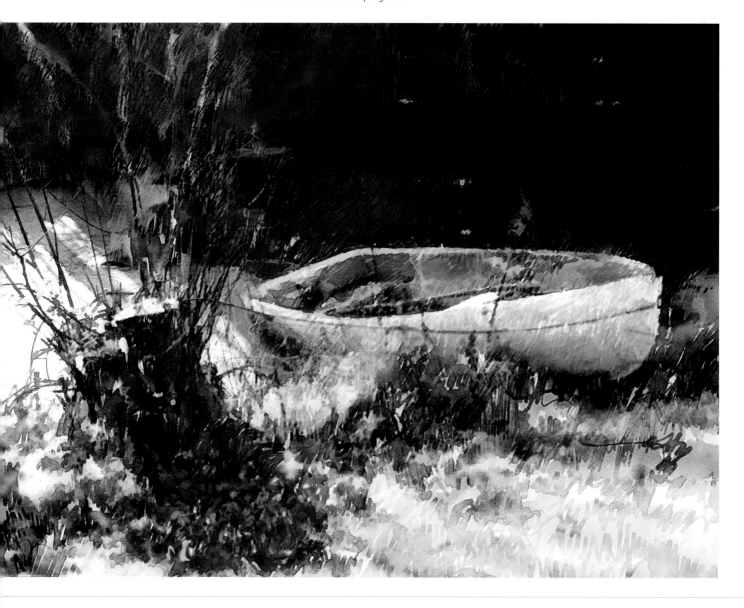

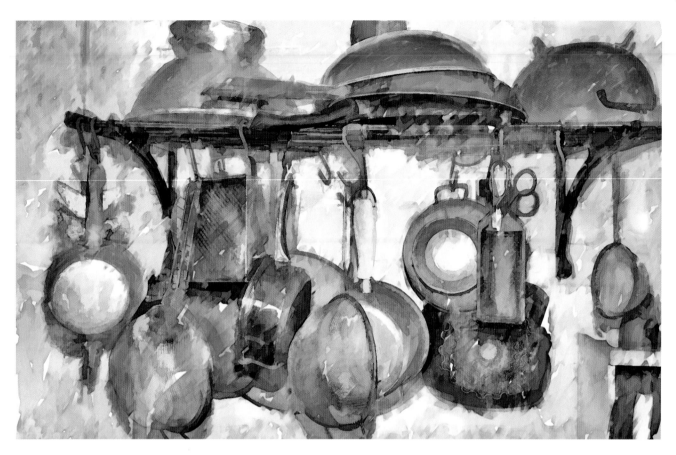

Having pointed out the differences between Painter and Photoshop brushes, it's worth noting that brushes in Photoshop and Painter do have some very similar basic attributes.

- Brush tip types (round, flat, size)
- Brushstroke types (bristle, dual, smooth, scattered, shaped)
- Opacity (how much paint is applied and how transparent it is)
- Brush interaction with the support (paper/canvas, etc.) to create texture, interaction with paint already present, and how long the paint stays wet

In this chapter, I will look at these features in some detail and examine other key tools like filters, color adjustment, and texture creation. I will also look at software plug-ins that enhance the main graphics programs, and how they can be used to turn photographs into engaging artwork that convincingly simulates natural media. I will then describe how to use Painter's Clone Color function and Photoshop's Art History and Pattern Stamp tools. Finally, I will examine Higher Dynamic Range photography and processes as a source of interesting starting pictures and at how scanning factors into digital painting.

Before running through the various brush features in Photoshop and Painter, it is worth looking at the Digital Pen Stylus and how it operates with these and other programs that support pen tool sensitivity.

A real world brush changes the way it deposits paint when its shape changes. Push down on a brush tip and the bristles spread out and so make the stroke larger, tilt a brush and again the shape changes, depositing paint in a different way. These features can now be mimicked with varying degrees of success using a Pen Stylus (pen tool) and a digital tablet to make your marks, provided that the software you are using supports these features. In Photoshop, you can control the interaction of Pen Stylus and software in the *Brushes* palette. These pen controllers can change the shape of the brush, how scattered the brushstroke is and the relationship of foreground and background colors. Below are examples of how these filters affect the look of the Hard Round Brush, using **Jitter** values between 0 and 30%.

Brush Size

With many Painter and Photoshop brushes you need to set a large maximum size and a very small minimum size to get a brushstroke to go from fat to thin as it is applied with decreasing pressure—or vice versa. In Photoshop, you can change the size settings in the *Brushes* palette, and in Painter, in the *Size* window of the *Brush Creator*. In Painter, you can set *Brush Tracking* sensitivity (*Edit>Preferences>Brush Tracking*), which helps to get the pressure-to-line thickness relationship right for you.

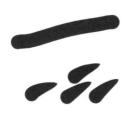

Shape Dynamics: Fade.
The top brushstroke has no controller on, and the lower four strokes have *Fade* applied. This is good for dabbing brushstrokes.

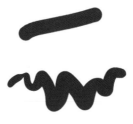

Shape Dynamics: Pen Pressure.
Top brushstroke has no controller on. The brushstroke below illustrates the effect of varying amounts of pressure with the *Pen Pressure* option selected.

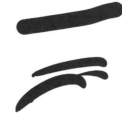

Shape Dynamics: Pen Tilt.
Top brushstroke has no controller on. Below it are some marks made with *Pen Tilt* switched on, changing the shape and character of the line.

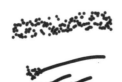

Scatter: Fade.
Top stroke has no controller applied. The marks below illustrate the effect of having Fade on. Note that the *Count Jitter* controller was not applied in any of these Scatter examples.

Scatter: Pen Pressure.
Top brushstroke with no controller. Below with *Pen Pressure* on, observe how the line tapers with varying amounts of pressure.

Scatter: Pen Tilt.
Top with no controller. Below is an example of how *Pen Tilt* compresses the scattering a little.

Color Dynamics: Fade.
Top with no controller on. Below is an example of how turning *Fade* on can alter the relationship between the foreground and background colors.

Color Dynamics: Pen Pressure.
With no controller, the top color is almost all the foreground green. With *Pen Pressure* controller active, applying and reducing pen pressure alters the amount of foreground and background colors visible.

Color Dynamics: Pen Tilt.
Note that there is little difference visible with *Pen Tilt* active and inactive.

➤ Jitter see Photoshop Brushes Basics pp. 16–17

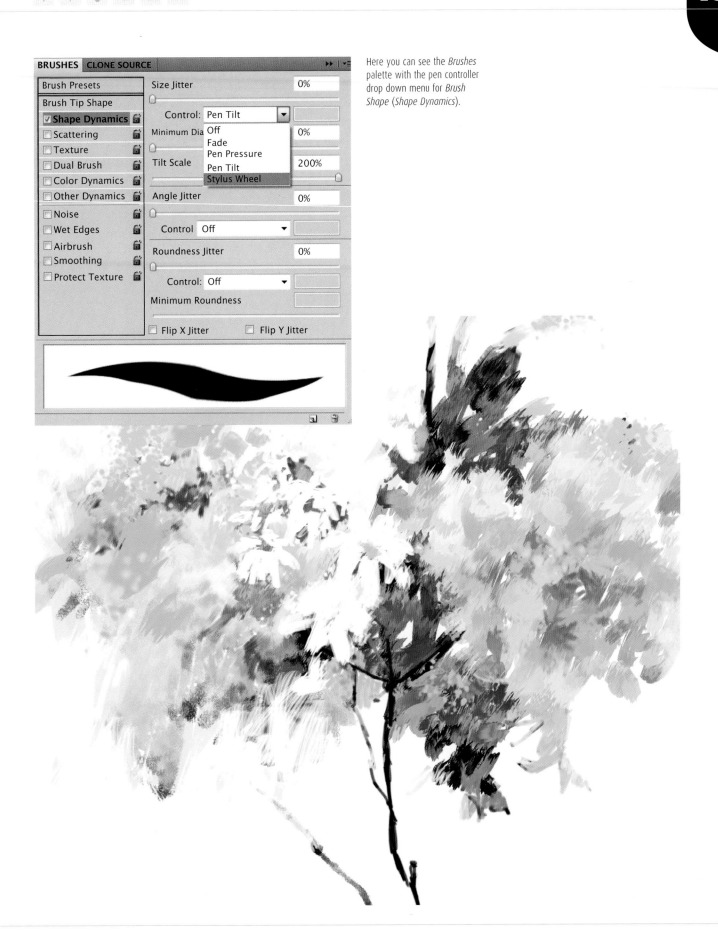

BRUSHES **CLONE SOURCE**

| Brush Presets |
| Brush Tip Shape |
| ☑ **Shape Dynamics** 🔒 |
| ☐ Scattering 🔒 |
| ☐ Texture 🔒 |
| ☐ Dual Brush 🔒 |
| ☐ Color Dynamics 🔒 |
| ☐ Other Dynamics 🔒 |
| ☐ Noise 🔒 |
| ☐ Wet Edges 🔒 |
| ☐ Airbrush 🔒 |
| ☐ Smoothing 🔒 |
| ☐ Protect Texture 🔒 |

Size Jitter 0%

Control: Pen Tilt ▼

Minimum Dia Off 0%
 Fade
 Pen Pressure
Tilt Scale Pen Tilt 200%
 Stylus Wheel

Angle Jitter 0%

Control Off ▼

Roundness Jitter 0%

Control: Off ▼

Minimum Roundness

☐ Flip X Jitter ☐ Flip Y Jitter

Here you can see the *Brushes* palette with the pen controller drop down menu for *Brush Shape* (*Shape Dynamics*).

Although Photoshop is not primarily a painting program, it has a wide range of surprisingly powerful brushes. These were originally intended for photo retouching, but they are capable of much more, and a number of contemporary artists, such as Craig Mullins, have done some breathtaking painting with Photoshop. Photoshop provides a good number of brush controls that can make a very reasonable job of mimicking traditional brushes like bristles, camel hairs, and flat.

The diagram below sets out Photoshop brush basics—where to find them in the workspace, where to look at the available brushes and load new ones, and where to go to make changes to them.

The *Brush Tool* is accessed through the *Brush* button on the *Toolbox* to the left hand side of the default workspace. Below the *Menu* bar at the top is the *Tool Options* bar, which has much the same function as the *Properties* bar in Painter—a number of key brush controls are available there.

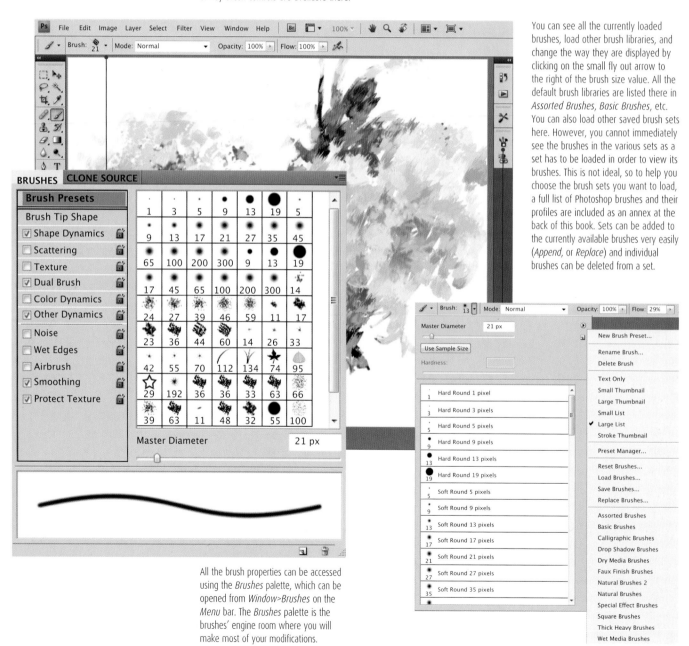

You can see all the currently loaded brushes, load other brush libraries, and change the way they are displayed by clicking on the small fly out arrow to the right of the brush size value. All the default brush libraries are listed there in *Assorted Brushes, Basic Brushes*, etc. You can also load other saved brush sets here. However, you cannot immediately see the brushes in the various sets as a set has to be loaded in order to view its brushes. This is not ideal, so to help you choose the brush sets you want to load, a full list of Photoshop brushes and their profiles are included as an annex at the back of this book. Sets can be added to the currently available brushes very easily (*Append*, or *Replace*) and individual brushes can be deleted from a set.

All the brush properties can be accessed using the *Brushes* palette, which can be opened from *Window>Brushes* on the *Menu* bar. The *Brushes* palette is the brushes' engine room where you will make most of your modifications.

To see the effect that changing the brush controls (Shape Dynamics, Scattering, etc.) has on a brush, I will take you through the process of creating a Photoshop brush here.

1

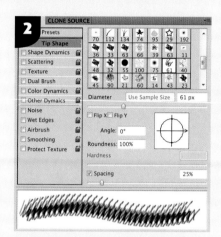

1 First, you need to define the brush tip shape. To do this, open a new white document at 72ppi, make a small selection—200 pixel diameter in this case—and make a random mark within your selection using a 5 Pixel Hard Round Brush. Next, save the brush tip as a new brush preset at *Edit>Define Brush Preset*. I called the new brush in this example "newbristle1." The new brush will now appear at the bottom of the list of current brushes.

2

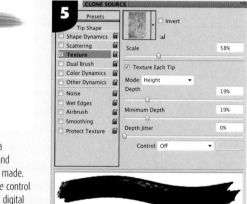

2 When the *Brushes* palette is opened up again (from *Window>Brushes*) the brushstroke made by the new brush is displayed at the bottom.

3

3 The jerky-looking stroke made in step 1 is easily made smooth by reducing or removing the spacing between brush marks. When the *Spacing* slider is moved all the way to the left, the brush straightens and becomes more bristly.

4

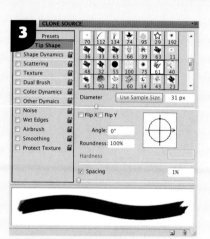

4 *Shape Dynamics* controls the size of a brushstroke, along with the manner and extent of the changes to the stroke as it is made. It comes into its own with the *Pen Pressure* control selected, which—assuming you are using a digital tablet and pen tool—gives you the ability to change the thickness during the course of a single stroke.

5

5 Within *Shape Dynamics* you can alter the size, angle, and roundness of the brushstroke's basic imprint using the *Jitter* and *Roundness* controls. The general effect of this is to break-up the smooth edges of a mark so that it looks more like wet paint on absorbent material. *Brush Scattering* determines how paint is distributed in a stroke and *Texture* determines whether the brushstroke will be applied with a texture.

6

6 I saved this brush with the *Define Brush Preset* command and called it "newbristle1a." The brush is (as the name suggests) bristly, as you can see here.

7

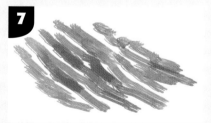

7 *Dual Brush* uses two tips to create a brush, and *Color Dynamics* allows you to play with the relationship between foreground and background colors. Each stroke of the brush will only use one color, but the appearance of the foreground and background colors can be varied with the sliders.

There are five additional features that can be switched on or off. *Noise* adds noise to gray areas of the brush; *Wet Edges* simulates the fringing you get around washes in watercolors (although not as aggressively as in Painter *Digital Watercolor* brushes); *Airbrush* turns the *Airbrush* control on the brush options bar on and off; *Smoothing* can remove some of the sharpness from painted curves when painting or drawing; and *Protect Texture* ensures all brushes use the same texture.

Foreground/Background Jitter and *Hue Jitter* control aspects of the balance between foreground and background colors, while *Purity* controls saturation. With *Pen Tool* enabled, the jittering creates brush effects like the one depicted here, which used the default *Large Texture* stroke.

Painter is *the* digital painting software and brushes are at the heart of the program. There is an enormous array of available brushes, readily accessible to use as is or modify to suit your needs.

Brushes of a similar medium or process type—for example oils, gouache, photo—are grouped together into categories within brush libraries. So, brush variants make up categories and categories make up libraries. Unlike Photoshop, you can easily see all of the brushes and their tip shapes without having to load any additional sets, as the categories of all of Painter's available brushes are installed in the default library. For this reason (and because of the space required) the Painter brushes are not shown in an annex to this book as the Photoshop brushes are. I do, however, look at a few specific Painter brushes in depth later on in this chapter. The basic Painter brush controls are set out in the diagram below.

To use a brush, select the *Brush Tool*, which is at the top left of the Toolbox.

Some key brush controls like *Size*, *Opacity*, and *Grain* are conveniently available in the *Properties* bar, below the *Menu* bar when the *Brush Tool* is active.

Clicking on the small fly out arrow to the right of the *Brush Selector* bar gives you access to a menu of additional functions, including brush tip creation (*Capture Dab*) and brush customization (*Show Brush Creator*).

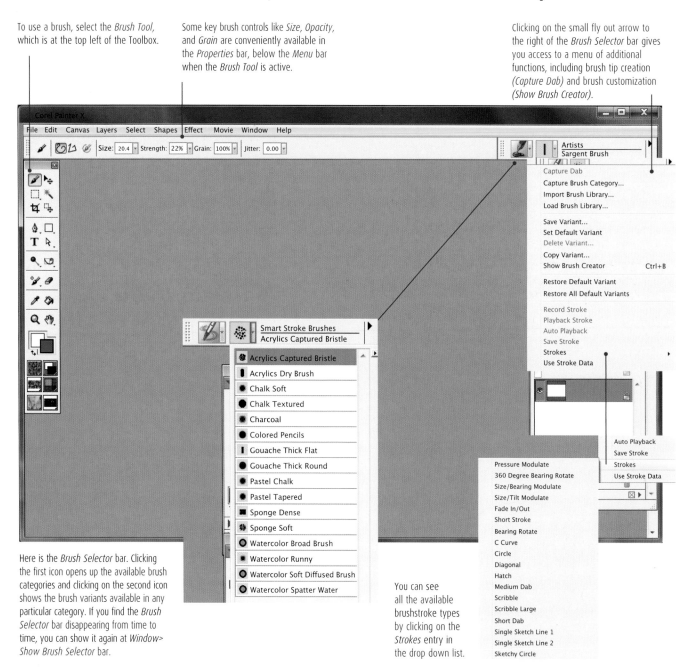

Here is the *Brush Selector* bar. Clicking the first icon opens up the available brush categories and clicking on the second icon shows the brush variants available in any particular category. If you find the *Brush Selector* bar disappearing from time to time, you can show it again at *Window> Show Brush Selector* bar.

You can see all the available brushstroke types by clicking on the *Strokes* entry in the drop down list.

Here I will take you through the process of creating a Painter brush, and explore some of the program's brush controls.

1

1 First, make a random mark on a blank sheet to create a bristle effect in the stroke. Then draw the *Rectangular Selection Tool* over it to make a selection.

2

Smart Stroke Brushes

Capture Dab
Capture Brush Category...
Import Brush Library....
Load Brush Library...

Save Variant...
Set Default Variant
Delete Variant...
Copy Variant
Show Brush Creator Ctrl+

Restore Default Variant

2 Next, click on the small arrow next to the *Brush Selector* bar and then on *Capture Dab*, the first item in the menu. This lodges the Dab you have captured in Painter's memory temporarily, but you should save it if you want to keep it permanently.

3

dc paintCapture
dcBESTGlazAcr
dcBESTGlazAcrsmaller
dcCaptured Bristlebest
dcacrylicbristlegrainy
dcbestacrylicglazer
dcdrybrushgrainy
dcgppdCaptured Bristle

3 To save the Dab you have just made, go to the same drop down list and choose *Save Variant*. Give it a unique name—I have called this one "dcacrylicbristlygrainy." It will now appear in the list of brushes in whatever category you open.

4

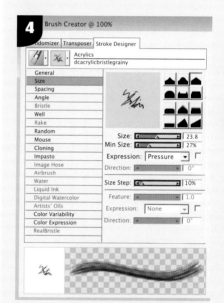

4 To customize this brush so it is more bristly, open the *Brush Creator* from the drop down list shown previously and select the *Size* tab. Here you will find a number of attributes, including the brush's *Shape Profile* (density of paint deposited), its maximum and minimum sizes, and the *Size Steps*—which determine how it moves between maximum and minimum sizes in a stroke. If you now open the *Angle* tab, you will see controls for managing the orientation of the stroke; increasing *Squeeze* flattens the brush shape and changes the stroke accordingly. I did not need to make any *Angle* changes to my brush, so I went to the *General* tab. This is an important area where a number of key controls are to be found. From the drop down list next to *Dab*, you will see that *Captured* is ticked because you are using an original brush Dab, rather than one of the many default Dab types. The *Stroke Type* determines how Dab paths (brush tip shapes) are distributed.

5

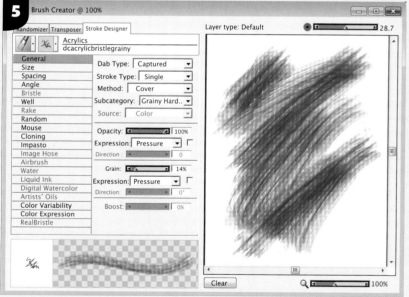

5 The *Methods* and their *Subcategories* are crucial to determining how a brushstroke looks. So, for example, in *Build Up*, a paint-on-paint method leads to black (like a felt tip marker pen), while in *Cover*, one brushstroke obscures the one below it without darkening the color of the strokes. *Subcategories* determine other qualities, such as graininess (adding texture in the brushstroke). Playing with these two sets of controls is the best way to really understand the extent and nature of their effects. There's no getting away from the fact that these controls are numerous and intricate, but with a little bit of practice, using them will become second nature. As you will not want your new brushstrokes to lead to black when they are applied on top of each other, select *Cover*. For some texture with the stroke, choose *Grainy Hard Cover* from the *Subcategory*. Leaving *Opacity* at 100%, select a *Grain* of 14%, and you get a brush like the one shown here. There are many other aspects of brush creation and customization, which I will explore later on in the book.

HINT
Dragging any Artists' brush quickly makes the brushstroke wider.

There are six brushes in Painter's *Artists' Brushes* category: Auto Van Gogh, Impressionist, Sargent Brush, Seurat, Tubism, and Van Gogh. The aim of these brushes is to help you paint in the style of their namesakes. So, with Van Gogh, you get the appearance of thick Impasto paint, and the Seurat brush gives you those well-known Pointilist spots of color.

Impressionist

The Impressionist Brush imitates the style of painting associated with the Impressionists, in which paint was dabbed on to the canvas to create interesting effects of light and color. It has a **Captured Dab** type—this means that the *Dab* has been hand drawn and "captured" in Painter to form a new Dab type. The paint can be either applied in a dabbing motion or brushed. The exact positioning of the dabbed brushstrokes is sometimes hit and miss, but with a little bit of patience you can make paintings that work quite well. The inset image to the right shows the basic brushstroke, which is very similar to the Photoshop *Fade* controlled brushstrokes. For the main image of the eye on the right, brush sizes varied between 2.9 and 30, and *Opacity* was at 100%. By default this brush has no *Color Hue* or *Saturation* variability, but it does have its *Value* variability set to 19%. These settings make for a lively color effect.

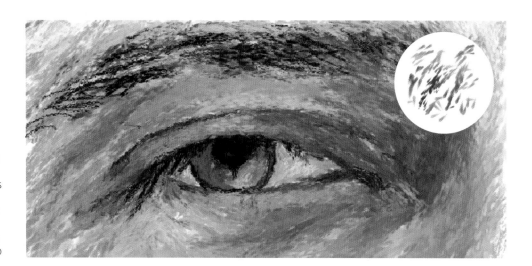

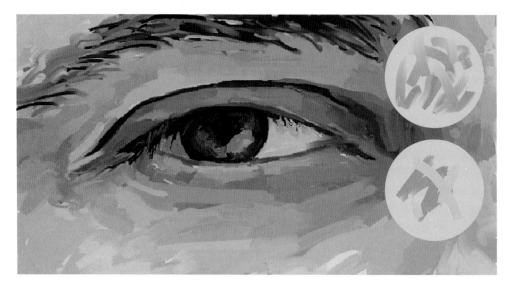

Sargent

John Singer Sargent was the top portraitist of his day. The brush carrying his name is excellent for portraits, producing thick, creamy brushstrokes that can be very expressive. Like the Impressionist Brush, the Sargent Brush uses a *Captured Dab* type, but unlike the other brushes covered, it has no default *Hue*, *Saturation*, or *Value* variability.

The trick up its sleeve is its *Grainy* control and its relationship to *Strength*. Grainy brushes pick up the texture of the paper and display it to a greater or lesser extent, but the Sargent Brush doesn't do this. With *Strength* at 10% and *Grain* at 100%, the brush picks up and moves the paint below, but with *Strength* at 100% and *Grain* at 100%, you get solid covering color that is not affected by the paint below. If there is just white (canvas), the brush will mix with the white. If there is nothing on the layer and it is transparent, the Sargent Brush will appear not to have any effect at all. The brushes using the *Plug-in* subcategory are all like this. The *Plug-in Method* does not in fact provide a brush quality of its own, but instead allows a wide range of other brush effects to be used. In the Sargent Brush the sub-category used is the *Liquid Brush*, which is what gives the Sargent brushstrokes their creamy character, as illustrated in the image above.

In the top inset image above, the brush had low *Strength* and high *Grain*, so the brushstrokes picked up the color below them. The lower inset image brush had high *Strength* and high *Grain*, making all strokes solid as they were applied over other colors. The main eye image had *Strength* at 68% and *Grain* at 100%.

➽ Captured Dab see Painter Brushes Basics pp. 18–19

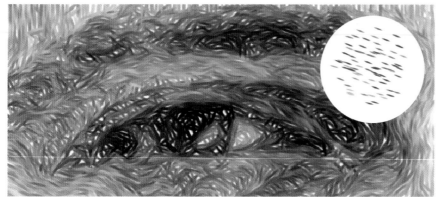

Auto Van Gogh

It is a little odd finding this brush in the *Artists'* category because it works only in **Clone Color Mode**, which I will look at later. Essentially, once you are in Clone Color Mode, the auto clone feature (in this case *Auto Van Gogh*) applies brushstrokes for you in its own approximation of the style of Van Gogh. You can see the sort of strokes the auto Van Gogh feature creates in the inset image to the left. In the main image of the eye, the Auto Van Gogh effect was applied using a brush *Size* of 14.4 and an *Opacity* of 100%.

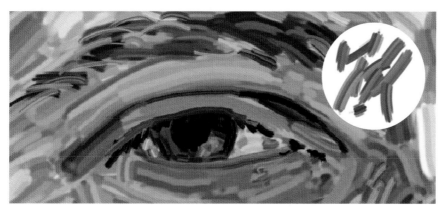

Van Gogh

The Van Gogh Brush proper is more sophisticated than the Auto Van Gogh Brush and aims to reproduce the thick **Impasto** effect of the artist's brushstrokes by simulating multi-shading in each mark made. In fact, the *Impasto* setting in the *Brush Creator* is not active for the brush. The main changes to standard settings are to be found in *Color Variability*, where *Hue Variability* is set to 4% and *Value Variability* to 17%. These are important aspects of the brush's characteristics, as depicted in the inset image. The main eye illustration was created with the Van Gogh Brush set at full *Opacity* and *Sizes* between 2.5 and 7.5. The trick is to work with the contours as you see them and recognize that moving the brush in different directions varies the stroke.

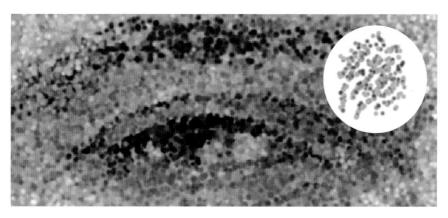

Seurat

Seurat's **Pointilist** paintings involved the application of many small spots and squiggles of color. Accordingly, the Seurat Brush delivers small spots of color and uses the *Circular Dab* type. The variation of color is simulated by having some variation of *Hue* and *Value* in the *Color Variability* feature in the *Brush Creator*. Default settings are 7% for *Hue* and 15%, but you can adjust these. A dabbing motion is the best way to apply paint, as depicted in the inset image with the stroke at full *Opacity*. For the main eye image, I used a constant *Size* of 6.4 at full *Opacity*. I turned *Jitter* down to 1.45, as the default setting makes it difficult to control the spots. To enhance colors, I filled the white canvas with a medium gray. I set the *Method*'s *Sub-Category* (in the *General* window of the *Brush Creator*) to *Soft Cover*, so individual spots would be indistinct. For starker spots, switch the *Sub-Category* to *Flat Cover*.

Tubism

Tubism is not a brush that delivers a natural media simulation; it essentially plays with gradients in the form of transparent tubes. It uses a *Rendered Dab*, which explains its exotic character—the Dab being the method of application. The brush is more fun to play with if you change the *Dab* to *Camel Hair* in the *General* window of the *Brush Creator*, but the default version is illustrated here. The brush also has to be in Clone Mode for any actual brushstroke to appear. The image on the left demonstrates what the Tubism Brush does to my eye in Clone Color Mode. The *Size* was 9.2 with full *Opacity*.

➡ **Clone Color Mode** see pp. 44–45 ➡ **Impasto** see pp. 74–75 ➡ **Pointilism** see pp. 90–91

Artists who paint in opaque and transparent mediums like oil, acrylic, and watercolor are accustomed to mixing the colors they want by combining basic colors from tubes or pans on a palette of some kind. It is now possible to do exactly the same thing in Painter using the *Mixer Palette*. The *Mixer Palette* is nested with the *Colors Palette* and *Color Sets Palette* on the right hand side of the workspace. You can open it from *Windows>Color Palettes>Show Mixer*.

Default colors run along the top of the *Mixer Palette*, but it is easy to add and subtract from this library as you see fit. The white space in the middle is the *Mixer Pad*, where you can mix colors. Pad colors can be saved and reloaded for repeated use. The icons are the controls for using the *Mixer*. The slider along the bottom determines how large the dabs of paint for mixing will be when they appear on the *Mixer Pad*.

The *Mixer* tools are quite complicated because they are used in different combinations depending on the **Dab** type of the active brush. There are two ways to mix paint and apply it to canvas:

1 Use a brush that has a Dab type that supports mixing. The Dab types that work with the mixer are Camel Hair, Flat, Bristle Spray, Watercolor Camel, Watercolor Flat, and Watercolor Bristle. These can be mixed and applied to your canvas without having to use the *Apply Paint*, *Mixing*, or *Sample* tools.

2 With brushes that do not have a qualifying Dab type, use the *Apply Color Tool* to take your selected color and apply it to the *Mixer Pad*. Then mix your selected (and any other) color with the *Mix Color Tool*, and use the *Sample Tool* to sample the color you want on the *Mixer Pad*. Finally use your chosen brush to apply the mixed color to the canvas.

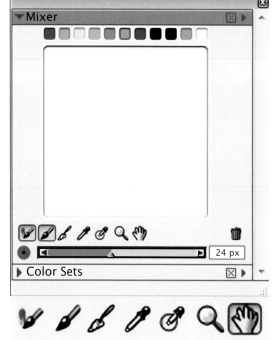

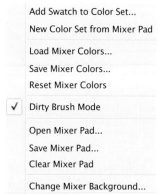

Add Swatch to Color Set...
New Color Set from Mixer Pad

Load Mixer Colors...
Save Mixer Colors...
Reset Mixer Colors

✓ Dirty Brush Mode

Open Mixer Pad...
Save Mixer Pad...
Clear Mixer Pad

Change Mixer Background...

Above is the fly out menu from the *Mixer Palette*. Here you can import color swatches and create color sets from your *Mixer Pad* colors; load new or saved *Mixer Colors* and reset them; switch *Dirty Brush Mode* on and off; open a saved *Mixer Pad* of colors; save a newly mixed color or clear it of all colors. If you do not like the white background color of the *Mixer Pad*, you can also change that here.

The *Dirty Brush Tool* is active by default. It lets you mix and apply mixed colors to your canvas, provided the brush you are using has one of the Dab types that support direct mixing. Dab types that work are Camel Hair, Flat, Bristle Spray, Watercolor Camel, Watercolor Flat, and Watercolor Bristle.

The *Apply Color Tool* applies paint to the *Mixer Pad* so that you can use it for mixing. Using brushes with the right Dab type, it will (in combination with the *Dirty Brush Tool*) be sufficient to allow you to mix colors on the *Mixer Pad* and then automatically transfer the mixed color to your brush for painting on the canvas. However, with brushes of all other Dab types, it must be used in combination with the *Mix* and *Sample* tools to get the mixed color on to your canvas. The *Apply Color Tool* does not apply color to your canvas.

The *Mix Color Tool* mixes the colors you have applied to the *Mixer Pad*. You then use the *Sample Color Tool* to transfer the mixed color to your current brush ready for painting.

The *Sample Tool* picks up mixed color on the *Mixer Pad* so that it becomes the main color on the color wheel, ready to be used for painting with your chosen brush. It does not sample colors for use on the *Mixer Pad*.

The *Sample Multiple Colors Tool* lifts colors from an area of the *Mixer Pad*; with the size of the area determined by the slider at the bottom of the *Mixer Palette*. Using the right brushes—such as **Artists' Oils**—the multiple sampled colors will then appear on the canvas as you make a brushstroke.

The *Zoom Tool* lets you magnify any area of the *Mixer Pad*.

The *Scroll Tool* lets you explore different areas of the *Mixer Pad*.

In addition to the tools described above, the *Slider Tool* not only controls the size of the area sampled by the *Sample Multiple Colors Tool*, it also increases the size of the *Apply* and *Mix Color* tools. The dustbin in the bottom right corner of the palette enables you to clear the *Mixer Pad*.

Mixing Workflow 1: Oils—Opaque Round with Dab type changed to Static Bristle (NOT a mixer Dab type)

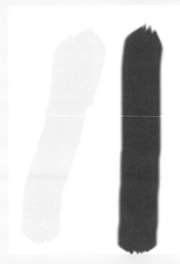 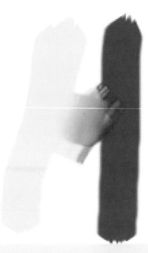

With *Dirty Brush* active and using *Apply Color Tool*, I applied yellow and blue strips of color.

De-selecting the *Apply Color Tool*, I activated the *Mix Color Tool* and used it to smear the yellow and blue colors together, creating a green color.

Using the *Sample Color Tool*, with the *Mix Color Tool* de-selected, I picked up the new green so it could be applied to the canvas with a brush of my choosing.

Mixing Workflow 2: Oils—Opaque Round with Dab type changed to Camel Hair (a Dab Mixer)

With *Dirty Brush* and *Apply Color Tool* active, I applied yellow and blue strips of color.

Still with *only* the *Dirty Brush* and *Apply Color Tool* active, I smeared the yellow and blue together, producing a green color.

Still with just the *Dirty Brush* and *Apply Color Tool* active, I made the green the selected color, making it available for use in painting with whatever brush I chose.

Artists' Oils brushes were quite a breakthrough for Corel, bringing a new sense of realism to the brushstrokes available. They work exceptionally well with the **Mixer Palette** and the experience of using them is very close to real painting, due to their excellent simulation of the behavior and appearance of real oil paint. While they can be used for **Clone Color** painting, they really come into their own during freehand painting, where their liquid, marbling quality produces very true-to-life effects. The key features of Artists' Oils are:

- Like a real oil paint brushstroke, the Artists' Oils brushstroke is loaded with a limited amount of paint, so the paint runs out as the brushstroke progresses.
- If the *Dirty Brush Mode* is activated on the *Brush Toolbar* (separate from the *Dirty Brush Mode* on the *Mixer Palette*), a brushstroke reacts with whatever color is below it, affecting subsequent strokes by effectively mixing colors and their values. But if *Dirty Brush Mode* is off, each stroke loads a new brush full of clean paint without any pick-up or mixing.
- You can mix colors using the *Mixer Pad* and create multicolor brush strokes by using the *Sample Multiple Colors Tool* to sample colors you have mixed on the *Mixer Palette*. The resulting brushstroke on your canvas will have a multi-colored marbling appearance.

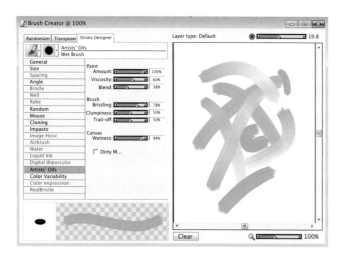

The *Artists' Oils* controls in the *Brush Creator* have a unique feature: under the *Paint* setting, *Amount* determines how much paint is loaded onto the brush with each new stroke, *Viscosity* controls how malleable the paint is, and *Blend* determines interaction with the surface. Within the *Brush* category, *Trail-off* sets the length of the stroke's trail-off, and *Canvas Wetness* controls the extent of mixing between the stroke's color and the under color.

Dirty Brush Mode

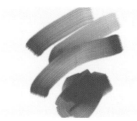

Dirty Brush Mode OFF: observe how the blue color strokes do not interact with background cream color. New strokes apply pure blue.

Dirty Brush Mode ON: here we see how the foreground and background colors interact and brushstrokes apply mixed colors.

Here are four brushes that illustrate the range of Artists' Oils variants:

Size 20, *Opacity* 100%, *Grain* 0%, *Dirty Brush Mode* off, *Viscosity* 22%, *Blend* 70%, *Wetness* 95%, *Trail-off* 50%. Single red, yellow, and blue strokes show how the brushstrokes fade and mix with the underlying color. Small crosshatched yellow strokes illustrate how colors do not mix on the canvas when *Dirty Brush Mode* is off. Lower arcs show marbling/fading effects of the brush.

Dry Brush
Size 20, *Opacity* 100%, *Grain* 0%, *Dirty Brush Mode* off, *Viscosity* 50%, *Blend* 50%, *Wetness* 25%, *Trail-off* 25%. Brushstrokes do not run out of paint as quickly as they do with Wet Brush, nor do they interact with the underlying color to the same extent. They form a much more pronounced marbling or striping when loaded with color from the *Mixer Palette's Sample Multiple Colors*.

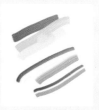

Impasto Oil
Size 30, *Opacity* 30%, *Grain* 0%, *Dirty Mode* off, *Viscosity* 30%, *Blend* 40%, *Wetness* 60%, *Trail-off* 75%. Different values for *Viscosity*, *Blend*, *Wetness*, and *Trail-off* will make the brush variant more smeary than the Dry Brush, but less smeary than the Wet Brush. The main difference is the **Impasto** effect, which gives depth to the applied paint.

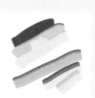

Oily Palette Knife
Size 30, *Opacity* 100%, *Grain* 0%, *Dirty Mode* off, *Viscosity* 25%, *Blend* 50%, *Wetness* 75%, *Trail-off* 40%. This brush has a further permutation of *Viscosity*, *Blend*, *Wetness*, and *Trail-off* values. The key point is that the Palette Knife does not add new color, it just smears the colors that are already present—including any background color.

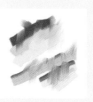

➤ Mixer Palette see pp. 22–23 ➤ Clone Color see pp. 44–45 ➤ Impasto see pp. 74–75

Here is an example of the Artists' Oils brushes used to make a painting of a Long Island beach scene. A photograph of the scene was used as the source for a drawing and for a *Color Set*, but otherwise the picture was painted entirely by hand.

For color, I used a *Color Set* made from the source photograph *(Color Sets>New Color Set from Image)*. The size of the swatches can be changed using the *Color Set*'s fly out menu, and it is simple to add colors to the *Mixer Palette* from the *Color Set* or otherwise further refine your color range.

1 First, I made a contour drawing by hand from the source photograph using a Wacom Tablet and a pen stylus. I made the drawing with the Charcoal Brush in the *Charcoal Brush* category, at *Size* 2.9, *Opacity* 22%, *Grain* 24%, *Resat* 100%, *Bleed* 0%, and *Jitter* 0%.

2 I painted in the main areas using a customized Wet Brush: *Size* between 7 and 24, *Opacity* 100%, *Grain* 0%, *Dirty Mode* off, *Viscosity* 14%, *Blend* 0%, *Wetness* 86%, *Amount* 92%, *Blend* 0%, and *Trail-off* at 100%. Having the *Blend* off meant there was no mixing of new and underlying color, which was what I wanted at this stage, as I was just roughly blocking in the color of the picture.

3 I added in more detail, this time using the Tapered Oils Brush: *Size* between 7.1 and 15.8, *Opacity* 100%, *Grain* 0%, *Dirty Mode* off, *Viscosity* 38%, *Blend* 50%, and *Wetness* 25%. You can see how the forms were becoming more distinct.

4 For the final stage, I went back to the Wet Brush (using the same settings as previous, although switching to *Dirty Brush Mode* occasionally to integrate the colors), but also used the Wet Oily Blender at these settings: *Size* between 6.9 and 24, *Opacity* 49%, *Grain* 0%, *Dirty Mode* off, *Viscosity* 90%, *Blend* 75%, *Wetness* 90%, *Paint Amount* 90%, and *Trail-off* 50%. The Blender is very useful because it delivers paint and softens edges simultaneously, where other brushes create predominantly. In fact, I did not want to soften all the edges because the sharp edges of the brushstrokes added energy to the painting. With a few final tweaks, I straightened the horizon and the painting was done.

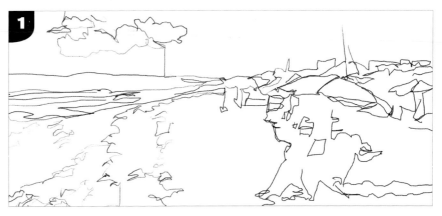

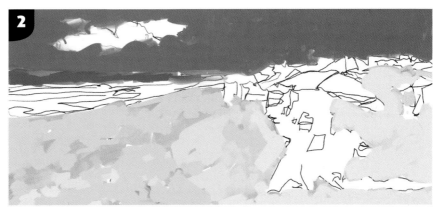

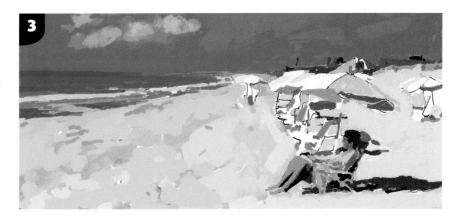

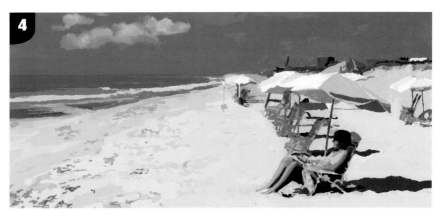

➺ **Hard Edges see pp. 64–65**

Corel introduced the RealBristle brush range with Painter X. The brushes have a highly developed bristle system, which makes them behave more like physical bristle brushes than any previous digital brush. When you press down on a real world bristle brush, the hairs spread and fan out and when you pull one across a canvas it flexes and spreads. Painter's RealBristle brushes mimic these behaviors.

Looking through the controls, the first thing you notice is that you can enable or disable the *RealBristle* function—when you deselect *RealBristle*, the brush returns to its standard characteristics. You can select a brush *Profile*, along with two other groups of controls: those that affect the shape of the brush and its bristles, and those that deal with the way it interacts with the canvas. The controls are pretty self-explanatory, although there are a few points worth making. With *Bristle Rigidity*, you can create simulations of brushes with softer or harder bristles, such as sable or ox hair (soft) or hog hair (heavier and rigid). *Friction* works in conjunction with *Brush Rigidity*—depending on the values set, you get less or more texture and splay in the stroke. *Height* determines how far the ferrule edge (the metal band that holds in the bristles) is from the canvas or paper; a high setting allows you to paint with a simulated brush tip and a low value will mean the brush can be easily spread out on the canvas.

Note that the *Feature* control has a big effect on the density of the bristles and if you want to see a more bristly brush you need to set a higher value.

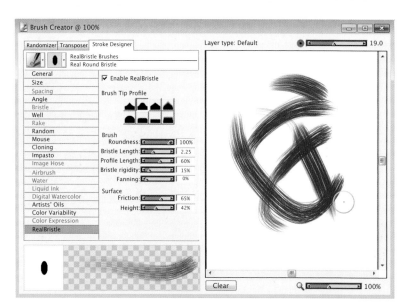

The RealBristle brushes are not associated with a particular medium, such as oil paint or acrylic. Their individuality stems from the realistic way they exhibit brush characteristics, and they are in fact linked to a number of other brush categories. You can apply RealBristle features to brushes using any of these **Dab** types: Camel Hair, Blend Camel Hair, Flat, Blend Flat, Palette Knife, or Bristle Spray. They also have controllers from other brush categories, such as **Artists' Oils** and *Oils*. You can see the special RealBristle controls to the left.

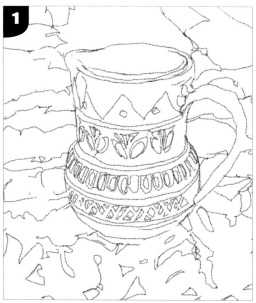

Here are examples of a few RealBristle brushes—all but one (the last) at default settings:

Based on an *Artists' Oils* brush, which contributes strongly to the brush's character, useful for adding hair and fur effects. *Blend* is 7%, *Trail-off* is 50%, and *Wetness* is 50%.

Real Round
One of only a few brush variants in this category that is not based on an *Artists' Oils* brush. Default settings are *Size* 35, *Opacity* 100%, *Bleed* 35%. It has a useful bristling quality, adjusted in the *RealBristle* controls.

Real Tapered Wet Flat
Another variant based on an *Artists' Oils* brush. By default, the *Blend* setting is 75%. This means a lot of background color (white) is being picked up. Change to a lower *Blend* setting to see the stroke.

1 To demonstrate the different character of the brushes, I created a painting of a vase. First, I made a hand-drawn sketch of a photograph and saved it as the bottom layer in the picture's layer stack. This delineated the shapes as a guide for painting. The drawing here was made with the Dull Grainy Chalk variant from the *Chalk* category: *Size* 13, *Opacity* 100%.

➡ **Dab see Painter Brushes Basics pp. 18–19** ➡ **Artists' Oils see pp. 24–25**

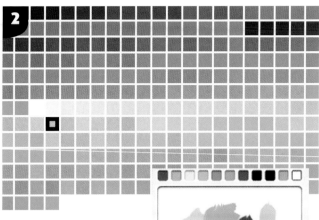

2 Next, I created a *Color Set* from the source photograph—obviously you won't do this if you are painting a subject from imagination. Then, using the Real Oils Short Brush at default settings, except with the *Size* at 19.8, *Opacity* 100%, *Feature* 2.6, and *Blend* 2%, I picked out some working colors and added them to the **Mixer Pad** using the *Apply Color Tool*.

3 I started by painting in the main areas, using the Real Oils Short Brush—I wanted to use as large a brush as possible as I did not want to run out of paint during brushstrokes. I modified the settings to: *Size* 11.3, *Opacity* 100%, and *Blend* 2%. My aim was to block in the forms of the picture, without worrying too much about getting the boundaries correct at this stage. You can see in the close up that the Real Oils Short has a very nice bristling effect.

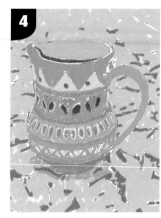

4 I continued to paint in the color areas with the Real Oils Short brush, establishing forms and some value relationships between them.

5 Next, I used the Real Blender Round Brush at the following settings: *Size* between 6.5 and 12, *Opacity* 100%, *Resat* 57%, *Bleed* 78%, and *Feature* 1.7. The aim here was to create an oily brush without too much bristle spread, which wouldn't be useful for detailed work. This brush was not based on an *Artists' Oils* variant; you can see the effect in this close up.

6 After some more work on the detail, the painting was still rather flat with little shading, as you can see here.

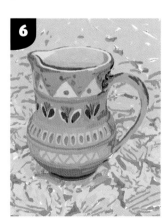

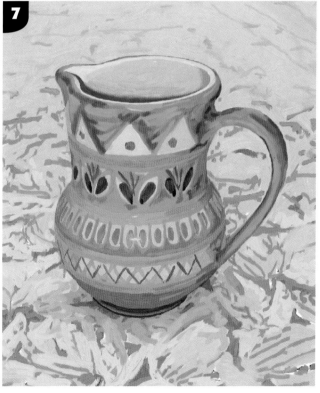

7 I used the Real Blender Tapered at *Size* 5.9, *Opacity* 29%, *Feature* 1.7, and *Blend* 30% to soften the edges and make the form look more rounded. I was not just smoothing out existing marks, I was also applying paint. I could drop the brush's *Opacity* to 60% to smooth edges. In the final picture, edges have been smoothed where necessary, and shading and highlights added to give the composition depth.

➡ **Mixer Pad see pp. 22–23**

Painter provides two kinds of watercolor brush: *Watercolor* brushes, which use a special wet layer, and *Digital Watercolor* brushes (introduced in Version 8), which don't use a wet layer and with which you can paint directly on to the "canvas." Real watercolor is difficult to master, and Painter's *Watercolor* brushes are the most complex to use. The *Digital Watercolor* brushes are easier—although less sophisticated—so I examine the more demanding *Watercolor* variants here. Corel's formidable task in designing these brushes was not only to get the tools to behave like real watercolor brushes (like a nice pointed full Kolinsky sable, for example) but also to simulate watercolor pigment flowing in different dilutions of water. The brushes had to react realistically with different types of simulated papers and watercolor board, and imitate other characteristics of watercolor, such as the effect of wind on drying pigment. There is, of course, more than one watercolor technique—opaque and transparent, **Wet-in-Wet** and **Dry Brush**, **Masking** and creating **Washes**—and some of these will be covered in later chapters.

When you first make a *Watercolor* (as opposed to *Digital Watercolor*) brushstroke on a new canvas (paper), a watercolor layer is automatically created. The layer is wet, which allows paint applied to it to flow around and be diluted. This is how the new wet layer will appear in the layer palette.

You can see the *Watercolor* brushes by opening up the *Brush Selector* and choosing *Watercolor*. You will first notice the large number of brushes available.

Their names fit their characteristics closely and there are specialist brushes in both bristle and camel varieties. There are brush controls on the *Properties* bar, but the full set of controls is in the *Brush Creator*.

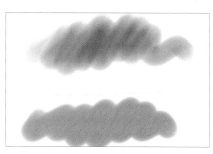

There are five watercolor **Dab** types: Watercolor Camel Hair, Watercolor Flat, Watercolor Palette Knife, Watercolor Bristle Spray, and Watercolor Airbrush. You can also use some other *Dab* types, as long as the *Method* is set to Wet. Here, for example, is the Watery Glazing Round with its default Camel Hair Dab above, and below it the Camel Hair Dab is replaced by a Static Bristle one. **RealBristle** bristles can be added to the *Watercolor Dab* types.

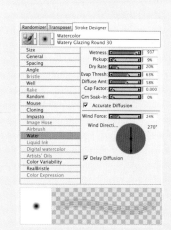

The real engine room of the *Watercolor* brushes are the *Water* controls in the *Stroke Designer*.

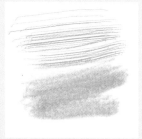

Wetness
Wetness determines how the paint is diluted—more *Wetness* gives a wider, softer edge stroke. The top brushstroke was made with the Diffuse Bristle Brush at default settings, except that *Wetness* was set to 0. The lower brushstroke had a maximum *Wetness* setting.

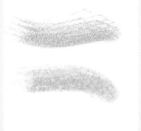

Pickup
Pickup determines how much paint is taken up as the diffusion (paint spreading) process takes place. Here is the same Diffuse Bristle Brush with different pickup values. The upper stroke had *Pickup* set to minimum and the lower stroke was set to maximum.

Dry Rate
Dry Rate controls how quickly the water dries during diffusion. The upper stroke illustrates the minimum value for *Dry Rate*—this had a marked effect on the diffusion. With the maximum value for *Dry Rate*, drying happens so quickly there is no time for any diffusion at all.

➤ **Wet-in-Wet** see pp. 110–111 ➤ **Dry Brush** see pp. 62–63 ➤ **Masking** see pp. 124–125 ➤ **Washes** see pp. 72–73, 82–85, 92–93 ➤ **Dab** see pp. 18–19 ➤ **RealBristle** see pp. 26–27

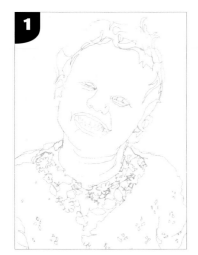

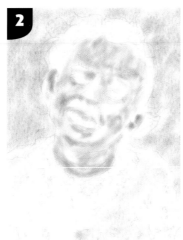

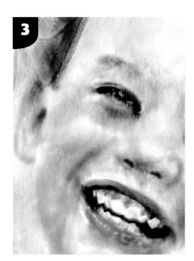

Portrait painting using Watercolor brushes

1 On a graphics tablet, I made a contour drawing from a source photograph using the Cover Pencil variant from the *Pencils* category. The main settings were: *Size* 2, *Opacity* 58%, *Grain* 44%, using a mid gray color. I made the drawing as much to gain familiarity with the forms as provide a line guide. I also created a color palette from the colors in the source photograph.

2 As you can see from this first stage, I painted in broad washes, establishing the forms using color and value. I left the highlights very light and did not add color to the hair area just yet. When painting with watercolor, it is typical to work from light to dark. However, Painter's *Watercolors* provide an Eraser that works on the wet layer and allows greater freedom for making corrections and adding highlights. I used the Runny Wash Camel Brush with *Size* 37.8 and *Opacity* 39% for the background, and the Soft Camel at *Size* 25.3 and *Opacity* 14% for the figure.

3 Here is a close up of the painting towards the end of the process. The paint was actually applied quite loosely as I didn't want the overall composition to look overworked. It is good to use different brushes; in addition to the Runny Wash Camel and Soft Camel, I used the Diffuse Bristle at default values but *Size* 34.9, particularly for the shadow areas. I painted the shadow areas with warm (more orange) and cool (more purple blue) washes to give them vitality.

4 Here is the final painting. I used the Eraser Brush to restore highlights or bring out hair wisps where necessary. I then warmed up the highlights with a light warm wash and painted the hair wisps with a customized Eraser Brush with settings at *Size* 15 and *Opacity* 11%. More importantly, I changed the *Dab* type to *Static Bristle* and set the *Stroke Type* to *Multi*. I added much of the hair using a Soft Camel, but added darker wisps of hair using either the Fine Brush at *Size* 3.4, *Opacity* 54%, and *Feature* 2.5, or the Dry Bristle Brush at *Size* 34.5 and *Opacity* 42%. Crucially, I increased the *Feature* of the customized Dry Bristle to 9 to give more space between the bristles of the brushstroke for a looser look.

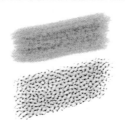

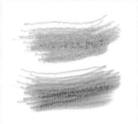

Evaporation Threshold
The *Evaporation Threshold (EvapThresh)* controls the least amount of water that can diffuse. The upper stroke had the default Diffuse Bristle with the *EvapThresh* setting to its minimum value and the lower stroke illustrates the effect when *EvapThresh* is set to maximum.

Diffusion Amount
The *Diffusion Amount (Diffuse Amt)* controls how much the stroke spreads. The upper stroke had the *Diffusion Amount* value at minimum; the lower stroke shows the value at maximum.

Capillary Factor
Capillary Factor (Cap Factor) and *Grain Soak-In (Grn Soak-In)* control aspects of the effect paper texture (grain) has on the diffusion and on the paint. The higher the values, the more obvious the grain. The upper stroke value for both features was set to zero; the lower stroke for both set to maximum. The Pebble Board texture is plainly visible in the lower stroke.

Accuracy Diffusion
Accuracy Diffusion determines the spread of diffusion. The *Wind Force* and *Wind Direction* controls mimic the effect of gravity on drying watercolor paint. The upper stroke had no *Wind Force* applied to it; the lower one had a southerly *Wind Force* of 100%. *Delay Diffusion* stops the diffusion process from starting until you have finished the brushstroke.

"Texture" in this context means the characteristics of the support surface onto which digital paint is applied. Supports can be canvas for oils, paper for watercolor or board for acrylics. Adding texture to a picture makes it look more realistic by mimicking the way media interact with support—for example, the way real oils interact with real canvas, or watercolors with paper. In Painter and Photoshop you can add texture in a number of ways—here I look at texture applied with a brush to an entire image.

You may wonder why you would want to add texture by brush rather than apply it to a whole image—after all, the whole support is textured. The reason is that in real world oil or acrylic paintings, the canvas underlying the paint does not show through evenly because canvas is only revealed where the paint is thin. To get this effect, you can either use a brush to selectively add texture or an eraser to selectively remove texture. Either of these approaches works, but there is most flexibility in using a brush, and the process feels more intuitive.

Here are three examples of texture as it occurs in different real world media:

Watercolor paper—medium roughness. This is a medium texture, not as smooth as "Hot Press" or as jagged as "Rough." Wet pigment sinks into the dips and creates a granulated effect.

Artist's canvas. When paint is applied in a dry brush technique the paint just catches the raised fibers creating a broken color effect. Palette knife scrapes react similarly with this texture.

A watercolor board, which is rigid and comes with various textures. This one is quite pronounced and jagged, and wet paint interacts with this in much the same way as it does with paper.

The texture effects on the far left can be simulated in Painter and Photoshop. Here are two examples of texture applied with a brush:

In Photoshop, the Paint on Rough Surface Brush at a *Size* of 100, *Opacity* at 61%, and *Texture* at a *Scale* of 346%. The texture used here was a Dry Brush at *Size* 127 and *Opacity* at 57%, with a *Texture* at 423% made from a noise pattern.

In Painter, the Grainy Dry Brush variant from the **Artists' Oils** category. *Size* was 20 and *Opacity* 23%. The **Dab** type was *Static Bristle* and the *Sub Category* was *Grainy Hard Cover*. Bristle settings were *Thickness* 100%, *Clumpiness* 76%, *Hair Scale* 1000%, and *Scale/Size* 51%.

In Photoshop, you can add texture to any brushstroke using the *Texture* controls in the *Brush* palette. There are a number of parameters that can be altered, such as *Scale* or *Blending Mode*—the full list of available textures is accessed from the *Patterns* drop down list.

Textures can be applied across a whole image using a *Pattern Overlay* or *Texturizer* filter at *Filter>Texture>Texturizer*. There are a few default textures that come with Photoshop, but you can easily add more by creating them yourself—any .psd (Photoshop's native format) file will act as texture, and scanning canvas or paper gets good results. *Pattern Overlay* for an image is achieved by going to *Layers>New Fill Layer>Pattern*, selecting the texture (pattern) you want and selecting the *Soft Light* blending mode. The texture will then appear above the active layer.

takes texture creation and application more deeply into the realm of embossing. This goes beyond the simulation of canvas and paper and therefore it is outside the scope of this book, but *Painter Help* is worth reading if you are interested in pursuing other sorts of textured effects.

Brushstrokes with thick paint (**Impasto**) also count as a form of texture—they are 3D, after all—and are an important technique in oil painting. This will be covered later in the book when we take a closer look at painting techniques.

The Painter texture capabilities are more specialized for digital painting, as you would expect. There are some confusing terms though: "Canvas" can mean "Paper" when it's in relation to layers; "Paper" can be "Canvas" when it's in the context of the Papers palette; "Grain" means texture in the context of a brush; and "Texture" only seems to refer to texture when it is used to apply overall *Surface Texture* in the *Effects* menu, when it will be one of the "Papers."

You can access the Painter papers from *Window>Library Palettes>Show Papers*, but you can also open them up using the *Papers* icon towards the bottom of the *Toolbox*. You can then use the small top right fly out arrow to access the additional related functions.

There are three controls that alter the size of the texture and change its contrast and brightness respectively. (Contrast and brightness affect the apparent depth of the texture.) There are two other buttons on the palette that enable you to invert the grain so you can fill with paint holes in the coverage made by a normal, grainy brushstroke and enable the grain to interact with the direction of the brushstroke.

Applying a texture to the whole image is easy in Painter—just go to *Effects>Surface Control>Apply Surface Texture*. You then have the options depicted here. These controls are mostly self-explanatory, but it is worth reading the *Painter Help* on the first option in particular, "Using... (various options)," because this

Here, you can see the *Make Paper* command on the flyout list. This enables you to create your own paper should you not find what you want among the default papers. The top item is *Launch Palette*—this brings up the key controls for the paper, or grain, itself.

On the left is a painting created in Painter that used *Texture—Artists Canvas*—quite extensively. The canvas texture was brushed on using various customized *Grainy* brushes, lightening darker areas and adding visual interest. Above is a close up of the *Texture* effect.

➔ **Impasto see pp. 74–75**

It may seem odd to discuss filters (which apply effects to your images automatically) in a book about painting techniques. But filters, used selectively, can help prepare your photos for painting or add a missing painterly effect to your digital paintings. There is no shame in using filters to reach your objectives, but they can look crude if used without the proper care.

Filters in Painter and Photoshop—called *Effects* in Painter, and *Adjustments and Filters* in Photoshop— produce a wide range of manipulations, from color change to sharpening, sketching to distortion and all points in between. Both programs have sophisticated color and tone processing, but Photoshop has some artistic effects that are very useful and are not fully reproduced in Painter.

There are too many *Filters* and *Adjustments* (Photoshop's word for changes to color and tone) to go through them all here, so in this section I briefly look at filters used to fix exposure problems, filters to sharpen, filters to simplify detail, and filters to add painterly effects.

Exposure

To fix exposure problems, use *Contrast* and *Brightness*, or *Levels* or *Curves* controls in Painter or Photoshop.

I fixed the exposure problems in the original photo on the left in Photoshop with the following modifications: *Brightness* +20 and *Contrast* +11 at *Image>Adjustments>Brightness Contrast*.

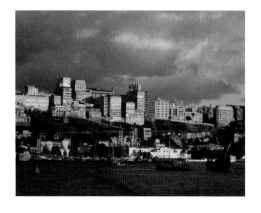 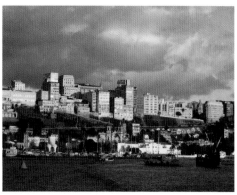

Exposure

For more subtle contrast effects use *Shadows/Highlights* in Photoshop.

I treated the original photo on the left in Photoshop, using *Shadows* 22%/ *Highlights* 16% at *Image>Adjustments> Shadows/Highlights*. The effect here is rather like **Higher Dynamic Range**.

Sharpening

Sharpen using Painter at *Effects> Focus>Sharpen*. Or Photoshop at *Filters>Sharpen>Unsharp Mask*. On the left is a magnification of 135% to give a close up of the original photo. I sharpened the image in Photoshop with *Unsharp Mask* using *Amount* 39%, *Radius* 2 pixels, and *Threshold* 0.

➥ **Higher Dynamic Range see pp. 36–37**

Simplification 1

To simplify an image, you can use *Smart Blur* in Painter at *Window> Underpainting* or in Photoshop at *Filter> Blur>Smart and Surface Blur.*

You can see A Magnification of 135% on the starting image on the left, which I simplified in Painter using a *Smart Blur* at 77%.

Simplification 2

Another way to simplify an image is to use *Dry Brush* in Photoshop. Using the same magnification as above, I simplified this image using *Dry Brush* at *Filter>Artistic>Dry Brush.* Settings: *Size 7, Brush Detail 10, Texture 1.*

Painterly Effects

In Photoshop, you can add a *Watercolor* filter at *Filters>Artistic>Watercolor.* There is no equivalent in Painter—the brushes in Painter themselves create a painterly effect. You can see the effect on the original photo on the left when I applied Photoshop's *Watercolor* filter at the following settings: *Brush Detail 11, Shadow Intensity 0,* and *Texture 1.*

Line Drawings

In Painter, use *Effects>Surface Control> Sketch.* In Photoshop, use *Desaturate, Glowing Edges, Invert Filters.* I applied this treatment to the original photo on the left in Photoshop using *Desaturate* at *Image>Adjustments>Desaturate* to make the image black and white, then *Glowing Edges* at *Filters>Stylize> Glowing Edges (Edge Width 2, Edge Brightness 4, Smoothness 0).* I then went back to *Adjustments* and inverted the image *(Image>Adjustments>Invert),* and added *Contrast* of 24 at *Image> Adjustments>Brightness/Contrast.*

There are small programs that work with Photoshop and Painter and provide additional functions to the parent program. These "plug-ins" aim to add functions that the main programs don't have or provide more effective specialized versions of functions they do have. The "Browse Filters Online" command at the bottom of the Photoshop filters menu takes you to the Adobe website, where a large number of plug-ins are listed.

Some plug-ins on the internet are free, but others aren't. Some work in Painter, others work only in Photoshop, and some only in particular versions of Photoshop. Some are offered only as plug-ins, others are also available as standalone features that are external to the Photoshop and Painter programs. There are hundreds of plug-ins to be found on the internet; you should check the system requirements carefully before installing them and you can often try them before you buy in free download trial versions.

The plug-ins that are relevant here are those that help prepare photos for digital painting or enhance paintings when they are complete. Many plug-ins have image preparation or refining functions; they correct lens distortion or perspective, improve color, remove noise, sharpen, enlarge, or perform other useful functions.

There are also plug-ins that contribute functions that Photoshop (and Painter) do not have, or have in more rudimentary or cumbersome ways. For example, plug-ins that add lighting effects, produce backgrounds for portraits, create highly detailed photorealistic results or simplify an image in a painterly way.

This book does not intend to steer you towards one plug-in or another. But I would encourage you not to ignore plug-ins entirely. There are some useful small programs, which will enhance your experience of Photoshop and Painter significantly. Here, by way of illustration, are a few examples of effects produced from two little Photoshop plug-ins: Topaz Simplify and Topaz Adjust. The first is helpful for super-realistic treatments, and the second for loose brushed paintings.

Plug-ins are installed in the *Plug-ins* folder of the parent program, and once installed, appear as extra items in the fly out list from *Effects> Other* in Painter, and below *Other* in Photoshop *(Filters>Other)*.

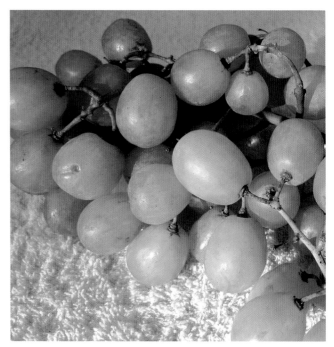

Here is the original image to which I wanted to apply my plug-ins.

The Topaz Simplifier removes detail from an image and has at least two useful, tweakable presets. Below is a simplified version of the grapes image using a preset, and then a pencil sketch.

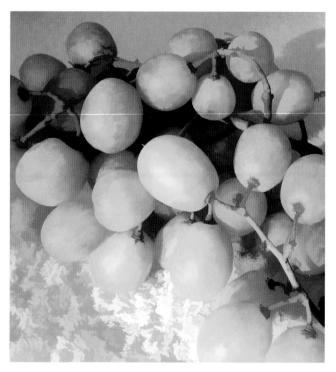

Simplify, simplified.

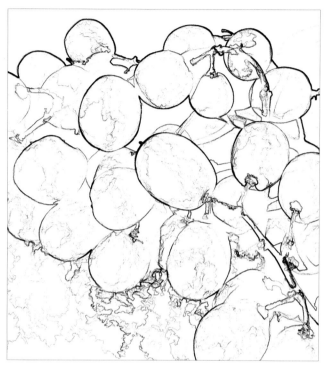

Simplify, sketch.

The Topaz Adjust plug-in enhances contrast and brings out detail in restrained or unrestrained ways.

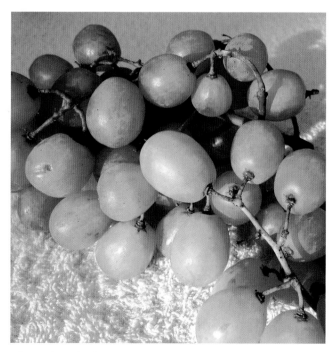

Adjust, moderate detail.

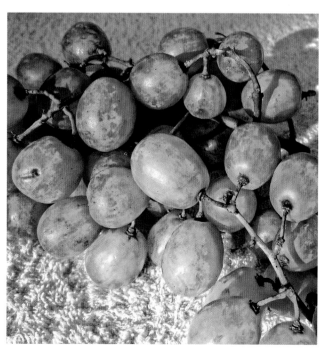

Adjust, extreme detail.

Above, the exposure was correct for the view outside the window, but most of the fish is in darkness, while below the fish is much clearer, but the background is bleached out.

Very often, the photos we take do not show us what is really there. Because of photographic exposure limitations, most cameras do not show detail in both shadows and highlights in a single take. This causes the typical problem for holiday photography and beach photos in particular, where you can either expose for the sky and see the figures on the beach only as dark silhouettes, or expose for the beach to get the figures on the beach properly lit, only to find the sky is burnt out and just showing white.

Higher Dynamic Range (HDR) photography gets around this by using a series of photos at different exposures to produce a single image—an HDR image—that draws on the information from all three photos from light to dark. This HDR image cannot be displayed properly on a normal monitor (because of its Higher Dynamic Range of light and dark) and has to be treated to make it viewable. This process is called Tone Mapping. So HDR photography has three steps: taking the differently exposed photos, combining them into a single HDR image, and converting that image into a new (Tone Mapped) image that reveals much more of the detail in both the shadow and lightest areas. The relevance of this for digital painting is that sometimes a very detailed image is required to convey information, for example about the sitter's life in addition to their likeness. Possessions and surroundings tell us about character as well as lifestyle. Alternatively, you may just enjoy working on super-photographic images with their dreamlike, otherworldly quality.

There are a number of programs that can produce HDR/Tone Mapped images, among them Photoshop (post CS2), Photomatix Pro, and Dynamic Photo HDR. The Photoshop HDR function is developing, but the other small specialist programs are easier to use and produce good results. The example on these pages uses Dynamic Photo HDR, which is considerably cheaper than Photomatix Pro, with much the same efficacy.

The first thing is to use the right photos. HDR/Tone Mapping works best and is most dramatic when there is bright lighting producing a high contrast of dark darks and very light lights. However, the effect is sometimes all the better for a little understatement as Tone Mapping is often overdone. You can get something of this effect by Tone Mapping from a single exposure in Dynamic Photo HDR and Photomatix, and also by using exposure controls like Photoshop's *Shadows/Highlights* and Topaz Adjust.

To start the HDR process you need three differently exposed photos. Using a tripod ensures that the photos will line up correctly when they are merged. Both the specialized programs mentioned above have processes to help you align pictures if you do not have the use of a tripod, but it is much simpler to get the alignment correct in the first place. Also, cut down the size of the photo file if possible.

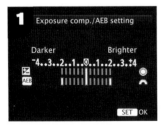

1 The way to make the three differently exposed photos is to use Automatic Exposure Bracketing (AEB) on your camera with the (probably three) exposure stops spread as much as possible: -2EV, 0EV (default), and +2EV. On the right are three photos from the AEB process before HDR processing.

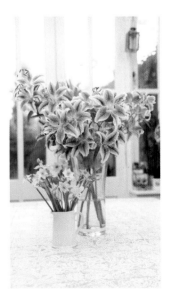

2 When the three (or more if your camera permits it) photos have been taken in AEB mode, open *Dynamic Photo HDR* and go to *File>Create New HDR*.

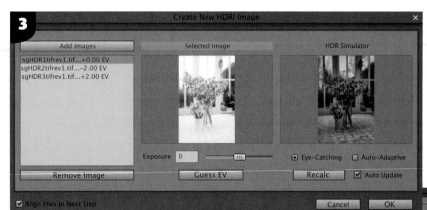

3 Add the three pictures you have taken, and after they appear, try the image style options of *Eye-Catching* and *Auto-Adaptive* under the HDR Simulator window. Pick the one you prefer. The example here used the *Eye-Catching* option. Clicking *OK* takes you to the controls for aligning the images. Because the photos were taken on a tripod, they should be well aligned so the process of aligning them here (by clicking on *Align View* for both file options) in the window is a formality.

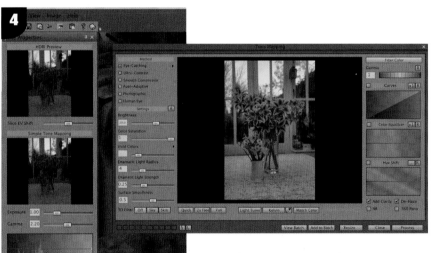

4 When you then click *OK*, an HDR image is created. This won't yet look like the finished image because it has to be converted to a viewable format for display (Tone Mapped). On the left is a preview of an HDR file. You can change the exposure of the finished image if you wish, or leave it as it is and click on *Tone Map HDR File* in the top right-hand corner of the program screen.

This goes to a preview of the Tone Mapped image that offers a number of controls to alter the color, tone, and sharpness of the image, including different Tone Mapping approaches and a range of presets in the top left hand corner. Here, I lifted the *Brightness* a little and then clicked *Process* to finalize the Tone Mapped image.

5 Save the file as an 8bit .tiff. Here is a comparison between the normally exposed image (on the left) and the final image with a few exposure adjustments *(Curves)*.

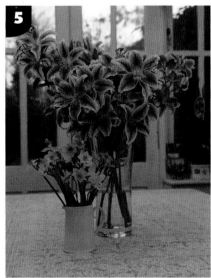
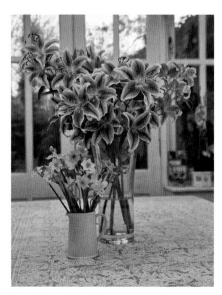

Photoshop has some very sophisticated color tools and Painter's are not far behind. This section concentrates on the Photoshop tools, but there is quite a lot of similarity between the two programs so understanding one system will help you to understand the other. These controls allow you to do almost anything you want with the colors in your photo or painting. As a starting point, you can use the automatic *Tone*, *Contrast*, and *Color* controls available under *Adjustments* and check the results with *Curves*.

It often helps a composition to give it bit more "pop." This generally means adding some more color saturation, or contrast, or both. There are many ways to do this: an adjustment in *Curves*, or *Levels*, where the *Histogram* can guide you, or using the *Contrast* and *Color Saturation* controls themselves. The *Vibrance* control in Photoshop CS4 allows you to lift color saturation without oversaturation or clipping; in other words, you can now easily raise the saturation of more muted colors in an image without increasing the saturation of those colors that are already vibrant. The *Photo* filter is useful in digital painting too, not only for warming and cooling pictures, but also in unifying the components of an image.

With *Match Color*, you can match a color in an image you are working on to a color from another image. This is good for changing color details. The most intuitive control to use quickly is *Replace Color*, which allows you to change particular colors in an image and not affect others. If you freehand paint, you will either make up your own colors or create a color palette comprising color swatches from a photograph. If you **Clone Color**, there is an interesting feature in Painter X that allows you to borrow colors from one image and deploy them in another—this is found in the *Underpainting* controls. In Photoshop, it is possible to use the *Match Color* palette command to out-source colors for **Underpainting**.

In Painter, the color controls are accessed from the *Effects* control on the *Menu* bar.

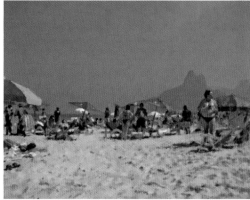

Before

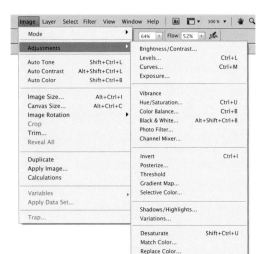

The Photoshop *Color* functions are opened from the *Image* control on the *Menu* bar.

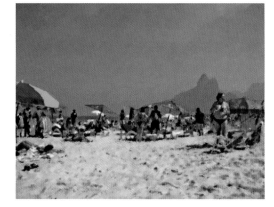

As the picture to the right demonstrates, duplicating the final image layer and switching the *Blending Mode* to *Soft Light* also gives an image punch.

After

➟ **Clone Color see pp. 44–45** ➟ **Underpainting see pp. 106–107**

Before

After

To bring out a little more detail, the *Shadows/Highlights* control is a great tool. This works very effectively if it is not overdone. It finds detail in moderate shadows—not to the extent of a full HDR/Tone Mapped photo, but sufficient for many pictures.

Below are four versions of the same image with different color schemes to show what an impact the color can have on the mood of a picture. None are more correct than the other—it is simply a matter of personal taste—but it underlines the importance of color choice.

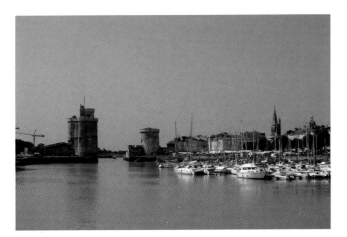

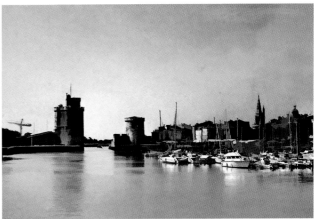

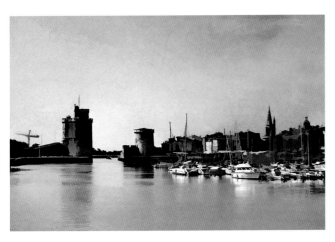

It would be wonderful if we were all able to make paintings—with real oils, or digitally—that met our expectations. But for many of us, freehand painting is a pretty frustrating affair, and noble as it is to struggle on despite your dissatisfaction, it can become demoralizing. This is not to imply that we shouldn't paint and draw freehand—it can be relaxing and fun—but it can also be dispiriting, sometimes to the extent that we give up on art altogether. Well, for those of us in this position, help is at hand in the form of **Clone Color** painting.

In this book, the expression "clone painting" is used generically, that is, it means the process of deriving a new painterly image from a photograph or any other picture. This includes tracing from a photo as well as using special tools to make painterly versions of a starting photo. In Photoshop and Painter both these approaches are possible and this section examines them.

The two different programs produce very different styles of cloned pictures, and you will probably reach the point when you know which program will deliver the particular results you want. For example, watercolor simulations in Painter and Photoshop look different; in Painter they are derived from its specialized *Watercolor* brushes, and in Photoshop from using the *Pattern Stamp* or *Art History Brush*.

It is important to note that the list of cloning and tracing techniques discussed here is not exhaustive. There are many ways to simulate different kinds of natural media, and you will discover more through experimentation.

Skeptics sometimes describe cloning and tracing as a form of cheating, but there is a history of artists using the available technology to make their lives easier, so do not worry too much about this criticism. It can be argued that cloning tools place as much emphasis on creativity as on craftsmanship, and that if we have no interesting creative ideas, this will be exposed when all our effort no longer has to go into simply reproducing by hand what we see with our eyes. Producing cloned work still raises all those difficult artistic questions: have I got the composition right? Do the colors work? Have I got the values correct? Have I achieved an effective center of interest? These fundamental questions are no more resolved by the cloning process than by hand painting. Certainly, successful photo preparation is crucial.

However, in choosing to navigate these deep waters of taste and opinion, be assured that cloning is a lot of fun and quite demanding enough for most of us, and that it will repay all the work put in to master it.

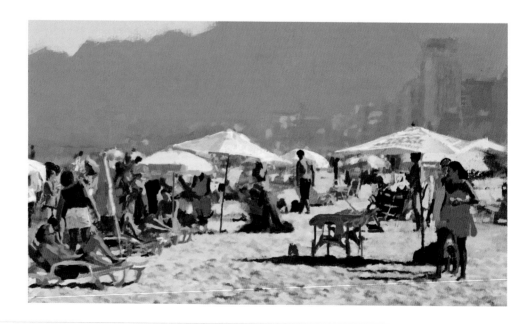

➻ Clone Color see pp. 44–45

The obvious question here is: why would you want to use tracing when sophisticated color cloning functions are available? The reason is that paintings by tracing never look like cloned photographs, unless you are the most fastidious of painters going over every detail. The principal objective with **Clone Color** images is to avoid making them look merely like slightly smudged photos. The advantage of the traced painting is that it avoids some of these dangers, as the painter is picking the colors and composition, not the software.

Traced paintings can be made in both Photoshop and Painter, and the processes are similar across both programs. If you have a large enough digital tablet, it is possible to put a hard copy of the source photo under the transparent plastic mat on the tablet and paint from that with your pen tool following the forms in the image, using whatever brushes you choose. You may either already have made a color palette from the photo or just rely on your eye to estimate the colors. The painted version appears like magic on the display. Or you can just open up the photo in Photoshop, duplicate the layer, and prepare it as you see fit. Then create a blank layer, which you fill with a background color at a low enough opacity to show the photo on the layer below. After this, either make up a color palette using the photograph's colors, or simply rely on your eye as you flick between traced top and photo under layers. This process in Painter is explained with a worked example below.

1 First select the paper you want—I chose **Artists Canvas**—and then choose a photo as a source. Remember, as you are not cloning, you can leave any offending elements out of your trace and paint alternative areas in their place. The photo here had an unsightly background, but this could be handled as I worked through my painting.

2 To use your own colors for your painting, create a copy of the image, make the original version active, and add a new layer above the original either by using *Layer>New Layer* or by clicking on the *Make New Layer* command at the bottom of the *Layers* palette. Then fill the new layer with a dark gray, and cut *Opacity* to 71%. The screen should now look like this.

➡➡➡ **Clone Color see pp. 44–45** ➡➡ **Artists Canvas see Expressing Texture pp. 30–31**

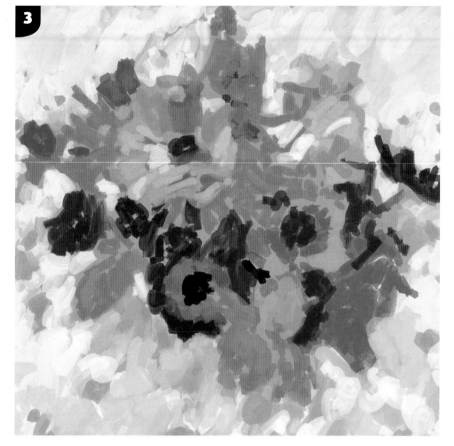

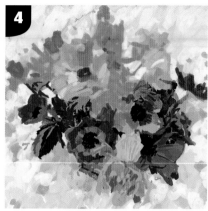

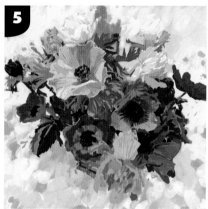

3 Choose a large **Artists' Oil** brush at a high *Opacity* (70%) to paint with, then get started using your own colors (from the *Colors* wheel) and some chosen from the copy image. Make sure that the *Clone Color Mode* below the color triangle is not selected. After some blocking-in, my picture was beginning to take shape.

4 I continued to add detail with the same brush.

5 Here I brought in more detail with a Detail Oils Brush.

6 Here is the finished picture. It avoids a photographic look, allowing a large amount of creativity. I did not use any blending here, preferring to keep the forms strong and distinct.

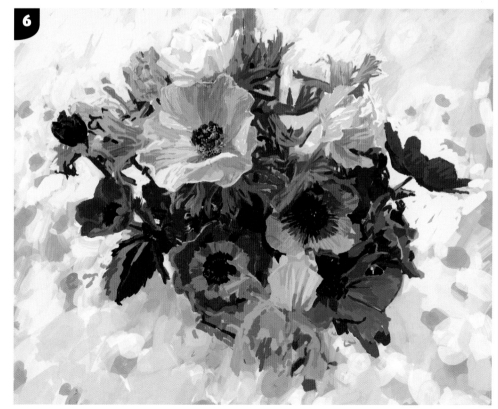

➻ Artists' Oils see pp. 24–25

Painter's Clone Color Mode is one of the program's crown jewels. It allows you to simulate natural media in paintings derived from photographs more effectively than in any other program. Photoshop has a clone tool too, but it does not function as well as a brush, being more similar to Painter's *Rubber Stamp Tool*, so I will concentrate on Painter's powerful cloning function here. In color cloning, colors and their location in a source image are replicated in another—usually blank—target image. Clone Color Mode performs this function for you. In Painter, there is a specific category of ready-made cloner brushes that lift color from a source image and deposit it on a receiving image. These brush variants are in the *Cloners* category, which you will find in the *Brush Selector*. It is also possible to turn almost any brush into a color cloning brush simply by setting the clone source and then making sure that the *Clone Stamp* icon in the *Color* palette is active.

HINT

Most brushes can be made into cloners by switching on *Clone Color Mode*. But you will find that some brushes, such as a number of the *Oils* variants, replicate the source image exactly—adding little of their own character. You will develop your own preferences to achieve the effects that you want.

1 Open the source image in Painter.

2 *Select Clone* from the drop down menu under *File*.

3 You now have another, clone image, which you will work on. Select all of this image at *Select>All*.

4 Now clear the image from the clone version at *Edit>Clear*.

5 Next, choose how much of the original image you want to see as you apply paint to the cloned image. You do this from the *Toggle Tracing Paper* button, just below the image's red close button.

6 Select the Oil Brush Cloner variant from the *Cloners* range.

7 Now choose the paper variant you want from the *Papers* palette at the bottom of the *Toolbox*. **Artists Canvas** is used here.

8 Make sure that *Clone Color Mode* is switched on—the little stamp tool icon below the color wheel needs to be depressed. This happens automatically with *Cloner* brush variants.

9 Start the painting by brushing in the forms you see through the transparent clone layer. Here is a detail of the picture without any transparency.

Here I have created a cloned painting in Painter and Photoshop with a loose style, using a couple of customized brush variants from the Acrylics category.

1 The starting photograph had *Auto-Levels* and some more color saturation added in Photoshop. The degree of preparation your photo needs depends on its condition—there is no set preparation workflow.

2 I set up the photo in Painter in *Clone Color Mode* as described earlier and added some *Artists Canvas* texture using *Effects>Apply Surface Texture*, with the *Amount* set to 19%. I then selected a customized Acrylics Dry Brush 30, with **Dab** type set to *Static Bristle, Stroke* type at *Single, Sub Category* at *Grainy Hard Soft, Grain* at 11%, *Opacity* at 96%, and *Size* at 52. *Bristle* settings were: *Thickness* 23%, *Clumpiness* 0%, *Hair Scale* 580%, *Scale/Size* 53%. I used this brush to paint in the main areas of the picture. It is essential to keep the strokes loose, following the forms with your brushstroke.

3 Here I brought in more detail using the same brush at the same settings, except that *Size* was down to 10.4. I was concentrating on bringing back selective detail—I did not want the whole canvas covered in paint or the painted areas to have a consistent level of detail. You can also use a higher *Grain* setting of 25% (less canvas texture—grain—will show through).

4 I changed to a Captured Bristle Brush at *Sizes* between 3.6 and 9.6 and at an *Opacity* of 100% for my final application of brushstrokes. There was no grain and I was effectively adding small areas of paint—more detail—with no texture (grain). When finished, I had achieved a range of grain in my painting from all over coverage (where there is no paint) to progressively less visible grain as I made thicker and thicker applications of paint with my brushstrokes.

5 For the final stage, I saved the painting as a Tiff file so that all the layers would be preserved, and also as a .tiff, which I opened in Photoshop. There I created a line drawing from the original photograph using *Desaturate (Image>Adjustment>Desaturate)*, *Glowing Edges (Filter>Stylize>Glowing Edges* and settings of *Edge Width* 2, *Edge Brightness* 4, *Smoothness* 1), and *Invert (Image>Adjustment)*. Then I dragged the line drawing onto the painting and gave it a *Blend Mode* of *Multiply* and an *Opacity* of 78%.

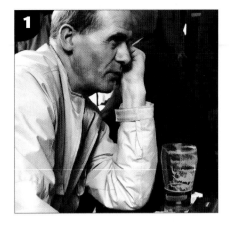

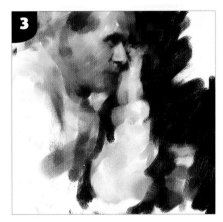

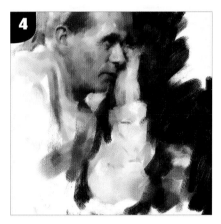

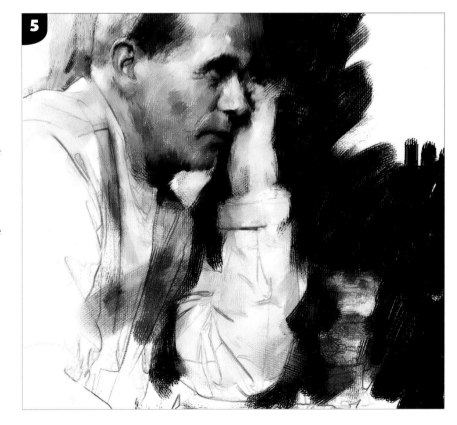

➡ **Dab see Painter Brushes Basics pp. 18–19**

The Art History Bush is similar to Painter's **Clone Color Mode** in that it uses one image as a source to paint into another. But in the case of the Art History Brush, it is always from one history state of an image to a layer of the same image. The great thing about this brush is that you can create a snapshot of your open image at any stage and use this as the source image for your brush. So it is possible to create a snapshot of your image at an early stage when it has plenty of detail and selectively play this detail back in later.

You can choose the type of brush, its *Blending Mode*, and its *Opacity*. There are other parameters that need clarification: the *Style* category allows you to choose from a number of different styles or shapes, which determine the form the brushstroke takes; *Area* controls how much canvas a brushstroke in its *Style* covers; and *Tolerance* sets where on the canvas the brushstroke can be applied (little *Tolerance* equals more coverage). Again, experimentation is the best way to master this tool. Even leaving aside other parameters, it is difficult to predict precisely how a certain stroke, in a certain *Style*, will display. Other considerations worth keeping in mind include the size of the brush and the size of the image.

1 To see how the Art History Brush works, select the *Art History Brush* from the *Toolbox*. Then open an image, duplicate the background layer, and go to *Window>History*. This will bring up the *History* palette. Note that there is an icon of the image along the top, and to its left a small image of the Art History Brush—this means that the original image is selected as the source for the Art History Brush.

Below are the brush controls for the Art History Brush on Photoshop's *Tool Options* bar.

2 To create a snapshot, open the *History* palette, and click on the small camera picture at the bottom of the palette while holding down the *Alt* key. This brings up a new box that enables you to give a name to the snapshot. Choose *Current Layer* to get a snapshot of whatever layer is open.

Below are some examples of the Art History Brush using the *Large Texture Stroke* at three sizes—40px, 50pix, and 60pix—and the *Tight Short Style*. *Mode* was *Normal* and *Opacity* 100%. All images are 674 x 692 pix and have a resolution of 300ppi. Just one *Style* brush was used here, but a painting can use different *Styles*, with different brush tips at different sizes. So you really do need to experiment. You will quickly get a sense of which combinations of features work best for you—for example, you may want to have large areas of the picture in broader, more smeary strokes, bringing out key areas of detail with smaller, more accurate marks. This at the least suggests larger sizes for the broader areas and smaller sizes for the more detailed ones. As you can see, Photoshop is capable of quite painterly brushing effects.

Size 40pix Art History Brush used. In each case, I applied paint with a dabbing movement, not dragged brushstrokes.

Size 50pix Art History Brush used. The brush treatment was broader and looser.

Size 60pix Art History Brush used. The brushstrokes were now very loose and expressive.

➡ Clone Color Mode see pp. 44–45

1 Here is a worked example—a portrait. I was aiming for a broad oil or acrylic look with the planes of the face simplified and with details brought back just in key areas to focus the attention on the main facial features.

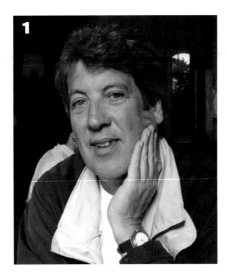

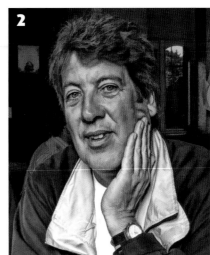

2 The starting photo needed some simplification, which I achieved using a plug-in: **Topaz Simplify**. The background was recessed a little and more contrast was added to the face.

3 Next, I duplicated the top layer and selected the duplicated layer as the source for the Art History Brush by selecting the small box to the left of the duplicated layer in the *History* palette. I then filled the top layer with a gray brown color.

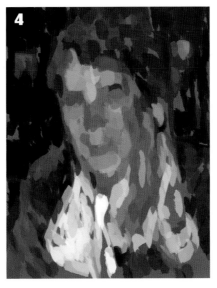

4 The picture was ready to paint. I selected a Veining Feather 2 Brush from the *Faux Finish* brush library with *Style* set to *Tight Long* (*Size* was 28, *Opacity* 74%, *Area* 32px, and *Tolerance* of 0). You need to reduce the *Spacing* for this brush (and others) or you will get a comb effect. Experiment with the size and its orientation, which are controlled in the *Brush Tip Shape* with the *Spacing*. After some brushwork the portrait began to take shape.

5 Next, I downsized the brush a little and set the *Style* to *Tight Medium*.

6 I then switched to a Texture 4 Brush and *Style Tight Short* to bring in more detail. As well as strokes I used a dabbing action to apply paint.

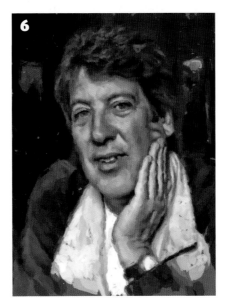

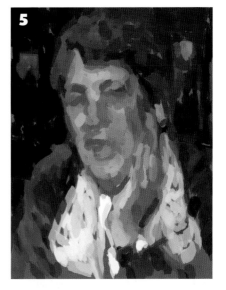

7 Here is the final image, which I duplicated and blended using *Soft Light* to give it more punch.

➤ Topaz Simplify see pp. 34–35

48 | Photoshop's Pattern Stamp Tool

Although this tool is called Pattern Stamp Tool, it does not restrict you to only making stamps. The Pattern Stamp Tool enables you to paint from a default pattern, or one you have loaded or created onto a layer; you are able to paint from one image into another, or into a blank sheet. When the tool is selected, its main controls appear above it in the *Tool Options* bar. The one to notice is the small *Pattern* display window; clicking on this gives you a drop down list from which you can choose the pattern you will paint with, and *Aligned* remembers where the brush has already painted. The *Impressionist* setting gives you a distorted but painterly brushstroke rather than a completely accurate one.

When you use the Pattern Stamp Tool you can also use the usual brush controls in the *Brush* palette. When selecting a brush to use with the Pattern Stamp Tool, remember to check that its *Spacing* setting is right for you and that *Wet Edges* is selected if you are going for a watercolor effect.

The Pattern Stamp Tool is in the *Toolbox* alongside the *Clone Stamp Tool*. Before you can paint, you have to give Photoshop a photo (or any image) to paint from. To do this, open the photo you want to turn into a painting and go to *Edit>Define Pattern*.

Select *Define Pattern* and you will be asked to save the image as a pattern, giving it a name. The pattern you have just saved now appears in the drop down list that is accessed from the *Pattern* window in the *Tool Options* bar.

Here is a walkthrough of a painting made with the Pattern Stamp Tool. It is a watercolor treatment of a photo of some kitchen equipment hanging from a rack.

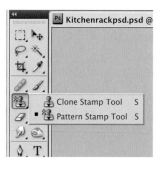

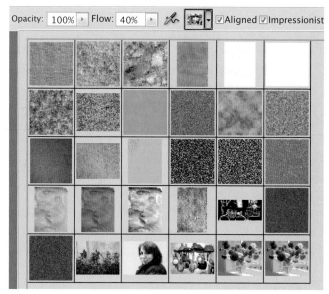

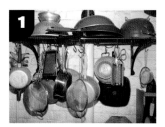

1 First, here is the starting photograph.

2 The detail in the photo needed to be simplified and its color boosted, to ready it for painting as a watercolor. Both were achieved using the BuzSim preset in **Topaz's Simplifier** plug-in, in Photoshop at default settings.

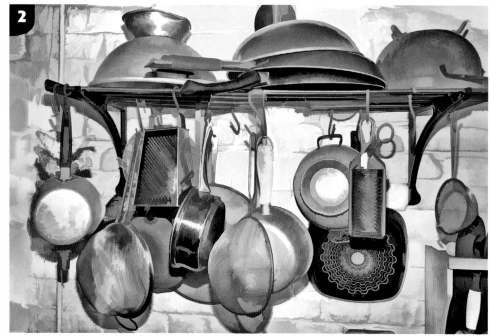

➡ Topaz Simplifier see pp. 34–35

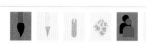

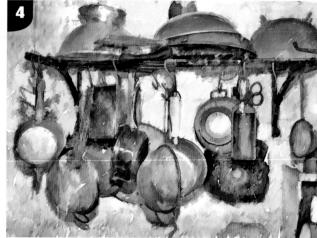

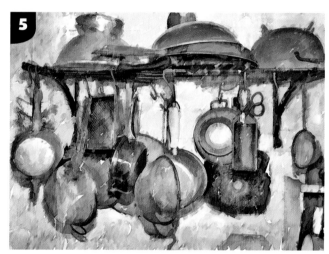

3 Now that I was happy with the source image, I made it into a pattern, created a new layer, and filled that with off-white. I selected a **Watercolor** brush and checked to ensure it had *Wet Edges* selected in the *Brush* palette. An important consideration with *Wet Edges* is that strokes in this mode build up over one another; that is to say, once you lift the brush from the paper and re-apply it to the paper, you are starting a new brushstroke on top of the old one, darkening it. So to make washes you need to keep your brush in contact with the paper. This is the image after the initial brushwork.

4 Here I was revealing detail and making the brushstrokes at a very low *Opacity* in *Non-Impressionist Mode*, so some photographic detail was played into the picture.

5 I was painting from light to dark, as is typical of real watercolor painting. As you can see from this next stage I reserved some white paper for highlights, trying to retain them during the painting process.

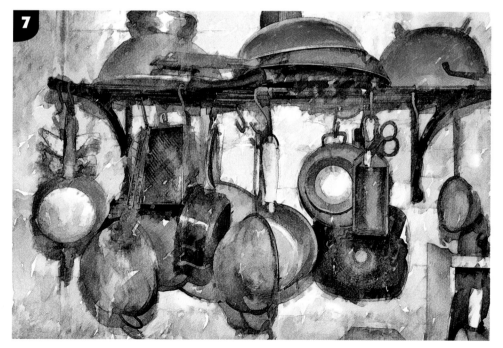

6 The picture now had all the detail it needed, though I added a pencil sketch to give a little more definition using Topaz Simplifier. I also applied a small amount of Photoshop's *Watercolor* filter to give a hint of paint pooling.

7 Here is the final picture, completed with a little *Unsharp Mask*.

➠ Watercolor see pp. 28–29

There is no single correct approach to photo preparation for painting; the key thing to remember is that you are getting the image ready to be cloned for a painting. The photo is not the end product—the painting is. So applying the basics of painting, the first issue is the subject and the composition. It is hard to make an affecting painting from a dull photograph of an unremarkable subject and it is disheartening to spend too long on a promising subject in a badly composed photo. It is also difficult to correct compositional faults, but not impossible. You will make your life easier if you start with a good photo of an interesting subject, or a well-tried subject captured in an unusual way.

It is important to have a good grasp of composition, particularly of how to create a center of interest, balance a picture using form, tonal values, and color, and how to create variety, energy, and harmony. Artists have been using carefully-honed techniques to deliver these qualities for hundreds of years, and the principles—like the "rule of thirds" derived from the Golden Mean—can be applied to photography just as well as other types of composition. Having said that, it is certainly possible to tweak the composition of photos in Photoshop—subject elements can be removed, moved, or added using tools like the *Clone Stamp Tool* and the *Healing Brush*. Below are two examples of major surgery performed on photographs through the addition and subtraction of aspects of the image to arrive at the most attractive composition.

The composition spoiled this picture—it was split into two halves along the line of the bridge and needed some unifying features as well as a strong center of interest.

I added a large mast, which helped to link the two halves, and some birds, which drew the eye into the top half of the composition. I also invented the red light on the nearest mooring.

The focus of interest was the two children, but the eye is distracted by the looming figure in white behind them.

Here I cloned out the figure in Photoshop using bits of the house and the tent corner as sources.

Lens distortion and perspective problems should also be corrected early on. This can be done using a plug-in like PTLens, or in Photoshop at *Filter>Distort>Lens Correction*.

After the basics of preparation are complete, you can work on the tonal values, color hues, and color saturation. Here is your opportunity to decide whether you want a punchy look to the picture (more contrasty), a strong color scheme, or whether you want cool or warm colors. There are tools in Painter and Photoshop to do these things; the *Shadows/Highlights* function is particularly useful for enlivening an image and revealing detail in shadows.

One thing that is not easy to do in either parent program is to make painterly simplifications of detail.

Artists rarely paint all the detail they see; apart from anything else, simplification helps to create a center, or centers, of interest with selective detail. The two plug-in programs that can do this for you are the **buZZ Simplifier** (which is no longer being sold, but can still be found), and **Topaz Adjust**, which has a preset that closely mimics the effect of buZZ.

Below are the six stages of preparation for painting of a photo of Rio De Janeiro. The original photo, while a striking shot, lacked punch and color interest.

The image had lens distortion—a central bulge—that I fixed with Photoshop's *Lens Correction (Filter>Distort>Lens Correction>Remove Distortion)* with a value of +2.00. I cropped to remove curved edges on each side that resulted from the correction.

I needed to get some light into the foreground and add a little more clarity, so I added some *Brightness* (14) and *Contrast* (29).

Now I needed to return more detail to the picture. I did this with the *Shadows/ Highlights* controls. These are at *Image>Adjustments>Shadows/Highlights*. I set the *Shadows* uplift amount at 14 and the *Highlights* amount at 24.

The picture still looked washed out, so I added some color saturation at *Image>Adjustments>Hue/Saturation*, and gave *Saturation* a value of +31.

It still needed some more clarity and "pop," so I duplicated the currently active layer twice, set the top layer to *Overlay Blend Mode*, and gave the layer an *Opacity* of 59%. Then I added a little more color saturation (+32).

I duplicated the top layer twice again and set the *Blend Mode* to *Soft Light* at an *Opacity* of of 75%. Lastly, I added 20% *Deep Red Photo Filter (Image>Adjustments> Photo Filter)* to give the composition an evening light.

➺ buZZ Simplifier and Topaz Adjust see Plug-ins pp. 34–35

The importance of scanners and scanning is that they act as a bridge between the real world and the virtual world. A scanner enables you to incorporate in your digital paintings real world sketches and drawings you have made, photographs on paper and transparencies, and textures of paper and canvas that you have made using real canvas and paper. You can even scan your existing natural media artwork so that it can be altered and enhanced digitally.

Scanners are pretty much essential for some digital painting effects—particularly when trying to produce digital watercolors. It is difficult (although just about possible in Photoshop) to produce watercolor **Backruns** digitally, so scanners are helpful in making runny washes look authentic. With a scanner, you can build up a library of wet paint effects and use them in digital watercolors. Painter has a very good selection of papers, including a number of watercolor papers and canvas types, but the great advantage of making textures with a scanner is that you will then be able to draw on exactly the support texture you like. Here I demonstrate the production of a number of watery paint effects and texture patterns using a scanner, particularly useful for those who don't have Painter. The range of support textures relevant to painting in Photoshop is very limited and if you want to add textures you really need to make some of your own.

Here is a practical look at how a scanner can help you create a digital watercolor in Photoshop, using a Wet Edges Brush and textures and effects that have been scanned from physical objects. I used an Epson Perfection V700 scanner with software from a third party scanner manufacturer—VueScan—although it is also possible to use Epsom's native software to get similar results.

Before the practical work, let's have a closer look at scanners and what you need to know in order to use them effectively. Here are the key aspects:

Buying
- Buy the scanner that fits your needs. Resolution is the big issue with scanners; understand how it works before buying anything. You will need a different resolution to produce postcard size images than is required to make detailed Letter size prints. For non-professional work, a scanner with an optical resolution of 2400 x 2400 dots per inch (dpi) and above and a hardware resolution of 300dpi, should be enough for your needs. Many—probably most—flatbed scanners comfortably exceed this and in fact most of the time you will be using much lower resolutions. The maximum sized document that non-professional scanners can scan is Letter (or the equivalent, A4).
- Make sure that the scanner handles a color depth of at least 24 bits. Most scanners now have a 48 bit or more rating, which is good for detailed artwork.
- Remember that your printer sets the upper resolution. There is no point in buying a scanner with a higher resolution than your printer.
- If you have a lot of old transparencies and film negatives you want to scan, you will need to make sure your new scanner provides for this.

Usage
- Make sure the glass screen of the scanner is clean and that you place your document on it squarely on its surface. Marks scanned in are irritating to get rid of and misplaced documents can cause the scanner to misread the document's brightness and you will have to spend time rotating and cropping the image. It is easier to do it right the first time.
- Choose the right document type and color mode. Confusing text with a color photo will mean you have to do more work later.
- For most day-to-day digital art purposes a scanning resolution of 300dpi will be sufficient. Higher resolution means a longer scan time and bigger files. But if you have to enlarge or crop, use a higher resolution.
- Save your scanned images as .tiffs so they don't lose quality when they are compressed.

Pencil drawing

Runny washes

Backruns

Salt and pepper texture

1 First I created the drawing and watercolor effects. I made these using real materials. Clockwise from top left are pencil drawing, some runny washes (drips), salt and pepper texture, and backruns.

2 I scanned these into my machine using mainly generic settings. The key ones are as follows: I set the *Type* of scan to *Color Photo* (rather than *Text* or *Line Art*; it is easy to forget this); no cropping was done here—any dimension changes and sharpening would be done in Photoshop; I set bits per pixel (*Color Depth*) to 24 bit RGB; and set the *Scan Resolution* to .tiff file format at a resolution of 300dpi. The relevant settings panel in VueScan can be seen on the right.

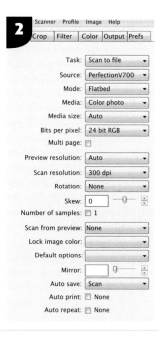

➥ Backruns see pp. 58–59

3 Before working on the scanned images, I took the photograph that the pencil drawing was made from, and the drawing itself, and created two layers with the drawing above the photograph. It's a good idea to simplify the photo a little—I did this with **Topaz Simplify**. I made a pattern from the simplified photo and painted on to a new layer below the drawing that was set to *Blend Mode Multiply*. I was using one of the **Watercolor** brushes with *Wet Edges*. Here is the picture as the pattern painting was being made.

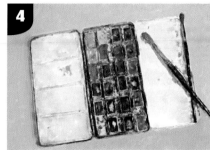

4 I added more paint using the *Watercolor* brush until the painting was more or less finished. Note that I reserved some white paper in places, adding a little sparkle to the picture.

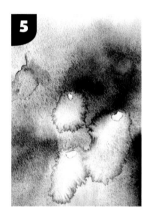

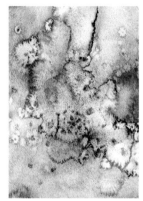

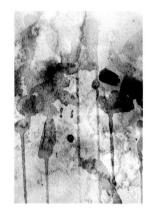

5 The painting was fine as it stood, but it lacked some visual watercolor characteristics that help an image to look realistically like a watercolor rather than a painting in another medium. This was where my work making real effects would pay off. They would be used to add some Backruns, drips, and salt-like effects to the picture. It's a good idea to try different *Blend Modes* with *Pattern Overlays*. In this instance I used *Color Burn*. Here you can see the three finished overlays.

6 You will notice that the tonal contrast was strong in these patterns. I did this in *Levels* to help the patterns to read well. The Backruns pattern came first with *Opacity* set at 42%. Remember you can always delete areas of the pattern if it gets in the way of areas you want to be unaffected.

7 Next I added the salt effect at an *Opacity* of 42%.

8 I added the drips at a low *Opacity* of 15%. The effect was subtle. The faint drip marks helped to unify the picture by linking to the bottom edge.

9 Finally, I added some sedimentation (granulation) effect. I used one that was made with the *Noise* filter, but you can easily scan in some rough watercolor paper and use that instead.

➨ **Topaz Simplify see pp. 34–35** ➨ **Watercolor see pp. 28–29**

Brushed Digital Painting Techniques

So far, this book has looked at the key tools needed for any kind of digital painting, showing how brushes in Painter and Photoshop work and how they can be customized to produce the effects you want. This chapter will also focus on brushed effects but will look more specifically at how particular, traditional oil, watercolor, and acrylic processes can be replicated in digital software programs.

The techniques covered here may be familiar to those who have experience in traditional painting, and many of them translate well to digital painting. For example, Blending and Hard and Soft Edges are as relevant to digital styles as they are to natural media. But while others, such as Glazing, may not be as intuitive, the natural media techniques included here should still prompt creative ideas.

Sometimes the methods for reproducing natural techniques overlap. For example, Glazing is used in acrylic and oil painting, but is also the basis for watercolor's transparent washes, whereas Preparatory Drawing can be used in all of the brushed approaches. Erasing, which gets primary coverage in Lifting Out, is also involved in Scraping and Scratching, whereas Backruns and the Runny Wash techniques both have a similar provenance. While this may seem initially confusing, you will soon become heartened that you don't have to learn completely new processes for each technique. As you gain greater familiarity with the processes you will quickly begin to develop your own approaches to simulating the various brushed styles.

There is an argument for trying to cover the methods for each technique in both Painter and Photoshop. But to avoid the book becoming unwieldy, the general focus is on the best method for the job. In any case, many of the processes are sufficiently similar in Painter and Photoshop that a demonstration in one program will be a generic approach; if you know how to make textures in Photoshop you should have a good idea of how to approach them in Painter. Of course, there are areas where the programs might have different weapons in their techniques' armory—Watercolor, for example, where Painter has two whole categories of brushes against Photoshop's ten or so brushes and the Wet Edges setting. Significant differences have been pointed out in the first chapter.

The aim has been to find the shortest distance between the techniques and the means of producing them. For example, with Backruns I am quite happy to suggest that real watercolor Backruns be scanned, and with Frottage/Grattage that photographs will help achieve the desired techniques. For most of the topics in this chapter, photographs have been used as the starting point—partly for the reasons set out in the Cloning Tools introduction, and partly because sometimes there is no freehand way to achieve a particular effect using a pen tool and software. As already noted, it is important to use the software however you can to achieve the effects you want.

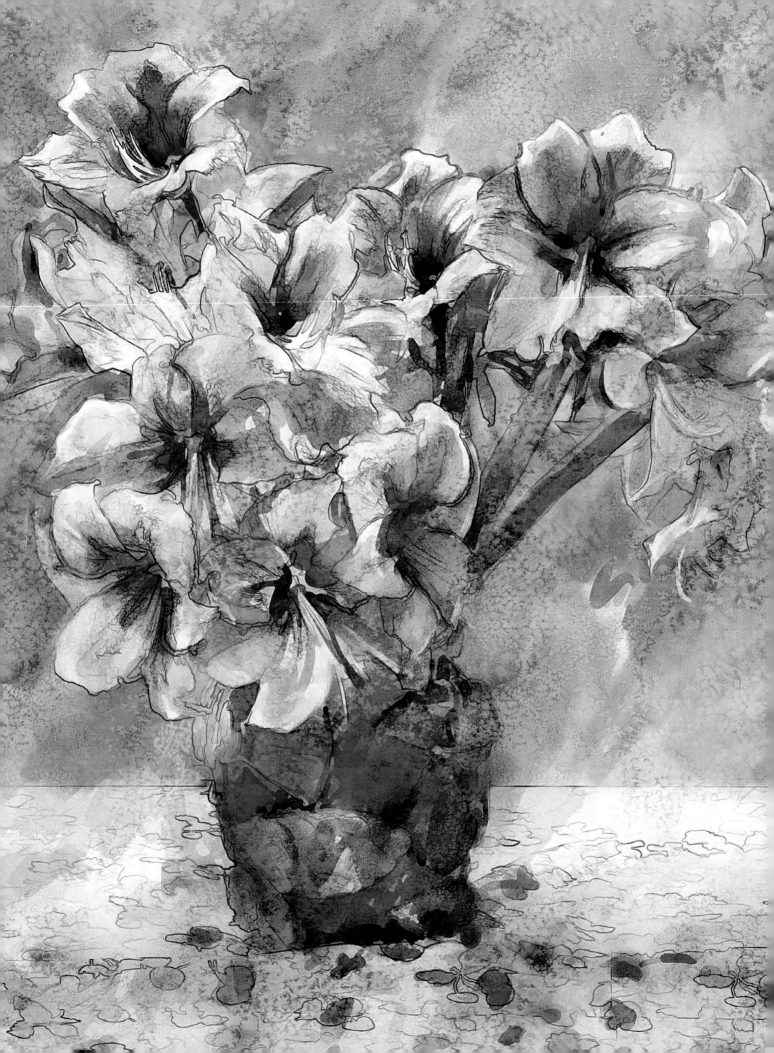

Simulated Medium
Oils

Simulated Support
Board (No Texture Visible)

Application
Painter, Photoshop

○ CHECKLIST

Brush type	Size/Opacity
Sargent-Artists (P)	34.9/95%
Loaded Palette Knife (P)	14.4/100%
Chalk (PS)	36/75%
Soft Round (PS)	91/58%
Dry Brush (PS)	28/66%

The term Alla Prima has various English translations, and almost as many definitions of what the process entails. What it has come to mean in painterly terms is a bold and direct style where paint is applied straight to the canvas with no blending or glazing or messing about with the paint. Many artists have used a variation of this technique, with examples prevalent in the works of Rembrandt, John Constable, and Van Gogh. The latter used the approach in a particularly distinctive and expressive manner, and the method was widely adopted by the Impressionists for their Plein Air paintings.

As practiced today by oil painters, Alla Prima usually involves little or no underpainting, though sometimes requires pre-toning. Paint of different hues and values can be pre-mixed and on the palette, while decisions on where the paint will go on the canvas are already mapped out.

The aim of all this is to achieve a fresh and bold-looking style. In digital painting, the letter of the technique does not have to be followed to achieve the style, but its spirit does have to be present—you need to be mentally prepared to put down as few brushstrokes as you can, intending each one to count, and often using as big a brush as possible. The challenge is doing your homework on how you will tackle the painting and being ready to make mistakes.

In the example that follows, the approach has been kept as loose as possible (made much easier by painting in **Clone Color Mode**, although **Tracing** would also have given a good bold treatment). In Clone Color Mode, it is easier to use a bold and direct style if the photo is fully and properly prepared.

1 I cropped the starting photo to focus attention on the figure in Photoshop, taking care to retain the garden context.

2 The reflection of a car in the barn window spoiled the mood of the picture, so I replaced this with some more greenery using *Cut and Paste* and the *Healing Brush (Tools Panel> Healing Brush Tool)*.

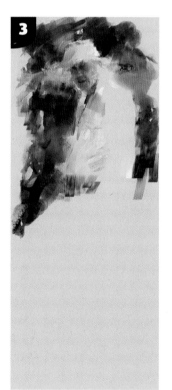

3 Opening the image in Painter, I set up Clone Color Mode. I filled the cloned image with a gray-green of medium value. I then began to paint with a large Sargent's Brush and a Loaded Palette Knife.

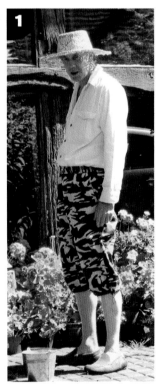

4 Continuing to paint with a large brush, I blocked in the figure. The brushstrokes followed the form, but were smeared to keep the treatment dynamic. I was more concerned with getting the paint moving than I was with detail at this point.

➤ Clone Color Mode see pp. 44-45 ➤ Tracing see Color Tracing pp. 42-43

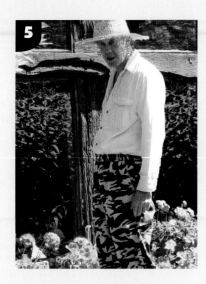

5 At this stage I realised the painting needed a clearer suggestion of the summer heat that was evident from the subject's sun hat and short trousers in the photograph. I opened the Clone Color source photo in Photoshop and warmed it up with some more color saturation *(Image>Adjustments>Hue/Saturation)* and a little yellow photo filter. Then I defined a pattern from it using **Edit>Define Pattern**.

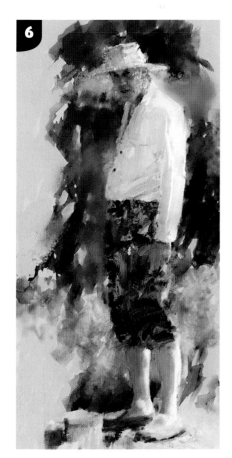

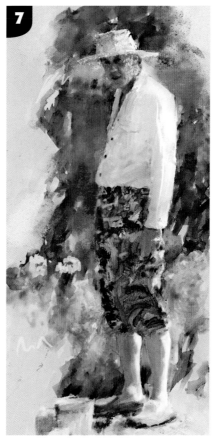

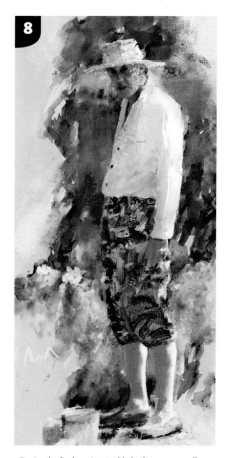

6 Back on the painting, I used a variety of brushes with Photoshop's Pattern Stamp Tool—particularly some Chalks, Drippy Water, Soft Round, and Dry brushes. I added some warmer and brighter colors to the flowers and figure. I wanted to keep the look loose throughout.

7 The picture still needed a greater sense of heat and warm light, so I tried a range of settings on the *Shadow/Highlight* filter *(Image>Adjustments>Shadow/Highlights)*—particularly increasing *Highlight* luminosity—and adding yellow and orange photo filters. You should aim to experiment, keeping the treatment loose and the brushstrokes expressive.

8 For the final version, I added a few more small flowers to keep the eye moving around the picture, and some *Unsharp Mask (Filter>Sharpen> Unsharp Mask)*. Despite the small refinements made in the final stages of the painting, the overall brushing treatment remains vigorous and does not look overworked.

➡ **Edit>Define Pattern** see Photoshop's Pattern Stamp Tool pp. 48-49

Simulated Medium
Watercolor

Simulated Support
Cold Pressed Paper

Application
Photoshop, Painter

◯ CHECKLIST

Brush type	Size/Opacity
Watercolor Heavy Pigments	42/66%
Watercolor Heavy Pigments	24/78%

Backruns are primarily a watercolor technique and occur when water is added to an already wet, or damp, area of paper. The new water pushes the pigment around to create a dark, hard fringe in (usually fluid) shapes with oftentimes beautiful effect. The three real world examples below were created by laying down multiple washes of paint, then adding very wet paint before the original paint was fully dry, but too late to for it to merge with the existing wet paint (i.e. **Wet-in-Wet**). Backruns can be intentional, but often occur accidentally. Sometimes this works in the picture's favor, and sometimes it does not. What they can do for a digital watercolor treatment is add a touch of authenticity—rather like including the sedimentation effect of pigment drying out into the troughs of rough watercolor paper.

It is possible to make small Backruns using Photoshop brushes set up as very wet watercolor brushes, but the easiest way to introduce Backruns into a digital picture is to first create them on real watercolor paper—this is very simple to do with little skill required—then scan them, desaturate them in Photoshop *(Image>Adjustments>Desaturate)*, and use them as overlays. The technique works best on painted areas without too much detail, such as simple flowers, skies and backgrounds.

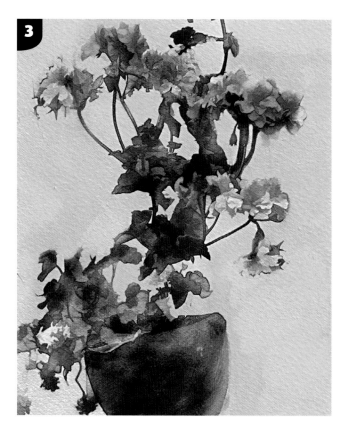

1 First, I made a number of real world Backruns on watercolor paper. I then selected one, scanned it in to my computer, opened it in Photoshop, and made it black and white through desaturation.

2 Next, using the *Clone Stamp Tool* from Photoshop's *Toolbox (Tools Panel>Clone Stamp Tool)*, I filled in the areas not covered by paint. I then added *Contrast* to the image so that it would read more clearly through the final painting.

3 To apply the Backrun to the picture, I chose a digital watercolor painting and scaled it so that the pattern fit. This was simply a matter of making sure that the physical dimensions and resolution of the picture and pattern were not too far apart. My start painting's dimensions were 4.5" x 6" and the resolution was 150ppi.

➥ Wet-in-Wet see pp. 110–111

4

4 I duplicated this image *(Layers>Top Layer>Right Click>Duplicate)* and applied *Multiply Blend Mode (Layers>Blend Mode>Multiply)* to the new top layer at an Opacity of 26%. I made sure the desaturated Backrun image was active and simply dragged it on top of the flowers layer. The image did not quite fit.

5

5 To fix the coverage mismatch, I went to *Edit>Transform>Distort* and pulled down the bottom arrow on the transform frame until the Backrun was covering the whole picture.

6

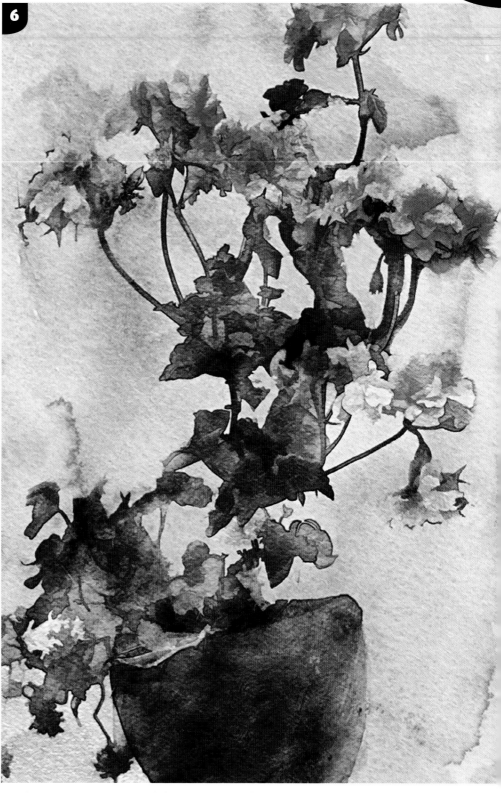

6 I changed the *Blend Mode* of my new top image to *Overlay* and set its *Opacity* at 85%. Here is the final image with the Backruns bound nicely in to the painting, creating quite a convincing watercolor effect.

Simulated Medium
Oils

Simulated Support
Artists Canvas

Application
Painter

○ CHECKLIST

Brush type	Size/Opacity
Sargent	24.4/88%
Sargent	10.4/95%
Detail Blender 5	6.4/48%

Dry Blending with a brush—as opposed to other kinds of Dry Blending, such as with colored pencils—is a process in which no flowing paint is used to merge two areas of color together. The idea is that you should not be able to see the join. Dry Blending is different from wet blending, where color areas are merged together using wet paint, often using a **Wet-in-Wet** approach. A classic wet blending technique would be a graduated blue wash in transparent watercolor to create a sky.

In digital painting it is, of course, easy to blend colors together in many different ways using the software tools available, but the trick here is to retain the brush texture. Indeed, in Painter there is a whole category of brushes for blending—fittingly called Blenders. You will see an example of a painting using a Painter blending brush at the end of this technique, but first, working in Photoshop, here is a demonstration of how Dry Blending can be accomplished without special brushes.

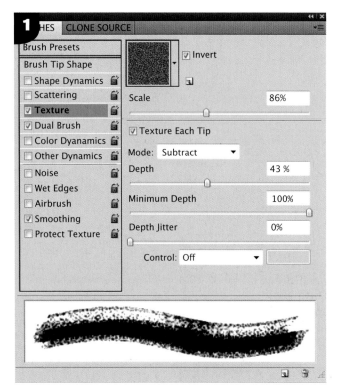

1 In Photoshop, I created a new document and used the bristle brush I made in **Photoshop Brushes Basics** in Chapter 1—"newbristle1." Here you can see the settings I used for this exercise. Notice that the *Wet Edges* function is not active—this ensured that colors were fully opaque when at maximum *Opacity* and layered on top of each other.

2 Using the "newbristle1" brush I roughly painted half of the new image with a deep pink, and half with a bluish purple color, making sure the colors were not too far apart—I did not want them to be nearly opposite (complementary), or there would be a lot of work required to blend them.

3 I laid down a strip of intermediate color along the diagonal axis where the existing colors met, judging the midway hue by eye using the *Color Picker*. (The *Color Picker* is accessed by clicking on one of the color swatches in the *Toolbox*.)

➡ **Wet-in-Wet** see pp. 110–111 ➡ **Photoshop Brushes Basics** see pp. 16–17

4 Next I began the process of blending the two halves together over the midway color. The secret is not to move the white eyedropper circle in the color square, as this circle determines the color and its saturation and tonal value. By choosing color samples using the *Color Picker's Color Sliders (Tools Panel> Color Picker)*, I was able to select colors with the same saturation and value, which allowed me to build up a range of colors between my starting pair that were all of the same saturation and value.

5 Choosing intermediate colors using only the sliders in the *Color Picker*, one by one I applied them with the brush tool from pink to purple. As I added these transition colors, I was able to achieve a gradual merging of the starting colors.

1 Dry Blending has practical applications too, of course. In this digital painting made in Painter, Dry Blending was used to help enhance the illusion of the rose petals' softness. The smooth petals counterpoint the jagged leaves, creating an attractive mixture of **Hard and Soft Edges**. The soft petals were blended using intermediate colors and values and a Detail Blender 5 Brush from the *Blenders* brush category. *Size* was set at 6.4 and *Opacity* at 48%.

2 Here is the full picture, where you can see the rose blooms and their petals in context. The painting was made with a Sargent Brush from the **Artists' Brushes** category, and used at different sizes. The only other brush used was the Detail Blender 5, which was used in blending colors at the end of the process.

➥ **Hard and Soft Edges** see pp. 64-65 ➥ **Artists' Brushes** see pp. 20–21

Simulated Medium
Watercolor

Simulated Support
Cold Pressed Paper

Application
Painter, Photoshop

● CHECKLIST

Brush type	Size/Opacity
Scattered Dry Brush	9/66%
Scattered Dry Brush	6/70%
Watercolor Heavy Medium	11/85%
Watercolor Heavy Medium	43/54%
Watercolor Heavy Medium	19/74%
Dry Brush	37/54%

As the name suggests, Dry Brush is a painting technique in which paint is applied to the canvas or paper with very little liquid on the brush. The paint is gently scraped or softly dragged across the support—the aim is to add broken paint coverage for artistic effect. The technique is primarily associated with watercolor but it can be used in other paint media as well. The effects you get depend on a number of things, such as how wet the paint is, how loaded the brush is, how hard you press down with the brush, and the nature of the support surface.

In watercolor, Dry Brush is often used with a rough paper; the "teeth" of the paper catch the paint as the brush is moved across it, but the indentations do not. This means that the paint is broken up and spots of white paper—or whatever color the paper happens to be—show through. This is useful in creating the illusion of sunlight on a pool of water, froth on a breaking wave, or clouds. Painter and Photoshop both have specific pre-built Dry Brushes but they operate differently. With Painter, in the *Watercolor* category, there are three Dry Brushes: Bristle, Camel, and Flat. The problem is that they all have no graininess (support texture) as an attribute, so no paper texture shows through. These brushes are probably best for suggesting paint applied to a smooth surface, with the result that the bristles of the brushes remain visible.

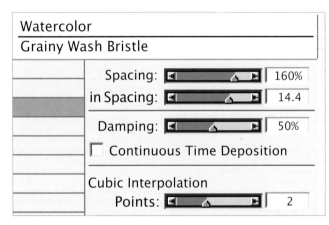

You can change the **Dab** type of the Painter Dry Brushes to another *Watercolor* variety but none of them have a *Grainy* attribute available. However, there is a Grainy Wash Bristle Brush; you can change its *Dab* type to *Static Bristle*, and its *Spacing* controls in the *Brush Creator*, as above.

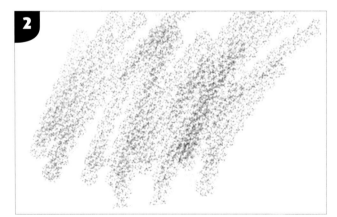

1 Here you can see the strokes made by the Painter Dry Bristle Brush (left) and Dry Camel Brush (right, with reduced Opacity).

2 By selecting *Invert Paper* in the *Paper* palette (the *Paper* palette is accessed by clicking on the Paper thumbnail in the Tools palette) you can achieve a brushstroke with something of the textured Dry Brush effect. Tweaking the *Bristle* controls in the *Brush Creator* can adjust the graininess.

3 In Photoshop, there are a number of Dry Brushes that are readymade with a texturing effect, including Dry Brush Tip Light Flow, Rough Dry Brush, and Scattered Dry Brush. The default Dry Brush looks like this.

➥ Dab see Painter Brushes Basics pp. 18–19

4

4 The Rough Dry Brush in Photoshop, with its *Spacing* value set to 17%, can give a very interesting effect, complete with visible bristle marks and paint being caught on the teeth of the paper.

5

5 The Scattered Dry Brush in Photoshop, with its *Spacing* value set to 17%, provides a good general purpose Dry Brush treatment.

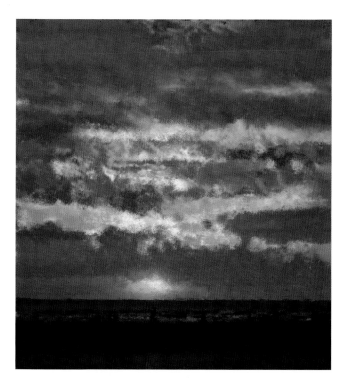

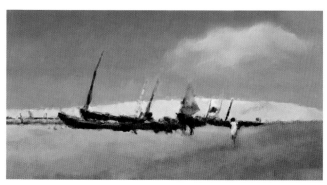

On the left is a sketch in which I used the Scattered Dry Brush entirely to depict a sunset sky over a beach. Above is a section from the picture showing the Scattered Dry Brush close up.

I used a Photoshop Dry Brush on this picture in areas like the beach and the clouds. Above is a close up of the use of Dry Brush in the foreground.

Simulated Medium
Watercolor

Simulated Support
French Watercolor Paper

Application
Painter

○ **CHECKLIST**

Brush type	Size/Opacity
Watercolor Wash Cloner	20/30%
Watercolor Dry Camel	16.9/38%

Hard and Soft Edges—often called "lost" and "found" edges—refer to the quality of the meeting of two shapes in a painting. Where two shapes meet, they can either do so with a Hard Edge, creating a clear line between them, or with a Soft Edge, a seamless transition from one shape to another. As a general rule, Hard Edges are best used in areas of high-value contrast, and Soft Edges are best for areas of low contrast or very similar values. In the portrait and the cake painting below, there are areas of both Lost and Found Edges, making the images more interesting. Many brushes in Painter and Photoshop can provide Hard Edges when areas are abutted, but each has tools that are particularly helpful for Soft Edges. Painter has the *Blender* brush range, and Photoshop has the *Healing Tool*.

Hard Edge

Soft Edge

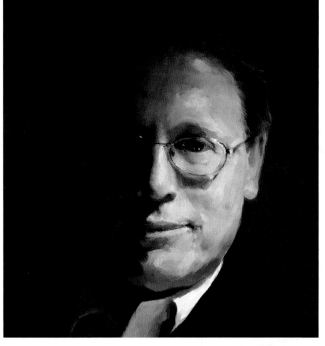

Edge treatments are very useful and can create a number of different effects. Soft Edges can ensure that the main subject in a portrait is tied into the overall canvas and does not sit starkly against the background.

Hard Edges can add drama to a portrait, as this detail shows.

Above is a Painter Round Blender Brush softening a margin.

Photoshop does not have any *Blender* brushes as such, but the *Spot Healing Brush Tool* works very well for this purpose. Unlike the *Healing Brush Tool*, the *Spot Healing Brush* does not have to sample an area of an image before being deployed; it uses the pixels below it to paint with as it is dragged across the image, which enables passable blends to be made, as above.

Another Edge effect can be seen in landscape painting, in which Soft Edges, usually used together with gradual color changes, help the background to recede and the illusion of distance to be created.

1 These steps in Painter illustrate the use of both Hard and Soft Edges on an unpromising photo of some amaryllis. The aim was to produce a pushing and pulling effect for the eye, with some areas being brought into focus and others left to merge with the background.

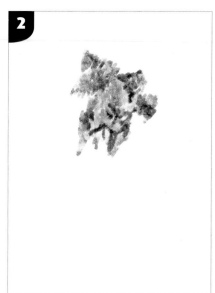

2 The objective here was to make a lighter, more vibrant treatment from the somber photograph and have the background emerging from the white paper with a gentle blue tint. Here you can see the start of the **Clone Color** process.

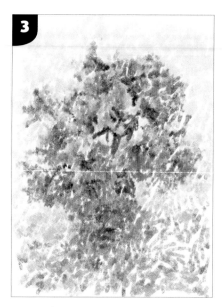

3 I roughly painted the whole area of the picture, allowing small gaps of white paper to show between painted brushstrokes, as is typical of watercolor painting.

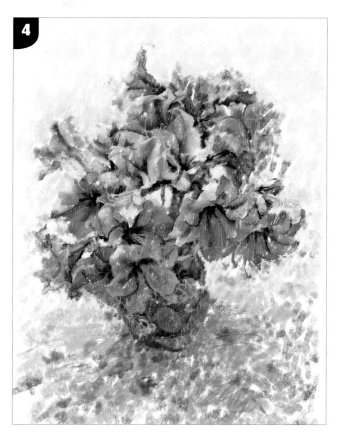

4 Using a Wet Camel Brush at a *Size* of around 20 and *Opacity* of 17%, I introduced more detail, while keeping the treatment light.

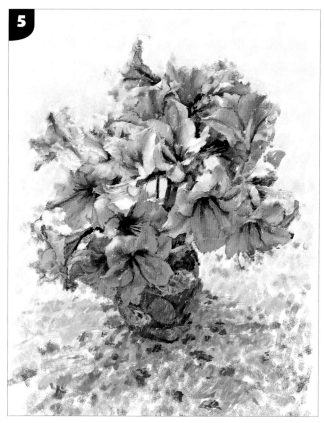

5 Here is the final image, with more saturated colors and a mix of Hard and Soft Edges—Soft around the farther flowers and foliage, Hard around the nearest flowers and the vase.

➡ **Clone Color see pp. 44–45**

Simulated Medium
Oils

Simulated Support
Artists Canvas

Application
Painter

☉ CHECKLIST

Brush type	Size/Opacity
Sargent + Grain 17%	34/43%
Sargent + Static Bristle Dab	27/45%
Sargent + Grain 17%	20.4/22%

Feathering is a slightly confusing term in the context of digital painting. Feathering in Photoshop and Painter refers to the ability to soften or blur the edge of a selection so that it will blend in without an awkward **Hard Edge** when it is added to an image. In painting terms, Feathering is a specific type of brushwork used to blend two Hard Edges together or to add additional color to an area of a painting—its name comes from the characteristic feather-like look of the effect.

It is worth noting that when working with pastels, Feathering has a distinctive use, which is the application of many small individual pastel strokes to build color on color, creating the illusion of some color transparency and adding effective color modifications. The same approach—introducing a new color—can work in brushed opaque media, as will be illustrated later.

Feathering is not the only technique for blending two edges together—indeed it is technically quite demanding to get right. But it can offer you variety in your painting style and for this reason alone is worth practicing.

1 For a basic feathering technique in Photoshop, I created two color areas with a Hard Edge using a Hard Round Brush at full *Opacity, Size* 42 pixels.

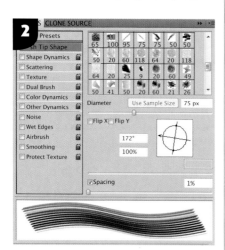

2 I then selected the Photoshop texture *Comb3* (75), ensuring that the *Spacing* setting was at its minimum and tilting the *Axis* until I got an angle of comb I liked.

3 Using the image with the blue and green horizontal shapes, I softened the edge between the two bands by making some bristly excursions into the opposing bands with the Texture Comb Brush.

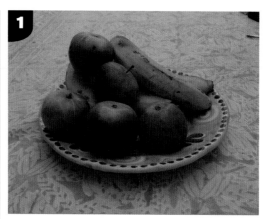

1 For this Feathering demonstration in Painter, I began with this initial photograph.

2 In Painter's **Clone Color Mode** I blocked in the color with a customized Sargent Brush to produce a very rough starting image.

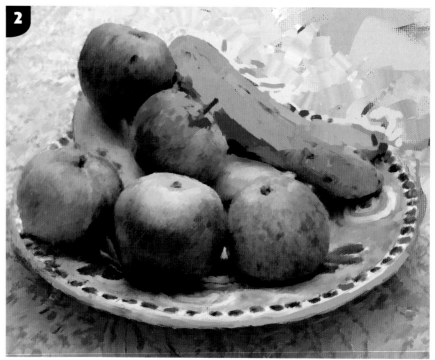

➻ Hard Edges see pp. 64–65 ➻ Clone Color Mode see pp. 44–45

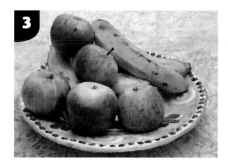

3 I further refined this using a customized brush built around a **Static Bristle Dab**, a **Cover** method, and a **Grainy Hard Cover** sub-category.

4+5 Here I introduced the Feathering technique, to soften edges and to introduce patches of new color. Close-ups of the Feathering shown here.

➡ **Static Bristle Dab, Cover, Grainy Hard Cover see Painter Brushes Basics pp. 18–19**

Simulated Medium
Oils

Simulated Support
Artists Canvas

Application
Photoshop, Painter

⊘ CHECKLIST

Brush type	Size/Opacity
Sargent + Grain 17%	29.7/22%
Square Chalk	35/27%
Smeary Palette Knife	117/77%

Frottage is a technique that will be familiar to anyone who, as a child, put a coin under a piece of paper and penciled on top of it to create a relief of the coin's face. Frottage in an artistic sense is most closely associated with Max Ernst, who developed the technique in the 1920s and used many different surfaces to make his rubbings. He used the technique as creative spur, inspiring new visual forms.

Frottage is primarily a technique for dry media like pencil and pastel, but was developed into a process that could be used with wet paint by Ernst. This breakaway technique is called Grattage, and it is on this method that I will be concentrating. In Grattage, thick paint is applied to a canvas supported by a textured surface. The paint is then scraped off with a palette knife, which leaves an impression of the texture on the surface of the canvas.

Grattage is easy to achieve in digital media, but remember, there is no one correct method here. All that matters is whether you like the end result.

1 Take a photograph or a scan of a textured surface you want to incorporate into a picture—I chose a tree with the bark showing prominently. I opened the image in Photoshop; this was the background layer. I duplicated the starting photo so it became the second layer and cropped it to make the texture more prominent.

2 Still working in Photoshop, I converted the image to black and white by duplicating the second layer so it became the third layer, then desaturated the image.

3 To get the bark to read more clearly in the final picture, I needed to make some level adjustments in Photoshop to increase the contrast. The *Levels* settings were 47/1.31/170.

4 Next, I created the image to be used with the bark texture. I took a photo of a British red mailbox and **Clone Colored** it in Painter using the Sargent Brush.

➥ Clone Color see pp. 44–45

5 At this stage, I brought the two images together. I saved my painted mailbox and then opened it in Photoshop. I also opened my black and white tree bark image. I dragged the bark image onto the mailbox image so it became the second layer. Here you can see the bark image at reduced *Opacity* sitting on top of the mailbox in Photoshop.

6 To trim back the tree image so that it fit the profile of the mailbox, I reduced the *Opacity* of the tree slightly so the mailbox was visible underneath, and then erased any overlap from the bark layer. After cleaning up the edges, I used the *Clone Tool* to add the missing areas of the image at the top left and right of the tree and at the bottom where the curves of the mailbox weren't covered (circled).

7 I made both layers visible and set the *Blend Mode* to *Overlay* (the top layer was the completed tree bark image). The red mailbox now had bark markings.

8 I wanted to add a suggestion of the canvas and some indication of scraping, so I saved the Photoshop image and opened it in Painter, then set up the image in Clone Color Mode, to introduce some canvas texture and some scraping elements. I selected the **Artists Canvas** from the *Paper* palette at a *Size* of 173%, and then the Square Chalk variant from the *Chalk Brush* category. I set the *Size* to 35, *Opacity* to 27%, and the *Grain* to 11%, then created a light application of canvas texture over the clone layer using a Chalk Brush (I chose this simply because it is effective in delivering clean canvas texture). I then smeared the area around the image using the Smeary Palette Knife 30 from the *Palette Knife* category, dragging a little of the color into the borders here and there. The *Size* of the Palette Knife was set at 117 and *Opacity* at 77%.

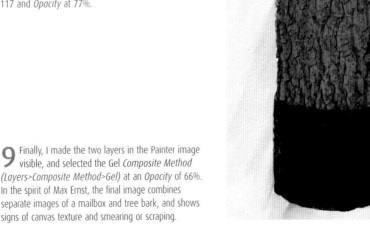

9 Finally, I made the two layers in the Painter image visible, and selected the Gel *Composite Method* (*Layers>Composite Method>Gel*) at an *Opacity* of 66%. In the spirit of Max Ernst, the final image combines separate images of a mailbox and tree bark, and shows signs of canvas texture and smearing or scraping.

➦ Artists Canvas see Expressing Texture pp. 30–31

Simulated Medium
Oils

Simulated Support
Artists Canvas

Application
Painter, Photoshop

⊙ **CHECKLIST**

Brush type	Size/Opacity
Oilds Glazing Round	21/6%
Bristle Brush Cloner	12.3/80%
Sargent + Grainy Hard Cover	27.4/45%

Glazing has been adopted in many artistic mediums: fine art, ceramics, interior design, and cabinet making. In fine art, the term means changing an area of dried paint by covering it with a thin transparent wash of another color. The term covers everything from adding color to a monochromatic underpainting, altering a color with the addition of a thin layer of color over it, the final coat of paint or varnish given to a picture (either to seal it or to help harmonize the colors) and one can even argue that it is used in wash form to build pictures in watercolor. It is quite different from direct painting and requires planning to work well.

The painting of a thin layer of one color over an opaque layer of another means that light is reflected back from the opaque layer through the transparent glaze. As a result the colors mix in the viewer's eye into a new color. Historically this was a way to build deep, rich colors like purples when such colors were not readily available to artists. Glazing is a difficult technique to convey in print or on a screen, as these media cannot present the same optical effect as a transparent glaze. The electronic screen emits light, and print—a 2D medium—simply reflects it flatly.

In digital painting, even at low opacity, most color brushstrokes cover the image below, and most digital color brushes apply color opaquely. In Painter, the best glazers are the *Watercolor* brushes and in Photoshop, the *Photo Filters (Image>Adjustments>Photo Filter)* best perform this function, but it is difficult to find satisfactory oil and acrylic transparent brushes. In Painter, the Glazing Round at 8% *Opacity* is about as good a non-watercolor glazer as any.

Glazing is also used to add color to **Underpainting**. Underpaintings are covered later in the book, but these are generally versions of a painted subject done in black and white and grays, or in shades of a monochrome, to which the artist adds color by thin applications.

To illustrate the principle of Glazing, a transparent French ultramarine over an opaque cadmium yellow will produce a green, or the same ultramarine over a cadmium red will create a purple. The illustrations here were made in Photoshop and give an impression of how this form of glazing works. The top two colors in each column are fully opaque, the next colors down have blue applied as a transparent Glaze at an *Opacity* of 26%, and at the bottom, blue glazes are applied at an *Opacity* of 40%.

Making a Color Set
If you are painting without using a photograph, you will obviously be using your own colors entirely. But if you are using a source photo, it can be helpful to create a Color Set from your image.

In Painter, Go to *Window>Color Palettes* and make sure that *Show Color Sets* is selected. *Color Sets* will appear in a list below *Colors* on the right hand side of the workspace. If the *Color Sets* palette is not open, click on the small inward facing arrow on the left of the palettes next to *Color Sets* to open it. Now you can sample all of the colors in your original photograph. Open the original photo, click on the very small arrow on the right of the *Color Sets* title, and select *New Color Set* from *Image*. Then simply select a brush and begin painting.

In Photoshop, from the menu bar, select *Image>Mode>Indexed Color*. In the dialog box select *Custom* from the *Palette* pop-up menu, then click *Save*. After saving, cancel both the *Table* dialog and the *Indexed Color* dialog. Then, in the *Swatches* palette, click on the icon at top right and select *Load Swatches*, navigating to the table you just saved.

➡ Underpainting see pp. 106–107

1 For this walkthrough, using the *Photo Filter*, I desaturated a photograph of a copper jug in Photoshop, recolored it, and loosened its forms to make it more painterly. I chose a bluish purple as it complemented the copper of the jug. To make it more interesting, I simplified the image using the *Stamp* filter at *Filter>Sketch>Stamp* using settings *Light/Dark Balance* 32 and *Smoothness* 9. This was blended with the purple version, and I added a little color saturation and contrast. At this point, I needed to make a *Color Set* from the original color photograph, which was done in Painter—see the boxout. Alternatively, I could have discarded the *Color Set* step and kept my source photo open, using the *Dropper* to pick colors.

2 In Painter, I selected an Oils Glazing Round Brush at a *Size* of 21% and an *Opacity* of 6%. (There are a number of Glazing brushes to choose from, including some also in the *Acrylics* brush category.) Classically, glazes were usually painted from dark to light, so I followed this method too. (I could just as easily have gone from light to dark—as in watercolor—which would have allowed large areas to be covered and recovered in single washes.) First, I selected dark colors for the jug, particularly its snout.

3 Using the same brush I added the midtone copper colors, along with the green lid, and the gray from the folds in the background drapery.

4 Still using the Glazing Round Brush I painted in the lightest copper tones and highlights, as well as the light background drapery colors.

5 I added some brushmarks and canvas texture in Painter in **Clone Color Mode**, using a Grainy Brush and a **RealBristle** Round Brush. For extra authenticity, I opened the picture in Photoshop again and—as a final Glaze—added a little warm *Photo Filter* to help harmonize the colors of the whole picture. Lastly, I applied some *Unsharp Mask*.

➻ **Clone Color Mode** see pp. 44–45 ➻ **RealBristle** see pp. 26–27

Simulated Medium
Watercolor

Simulated Support
Cold Pressed Paper

Application
Photoshop

◑ CHECKLIST

Brush type	Size/Opacity
Watercolor Heavy Medium	43/54%
Watercolor Heavy Medium	19/74%

The wash is one of the basics of watercolor painting. It uses transparent watercolor (so the white paper provides the lightest value) and is most often applied to open areas of an image like a sky, a field, or the sea. The aim is to make a seamless, often graduated, stretch of color. A classic wash would be sky that begins at the top of the image with a cobalt blue, gradually lightening in value and subtly changing to a light ochre or alizarin crimson just above the horizon—with gaps for clouds and their shadows. The trick in real watercolor is to get just the right amount of color and water working together.

Granulated Wash is a wash in which paint pigment has dried out into a sediment of dark particles, which settle in the indentations of textured watercolor paper. It can be a very beautiful effect. As not all watercolor paints create this effect, you can buy a watercolor granulation medium that creates the feature in paints. Granulation also requires a rough, textured paper surface for the granules to interact with.

You can achieve Granulated Washes in both Painter and Photoshop. In Painter, there are a number of brushes in the *Watercolor* category that deliver a form of granulation, for example the Diffuse Camel, Diffuse Grainy Camel, Runny Wash Camel, and Smooth Runny Camel (but, curiously, not the Grainy Wash Camel).

Here you can see the Painter Diffuse Grainy Camel brushstroke. Brush *Size* 91.9, *Opacity* 17%, and *Feature* 7.0.

An example of Runny Wash Camel brushstroke with *Wind Force* of 16.

Here you can see Runny Wash Camel brushstroke with no *Wind Force*.

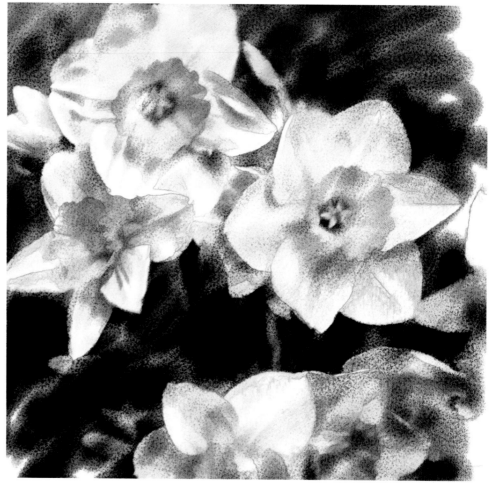

This picture was made with Painter's Diffuse Grainy Camel Brush at settings *Size* 91.9, *Opacity* 17%, and *Feature* 7.0. With this technique, it is important not to overdo the brushstrokes. The color quickly builds unpleasantly when over-applied, and the granulation gets too dark. Note also that a number of Painter's brushes show granulation better when there is no gravity (*Wind Force* in the *Brush Creator*) applied to their strokes.

In Painter, it is not easy to get the same granulation using a paper to get the desired effect. You can use rough or smooth paper, but whether or not there will be any granulation effect when you make a brushstroke depends on the brush, not the paper chosen. This picture has had the Pebble Board paper applied to it.

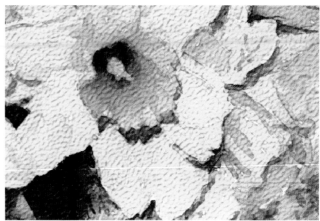

In this detail, you can see the effect of the Pebble Board clearly, but there is no sign of granulation in the grain of the paper.

1 In Photoshop, there are a few ways to create a Granulated Wash look. One is to create a new blank document and fill it with a very dark gray, adding *Noise*. I made the dark gray fill at *Filters>Noise>Add Noise* and selected *Gaussian* for *Distribution* and 117% for the Amount. Next, I defined the top (now speckled-gray) layer as a pattern, making this effect available to apply as a whole image. (Much the same effect could be achieved by using the *Reticulation* filter effect on the dark gray document—the *Reticulation* filter is at *Filter>Sketch>Reticulation*.)

2 This landscape painting was made in Photoshop using a Watercolor Heavy Medium Tip Brush in *Pattern Stamp Mode*. It has no granulation applied.

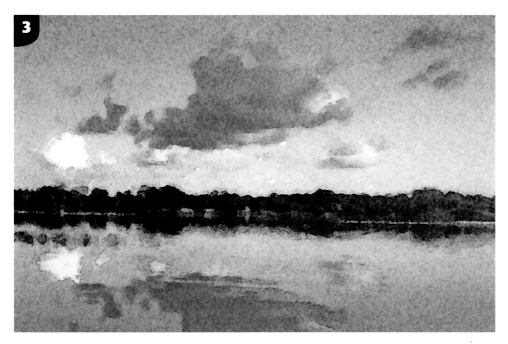

3 To add the granulation pattern to the painting, I set the pattern's scale to 240%, and the *Blend Mode* to *Soft Light* and at an *Opacity* of 43%. This made the painting appear as though it had been painted on rough watercolor paper with the granulation to match.

Simulated Medium
Oils

Simulated Support
Artists Canvas

Application
Painter

✪ CHECKLIST

Brush type	Size/Opacity
Sargent + Depth 144%	34.9/95%
Acrylics Wet Detail 5	7.5/71%

Impasto is painting either with a brush or knife, using paint so thick it stands proud from the support and achieves a 3D quality. It can only be done with an opaque medium like oil paint. When paint is applied in this way you can cearly see the swirls of brushstrokes, thick dabs, and slides of knife across canvas. It is often used across a whole surface because it is such an expressive way to paint, but it can also be applied in a more measured way to achieve particular visual effects on a smaller scale. For example, applying Impasto to the foreground subject of a painting but not to the background achieves focus on the subject and some recession, while applying the technique to highlights emphasizes an intended focus of interest.

Impasto has been used by many artists, but certainly Rembrandt, John Constable, J. M. W. Turner, and Van Gogh used it extensively, and it was *de rigeur* for much 20th Century abstract painting.

Simulating Impasto brushstrokes as you paint is not possible in Photoshop, although it is possible to add some textured depth effects after the brushstrokes are finished. It's better to use Painter, but the feature is conceptually quite complicated. To use Impasto on a brush or anywhere else, you have to create an Impasto layer—a virtual layer that carries depth information about the stroke. While rather difficult to explain, the technique is quite straightforward in practice as you will see from the following walkthrough.

Round Camelhair

Smeary Round

Thick Round

1 Painter has a specific category of Impasto brushes, with the other brush categories in the *Brush Selector*. There is a galaxy of different brushes and you need to experiment to determine the different effects they produce. Here you can see brushstrokes made by a Round Camelhair, Smeary Round, and Thick Round. Impasto is also available for most wet media brush categories and you can turn this on and off by going to *Windows>Brush Controls>Show Impasto* or *Show Brush Creator>Impasto*.

2 Generally, in Painter you will either use a pre-built Impasto brush or will already have a brush for which you want to turn *Impasto* on or off. To do this, go to the *Impasto* control palette and change either *Color* (no *Impasto*), *Color and Depth* (color in brushstroke and *Impasto*), or *Depth* (just *Impasto*). These three options are called the *Impasto Drawing Methods* and apply to default Impasto brushes, among others.

3 The first two options are self-explanatory but the third—*Depth*—gives you the ability to add depth to areas of a picture that do not already have them—although not to previously applied individual brushstrokes. Adding just a *Depth* stroke would create a look like the image here. The *Depth* method (whether by itself or in combination with *Color*) has a number of controls that have a marked effect on the look of the brushstroke, for example erasing previous *Depth* and adding the currently selected paper texture.

Other controls to note include *Invert* and *Negative Depth*, which also affect the brushstroke's appearance, although less dramatically than the *Depth* methods. The *Depth* slider determines how deep the brushstrokes are and, with the *Expression* option active, makes it possible for *Depth* to be set by your digital pen tool's pressure on its tablet. *Smoothing* at the highest setting softens brush height, and (directly underneath *Smoothing*) *Plow* determines how the Impasto brushstroke reacts with other Impasto strokes.

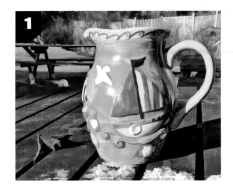

1 In this walkthrough, I first simplified a photograph in **Topaz Simplify** using the *Simplify* setting. This also increased the color saturation nicely.

2 I opened the image in Painter. In **Clone Color Mode**, I blocked in the image using a Sargent Brush at settings *Size* 34.9, *Strength* 95%, *Grain* 18%, *Impasto Color and Depth*, *Depth* 143%, *Smoothing* 100%, *Plow* 100%. I used very similar brushstrokes to create a uniform Impasto background. I could have used large strokes to follow form, but in either case it was important that the Impasto should not fight the detail of the subject when it was added later.

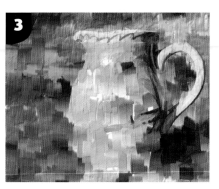

3 I completed the background Impasto strokes and started to add in the detail. This was done using an Acrylics Wet Detail Brush 5 at *Size* 7.5, *Opacity* 71%, and *Grain* 100%. I selected this brush because it has no bristles and gives a very smooth stroke that won't conflict with the Impasto. No Impasto was used on the Acrylics Brush.

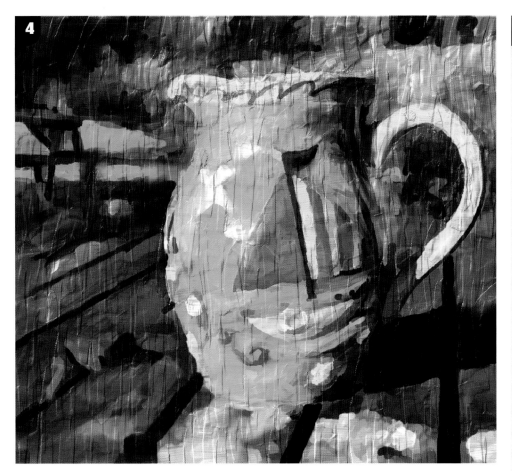

4 Here is the finished picture. To give the image a deeper color and tone I used the *Gel Composite Method* (found in the *Layers* palette). This colored the layer below with the colors of the layer above. Opacity of the top layer was set to 28%.

TIP

You can undo all the Impasto brush marks in an image by going to *Canvas>Clear Impasto*, or selectively by using the *Depth* and related erasers in the *Impasto* brush category. There are other features such as lighting and layers that are also important to the appearance of Impasto brushstrokes and the way they function.

When Impasto brushstrokes are overlaid it is not just the bristle marks that are on top of each other. As with real paint, the thickness of the paint increases proportionately. This can quickly give a painting an uneven or lumpy appearance, so Impasto strokes need to be carefully used.

Digital painters have mixed views on whether or not to add Impasto into their paintings. It is distracting if clumsy or overdone, and there is the look of the Impasto in a printed image to consider. Experiment for yourself, but try using it first in freehand paintings rather than Clone Color ones. With the Clone Color technique you need to be careful that, as far as possible, the Impasto, the brushstroke, and the content do not get out of alignment as the brushstrokes are made. Non-realistic painting effects can quickly pile up.

⇒ **Topaz Simplify see pp. 34–35** ⇒ **Clone Color Mode see pp. 44–45**

Simulated Medium
Oils

Simulated Support
Artists Canvas

Application
Photoshop, Painter

✪ CHECKLIST

Brush type	Size/Opacity
Sargent + Grain 22%	20.4/59%
Sargent + Grain 22%	10/59%

Imprimatura is the process of laying a toned neutral color onto canvas after priming—but before painting—to help the artist judge colors and their values. Imprimatura techniques have varied in their sophistication over time and among artists, but there seems to have been general agreement that judging colors and tones against a white or very light background (on wooden panels and then canvas) was difficult, as all colors looked darker than they were. It was much easier to judge and achieve harmonious color and value treatments if the paint was applied onto a support with a roughly middle tone. But colors differed from artist to artist: Vermeer liked light warm grays, Rembrandt gray or brown, Rubens brown, and Titian an iron oxide red. Today, some artists favor the complementary color of the dominant value in the subject.

Imprimatura is not the same as **Underpainting**. In Imprimatura the canvas gets an all-over—usually transparent—wash of paint; in Underpainting the artist establishes, usually using a single desaturated color, the main range of tonal values across the picture. So in Underpainting, a monochromatic image of the picture's subject is created. The two terms are often confused.

There are many views on the choice of color and precise process for applying an Imprimatura, and whether it should be partly opaque or fully transparent. However, there is general agreement that an Imprimatura should not provide much more than a tint of color and that it should have a middling tonal value.

In assessing the mid tone, you should take into account not just the lightest and darkest values, but also how much of the scene they cover. Even in digital painting, if you are creating a painting from scratch you will have to estimate your mid tone value by eye, looking at your subject—no short cut there. But if you are painting from a photograph, tracing one, or clone coloring from it, Photoshop can be very helpful in identifying the mid tone of your overall image.

1 To identify the mid tone in this digital photograph, I first opened it in Photoshop and used the *Adjustments* controls to fix its *Values* and *Color Saturation*. (If you don't know which settings to choose, you can simply opt for the *Auto-Tone, Auto-Contrast,* and *Auto-Color* settings.)

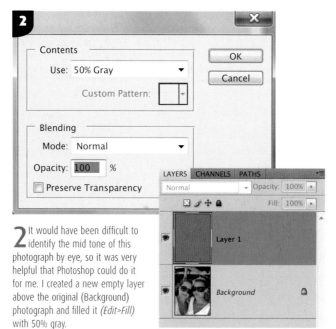

2 It would have been difficult to identify the mid tone of this photograph by eye, so it was very helpful that Photoshop could do it for me. I created a new empty layer above the original (Background) photograph and filled it *(Edit>Fill)* with 50% gray.

3 Next, I changed the *Blending Mode* for this gray layer to *Difference*, which produced this image. I created a new *Threshold Adjustment Layer* by selecting *Threshold* from the drop down list when creating the new *Adjustment Layer.*

➥ Underpainting see pp. 106–107

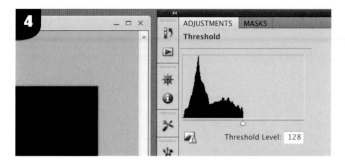

5 I moved the small white arrow under the far right side of the histogram to the left. This turned the image white. After that, I slid the same white arrow to the right, until just a small patch of black appeared.

4 This turned the image mostly black, and a *Threshold* histogram appeared above the *Layers* palette.

6 Next, I selected the Color Sampler Tool (Tools Panel>Color Sampler Tool) (not the Eye Dropper Tool) from the *Tools* panel. I sampled the color in the black area in the open image by clicking on the desired area. This left the *Color Sampler* cursor there.

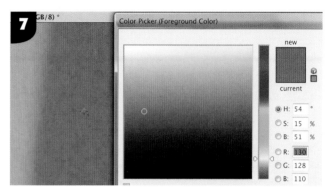

7 I deleted the *Threshold* and 50% gray layers and opened up the *Color Picker*. The *Color Sampler* cursor mark was now on the original image and in the *Color Picker's Color Field*. This was the mid tone with the associated color hue. I could now select this or another mid tone color simply by moving the small white arrows either side of the color bar to the right of the *Color Field*. With *H (Hue)* selected in the *Color Picker*, moving the small white arrows only changed the hues seen in the *Color Field*, not the tone. This effect was what I wanted for Imprimatura.

8 Here is a sketch made in Painter with the background Imprimatura color created earlier.

Simulated Medium
Watercolor

Simulated Support
Artists Canvas

Application
Photoshop

✪ CHECKLIST

Brush type	Size/Opacity
Rough Rnd Bristle + Wet Edges	74/45%
Watercolor Fat Tip + Wet Edges	26/100%

Ink Wash Off is a technique where soluble ink is removed from an ink-washed painting or sketch. An Ink Wash can be a substitute for a watercolor wash, but ink pigments have different effects on paper. Ink and ink washes have been used for centuries in many different ways and styles—from Rembrandt with his reed pen, to the bamboo pens of Chinese artists, and the **Sumi-e** brushes of Japanese artists. Today, traditional use runs alongside contemporary experimentation, where there are no rules about what or how to use it. For this technique I created a simulated ink drawing using ink washes, with some of the washes reduced in opacity by their partial removal. I worked in Photoshop, although there are relevant tools in Painter too, with a whole category of Liquid Inks, ready-made pens, and Sumi-e brushes.

You can do this as a freehand painting, or using a photo and a cloning tool, adding your own brushstrokes later. My approach comprised creating the washes and ink drawings, combining them, and then lowering opacity to suggest the effect of the water on the wash. It's better not to have a subject with too much detail, as this works best on strong graphic images. In my treatment, soluble ink was simulated for the drawing, but you could have the drawing in a permanent ink and the washes in a water-soluble one.

1 There was too much detail in the starting photograph for the technique to be effective, so I simplified it using **Topaz Simplify** (the *BuzSim* preset is a starting point) and added some saturation to create the first image. Beautiful as the colors in this simplified version were, a lighter tone was needed for the finished picture. But before I tackled that, I needed to make the ink contour drawings.

2 I selected *Filter>Stylize>Find Edges* to create an intricate drawing that would have a little of the scratchiness of a pen. I used the original simplified color image as the source (duplicated on a new layer) for the pen drawing.

3 This image needed to be desaturated.

4 Next, the black line drawing needed beefing up. For this I used one of the pencil presets in Topaz Simplify. Again, using the original simplified color image as the source (duplicated on a new layer) I created this image.

➻ Sumi-e see pp. 104–105 ➻ Topaz Simplify see pp. 34–35

5 I combined the *Find Edges* and Topaz Simplify versions of these line drawings and added some brightness using *Levels* to remove some of the superfluous spidery drawing.

6 Moving back to the color image, I created a pattern from the original simplified color version. Then I created a new layer, filled it with white, and made the wash using a nicely loaded watercolor brush (you can use a customized version of a Rough Round Bristle, but make sure it has *Wet Edges* enabled, *Shape Dynamics* off, and *Texture* on). The aim was to get a seamless wash typical of watercolor. Don't worry if you accidentally take your pen off your digital tablet and overlap; you can make good any joins using the *Healing Brush Tool* later.

7 I duplicated this light painted wash version onto a new layer just below the combined black and white pen drawing made earlier. With the pen drawing on top and with the *Blending Mode* set to *Multiply*, I merged the two layers to get a new combined image.

8 The problem with this was that the ink drawing was too perfect. It needed to be treated so that the ink would appear to have been washed away or distorted by water in some areas. I achieved this by again taking the original simplified painted wash version, duplicating it, then setting the *Blending Mode* to *Multiply* and merging the two images. From this image I made a new pattern for the *Pattern Tool Brush*.

9 Having made it into a new pattern, making sure that the latest combined ink line and color wash painting was open, I carefully added some of the pattern to the layer using a heavily loaded—really wet—brush. The key thing was to smudge, in a watery way, some of the line drawing of the woodwork. I could have added some to the ironmongery as well, but the key smearing areas were those with well-defined lines. *Flow* determines how wet a brush is—I used the Watercolor Fat Tip Brush at a *Size* of 26 pixels and a *Flow* of 72%.

10 This was quite effective, but one of the features of a washed off image is that there should be less paint saturation where the water has taken off surface ink. To give a suggestion of this effect, I duplicated the image I had just made, increased its brightness a little, and decreased its saturation. I then took the parent image of the one I had just made and duplicated it. Using a Soft Round Brush at a *Size* of 60 pixels, I gently removed areas from the top (more saturated and darker) image so that the lighter version showed through. I set the *Opacity* for the *Eraser Tool Brush* to about 40%.

11 For a final touch of authenticity, I added a pattern overlay in Photoshop—I used the granulation pattern demonstrated in **Granulated Wash**—to suggest that the drawing was made on rough paper.

➡ Granulated Wash see pp. 72–73

Simulated Medium
Watercolor

Simulated Support
Color Pressed Paper

Application
Painter, Photoshop

⊘ CHECKLIST

Brush type	Size/Opacity
Rolled Rag—Cotton	54/27%
Soft Round	65/65%

Lifting Out is primarily associated with watercolor, but it can be used with acrylics and oils. It involves the removal of unwanted paint, either to make a correction or serve some compositional purpose. It is mainly used when paint is applied transparently or semi-transparently and the artist does not want to make a correction using opaque or body color, but prefers the inherent whiteness of the support medium.

It's invaluable in transparent watercolor because purists will be reluctant to add white, or any other body color—gouache—to their picture. When the paint is still wet, you can use either a dry brush or an absorbent material like sponge or paper towel to lift pigment off of the surface. When paint is dry, you can re-wet the paint you want to remove to persuade it to come away with gentle scrubbing. Failing this, you can try a knife—but this often scrapes off the top layer of paper and certainly goes beyond the Lifting Off technique. The method is very useful in watercolor for suggesting subjects like sea and waterfall froth or clouds. A wash for the sky or local sea area is laid down, then using a sponge or kitchen towel the paint is dabbed off so that the new white area suggests clouds or water froth.

Removing unwanted paint is extremely easy in Painter and Photoshop. Both have Eraser tools—indeed, Painter not only has an Eraser Tool but an entire category of Eraser brushes.

In Painter, the Eraser brush variants will only remove paint down to the last selected paper color. If, for example, you fill a new image with red and paint green onto the image, applying the Eraser will remove all color down to white (if the paper color is white). Similarly, if you are working in **Clone Color Mode**, any erasing on the clone image will take you back to the paper color. Incidentally, you don't change the paper color on the **Paper** palette. The easiest way to adjust this is by going to *File>New*, and selecting the paper color there by clicking on the color rectangle. You may need to restart Painter to get the changed color to stick. This brings up the *Color* palette, and you then have all the color options right in front of you.

There are three sorts of Eraser brushes in Painter: the plain Eraser, the Bleach, and the Darkener. In practice, the Eraser brushes will remove surface color down to the support. Here the plain Eraser was used on green over red paper.

Bleach Eraser brushes, as the name suggests, always take you back to white and not the color of the paper, as demonstrated here using a Tapered Bleach brush.

The final type of Eraser is the Darkener. This brush increases the intensity of the color to which it is being applied, eventually pushing the color to black. This is rather like the effect of the Burn Brush in the *Photo* category of brushes. Painter also has an Eraser Tool, which is in the *Toolbox*. This is actually the straight Eraser brush. Like the Eraser in the Erasers category, the Eraser Tool will always take you back to the paper color.

➡· Clone Color Mode see pp. 44–45 ➡· Paper see Expressing Texture pp. 30–31

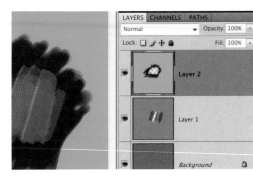

Photoshop doesn't have a range of Eraser brushes but you can achieve all the same Eraser effects in different ways. The top tool in Photoshop is the Eraser. This will remove the image on the layer to which it is applied. In this example, I created three colored layers with some black paint applied to the top one. The Eraser Tool cut through the layer below, where some of the bands of color could be seen painted on the blue. Note that in the top layer, the small image shows a transparent hole where the Eraser tool was applied.

The Background Eraser Tool removes any selected color in an image back to the layer below. To demonstrate this, I put half the diameter of the tool's cursor over the material I wanted to remove—black in this case—and then, by dragging the cursor along the edge of the black/green border, removed the black along that edge so that the bands of color in the layer below were visible.

The Magic Eraser Tool is equally clever. It removes pixels of a color you select using the tool. In this example, blue was selected and removed (you cannot see this, because it has been removed) and now some of the color band can be seen through the hole created.

1 Finally, here is an example of how you can use the Photoshop Eraser to create a cloud sketch employing the Lifting Out technique. First, I created two layers, filled the lower one with white, then added gradient fills to the top layer to create the background sky.

2 I then painted some of the smaller distant, grayer clouds into the top layer.

3 Next I used the Eraser Tool with a Rolled Rag Cotton 60 pixels brush to add some of the white cloud cover. This brush is in the *Faux Finish* brush library, loaded from the *Load Brushes* command in the drop down menu attached to the *Brushes* palette. As I erased the top layer, the layer below showed through as different shades of white.

4 I added a little more soft cloud with the Soft Round Brush for the Eraser Tool. Then I duplicated the working layer, and added some *Soft Light Blending Mode* to bring back more light and punch.

Simulated Medium
Pen and Watercolor

Simulated Support
Cold Pressed Paper

Application
Painter, Photoshop

○ CHECKLIST

Brush type	Size/Opacity
Round Tip Pen 20	3.6/100%
Soft Broad Digital Watercolor	10/21%

Line and Wash is a technique to record subjects, usually quickly and in sketch form, using a wide variety of materials. The line—the means of showing contours and edges—can be produced with pen, pencil, charcoal, and chalks or pastels, and the wash—the method of applying flat areas of color—by wet mixes of color in oils, acrylics, watercolor, or ink. They are made in **Mixed Media**, which I will look at later.

Some artists do produce Line and Wash pictures as finished artwork, but more often they are used as an aid to the memory, providing visual notes about a subject that can be worked up more fully in the studio. In its simplest form, the line gives you the boundaries of the contents in your scene, and the wash shows its values and color hue. Line and Wash using a single color for the wash is an exceptionally good way to learn about values in painting; judging tone without the distraction of color makes correctly identifying tones more simple, and five minutes spent jotting down a scene in line and a single color wash is never wasted.

In digital painting, sketching is going to be done indoors unless you are equipped with a laptop and a power source. You can, of course, draw and sketch what you see where you do your digital painting; this is perfectly feasible if your studio set up can accommodate such a practice. But most digital painters will either make sketches with real media that are scanned into a computer for further development, or derive Line and Wash pictures from photographs using various methods.

Painter and Photoshop are fully equipped to produce Line and Wash pictures and there is a large range of possible combinations of materials. Both programs also enable you to make them in different ways. You can make the line or contour drawing by direct observation using hand and eye, by tracing from a photo, or by cloning from a photo. Painter and Photoshop both have sketching functions that automatically produce line drawings, as do the Topaz Simplifier plug-in and the late buZZ plug-in.

One of the other marvels of making Line and Wash pictures using these programs is that you can use layers. This means that, in addition to being able to erase anything you don't like, you can have as many attempts as you wish at producing what will eventually look like a spontaneous likeness in a few pencil strokes!

1 For this walkthrough of a Line and Wash drawing, I began in Painter and finished in Photoshop. Here is the starting photograph.

2 Before setting the picture up for **Clone Color** painting, I first traced a contour drawing from the photo in Painter. To do this, I used a Round Tip Pen (20) from the *Pen* category and traced the lines in black ink. The idea behind a contour drawing is to try to keep your pen on the paper for as long as possible and not have too many unconnected lines. This increases the emphasis on flowing shape and form rather than abrupt pieces of the subject.

➛ Mixed Media see pp. 128–129 ➛ Clone Color see pp. 44–45

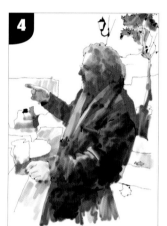

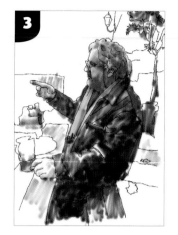

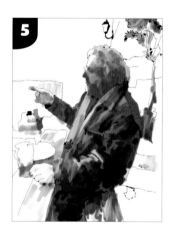

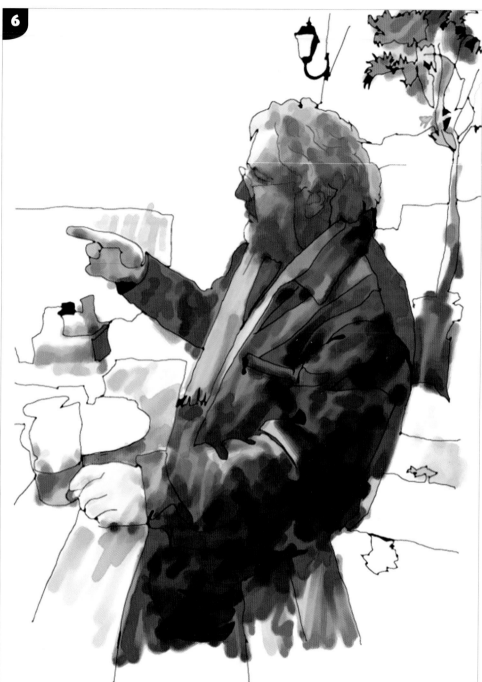

3 I wanted to add the color as a wash, so I used the Soft Broad Brush in the *Digital Watercolor* library at a large size and low opacity. I worked in Clone Color Mode, but the soft brush and wet effect meant that the brushstrokes did not exactly follow all the boundaries. I was intent on avoiding a coloring-by-numbers look. I did not intend to paint the whole picture, rather enough to give substance to the subject and balance the composition.

4 This was a good start, but I needed to flatten the wash to make it look less like a cloned treatment. To do this, I opened the picture in Photoshop and applied the *Dry Brush* filter to it *(Filter>Artistic>Dry Brush)* with *Brush Size* and *Brush Detail* at maximum and *Texture* at its minimum.

5 Not only was the wash flatter now, but the filter was having a delightful effect on the lines in the image, giving them some interesting random thickness and slight distortion. I needed to further flatten the wash areas, so I used **Topaz Simplify**. I opened up the plug-in and used the *BuzSim* preset filter with some additional simplification set using the slider control.

6 To finish off this image, back in Painter I saved the line drawing layer and brought it into the Photoshop version, so it became the top layer. I applied the *Dry Brush* filter to ensure it matched the lines in the colored version, set the *Blend Mode* of this new layer to *Multiply*, and reduced the *Opacity* right down to 20%, reinforcing the pen drawing in places. Finally, I added a little paper texture using the *Texturizer* filter at *Filter>Texturizer*.

➤ Topaz Simplify see pp. 34–35

Simulated Medium
Watercolor

Simulated Support
Cold Pressed Paper

Application
Photoshop

⚙ **CHECKLIST**

Brush type	Size/Opacity
Rough Rnd Bristle + Wet Edges	17/27%
Rough Rnd Bristle + Wet Edges	8/34%

In this second Line and Wash walkthrough, I demonstrate how the treatment can be applied to a landscape—in this instance of the famous Grand Canal in Venice, Italy—using a slightly different technique. This time, the work was all done in Photoshop. I used the Topaz Simplify plug-in to make an image for use as a pattern source, and also to create a line drawing. I applied the wash using the *Pattern Stamp Tool* as a brush.

1 First, I opened the starting photograph in Photoshop, duplicated it, and simplified it using **Topaz Simplify**. I used the *BuzSim* preset with these settings.

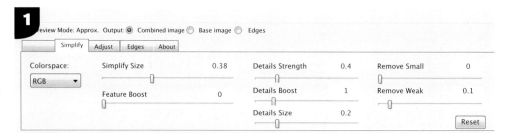

2 After adding a little more color saturation and brightness I had an image to use as the pattern template.

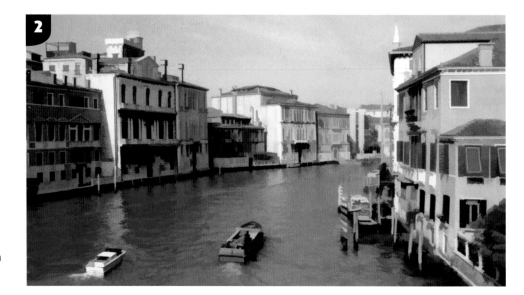

3 I duplicated the original photograph again and this time used Topaz Simplify to create a line drawing. I used the *Sketch_HardPencil* preset to produce this.

➡ Topaz Simplify see pp. 34–35

4 I then created a new blank layer below the top line drawing layer and filled it with white. I set the line drawing layer *Blend Mode* to *Multiply* and started to paint into the blank layer with the pattern I created using the Rough Round Bristle (100) Brush set to 100% *Flow*. Making sure that *Impressionist* was selected in the *Tools Options* bar, I reduced the *Opacity* of the line drawing that I would be using to guide the color painting. I did not intend to follow the boundaries of the drawing closely, however—a loose treatment would be fine. Note that I changed the sky. This new sky was more interesting than the original and I painted it in by eye, from scratch. The painted treatment was opaque rather than transparent and I interpreted "wash" here as a paint application that was very wet; it was for this reason I set the brush *Flow* to 100%.

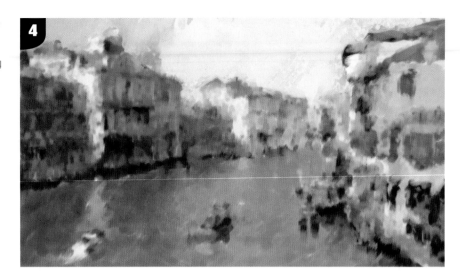

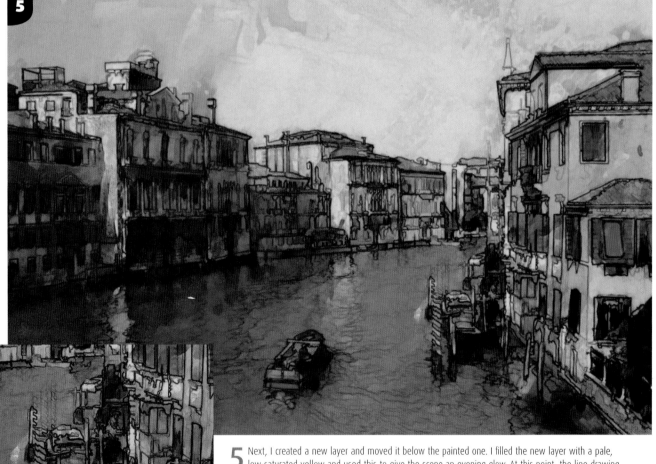

5 Next, I created a new layer and moved it below the painted one. I filled the new layer with a pale, low-saturated yellow and used this to give the scene an evening glow. At this point, the line drawing layer was at the top of the layer stack, then the painted layer, and then the yellow filled layer. I set the drawing layer to a *Blend Mode* of *Multiply* and an *Opacity* of 77%. I also set the second, painted layer to *Multiply* with an *Opacity* of 73%, and I set the *Opacity* of the yellow layer to 75%. Finally, I flattened the layers and added a little more color saturation along with some *Unsharp Mask*. Here is the final painting, with a detail showing the effects of the technique.

Simulated Medium
Oils

Simulated Support
Artists Canvas

Application
Painter

○ CHECKLIST

Brush type	Size/Opacity
Camel Oil Cloner + Feature 2	12/100%
Straight Cloner	19/100%
Oils Bristle Oils 30	12.2/100%
Oils Fine Feathering Oils + Grain	9.6/79%

Painterly Edges are the unpainted areas around edges of canvas, paper, or other supports where the main painting has not extended. In real media this is normally seen on sketches or other **Alla Prima** paintings, not on a highly finished painting. In digital painting these edges are often seen as brushstrokes that do not fully cover the edge of the canvas, leaving a white border around the picture broken by the brushstrokes. When done carefully Painterly Edges add authenticity to natural media simulations.

To make them look real, you need to consider what the support would look like where the brushstrokes have not reached. In a watercolor or transparent acrylic painting, the support is normally white or off-white as in a light-to-dark painting the white of the support provides the lightest value. If the painting is on a textured surface, that texture will need to extend to the support, even where there is no paint.

In an oil or thick acrylic painting, you need to consider not just the texture but any priming, **Imprimatura**, and **Underpainting**. These would extend to the edge of a painting and would be visible in the painting's border either as a solid color or as spots and flecks of color where the underpainting brush had not reached. There might also be small areas of white, primed, but unpainted canvas showing too. It is worth working out the sequence of paint application and other effects to be used to create your edges.

In the walkthrough that follows, I took a loose-looking, completed painting and created a corridor around its edge that I made to look accidental in a painterly way. The choice of picture is important for this effect to sit right—you need a painting you have made in a loose brush style, even if it is incomplete.

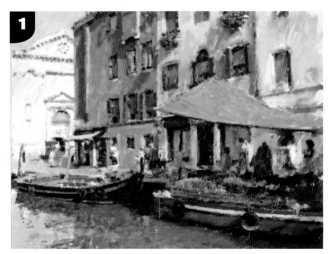

2 Enlarging the canvas would have created space beyond the image but might have posed a problem when brushing in that area, as it would require cloning color into the new section of canvas. All the colors and brushstrokes would have to be selected separately, which would be laborious. Imposing a boundary on the existing image was simpler, so I set up the image in **Clone Color Mode**, cleared the image in the clone stack *(Select All>Edit>Clear)*, and filled the resulting white area with an off-white, cream color.

1 I opened this previously painted digital oil sketch of a Venetian boat scene in Painter. My first decision was whether to add a border by enlarging the canvas, or impose a border on the existing image. I chose the latter.

4 I applied this canvas to the border at *Effects>Surface Control>Apply Surface Texture*. It was too prominent when first applied so I brought it down a little using the *Edit>Fade* control.

3 I made a rectangular selection inside the clone image and inverted it so just the border was now selected. The *Inversion* control is at *Select>Invert*. In the painted image there was quite a lot of canvas texture showing, so this needed to be matched in the border I had just created. To achieve this, I set the paper to **Artists Canvas** in the drop down paper list, judging the right scale for the canvas texture by eye.

➤ Alla Prima see pp. 56–57 ➤ Imprimatura see pp. 76–77 ➤ Underpainting see pp. 106–107 ➤ Clone Color Mode see pp. 44–45 ➤ Artists Canvas see Expressing Texture pp. 30–31

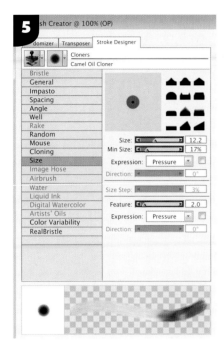

5 I selected the Straight Cloner from the *Cloners Category* and changed the *Feature* value to 8.2 in the *General* page of the *Stroke Designer*. *Opacity* was set at 100%.

6 Next I returned the *Selection* to *All* and began painting. The aim was to make the brushstrokes reach into the border as naturally as possible. In general this meant trying to make the strokes look as though they ended in the border.

7 I used the default Straight Cloner in the central area of the picture to recreate exactly the original picture there. The edges needed to be a little more bristly, so I used an Oils Bristle Oils 30 with the **Dab** type changed to *Static Bristle* and the *Bristle* thickness reduced to 23% to space the bristles apart *(Brush Creator>Stroke Designer>Bristle>Thickness)*.

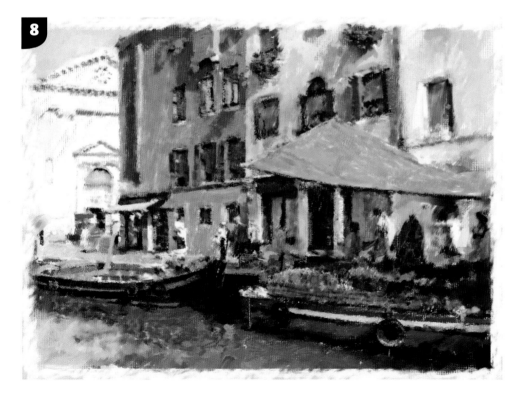

8 If I happened to go over any parts of the border with the Clone brush that should have been left clear, I simply took the Clone function off and painted with the neutral gray color to correct my mistake. I needed to add some white canvas texture in the border to simulate areas that were not painted at all (this will usually be the top of the canvas "teeth"). I used an Oils Fine Feathering Oils Brush with the Grain turned up and the Texture inverted in the Paper palette.

Here is the final picture with completed Painterly Edges.

➤ **Dab see Painter Brushes Basics pp. 18–19**

Simulated Medium
Watercolor and Pen

Simulated Support
Cold Pressed Paper

Application
Photoshop

○ CHECKLIST

Brush type	Size/Opacity
Rough Dry Bristle + Wet Edges	37/34%
Round Bristle + Wet Edges	22/60%

Preparatory Drawings, or underdrawings, take many forms. They can be rough sketches indicating the most striking elements of a subject, or they can be highly detailed and designed to be followed closely in a painting. Some artists, like Rembrandt, seem to have hardly used these at all, while others, like Canaletto—with or without the help of a camera obscura—often made very careful Preparatory Drawings.

They can be made in a wide range of material (everything from pencil, pen, charcoal, pastel and paint) on a variety of different supports. They can be produced to scale on the support to be used for the painting, or created on a small piece of paper to be scaled up; made at their full size and transferred to a support using small holes in the lines of the drawing, made visible by using a Pouncer brush dabbing charcoal dust, (which remains when the paper is removed) or traced using a lamp to project the image onto a support.

In freehand digital painting, Preparatory Drawings are often drawn by the artist on a piece of paper, scanned into a computer, and worked up in Painter or Photoshop. They can be created from scratch by drawing with a pen stylus on a digital tablet, traced from a digital copy of a photograph using the software, or traced from a real hard copy photograph under the transparent plastic flap of a digital tablet. You can even also use the software to fully automate the drawing for you. If you want to use the software or a digital tablet to help you, the first thing to decide is how much of the original drawing you want to appear in the final painting. This decision is important for Clone Color artists; getting just the right amount of original drawing showing through in your final painting can greatly add to the illusion of natural media.

Allowing most of the underdrawing to be seen through paint can work very well; John Piper used this approach very effectively. Seeing traces of underdrawing is also useful in watercolor or oil sketches. Indications of a charcoal line here and there in an oil or acrylic painting can add punch to a painting by defining some of the subject's edges.

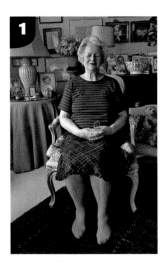

1 Whether you intend your Preliminary Drawing to be present in the final painting or not, Painter and Photoshop—along with some plug-ins—offer some very good ways of working up drawings. Using Photoshop (Painter offers much the same range of possibilities) this walkthrough shows how different drawings can be created from a photo using different approaches.

I created this drawing using Photoshop's *Find Edges* at *Filter>Stylize>Find Edges*. This produced a line version of the original, which I then desaturated. I then increased the brightness of the image to reduce the gray midtones.

I produced this drawing using *Glowing Edges* at *Filter>Stylize>Glowing Edges*, using settings *Edge Width* 2, *Edge Brightness* 4, and *Smoothness* 3, then inverted the image at *Image>Adjustment>Invert*. As before, I desaturated and added brightness to the image to reduce mid gray tones. (To produce a pencil effect you can always use the line drawing at a reduced *Opacity*.)

Here I used the **Topaz Simplify_** Lightpencil plug-in to create a line drawing. This is found near the bottom of the *Filter* list. The Topaz settings offer a wide array of adjustments, including how simplified the image is, how the edges appear, how much detail is left in, and how much brightness and contrast are applied. This allows for a great deal of control over the line drawing.

➤ Topaz Simplify see pp. 34–35

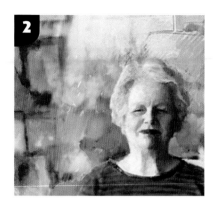

2 Using a version of the Topaz Simplify pencil sketch as the underdrawing, I filled the canvas with a mildly saturated mid-pink sampled from the subject's skin, and used the **Pattern Stamp Tool** as a brush to bring back detail. There was a lot going on in this photograph—the trick was to simplify the surrounding context without losing it altogether, as it was an important feature. To achieve this, I allowed the underdrawing to show through in areas to indicate the contours of the furniture surrounding the sitter without actually painting most of it in. Without the underdrawing, the painted image looked like this at this stage.

After creating a line drawing you can also produce a charcoal-like line using two filters. On this drawing, I used the *Photocopy (Filter>Sketch>Photocopy)* filter with settings *Detail* 7 and *Darkness* 8.

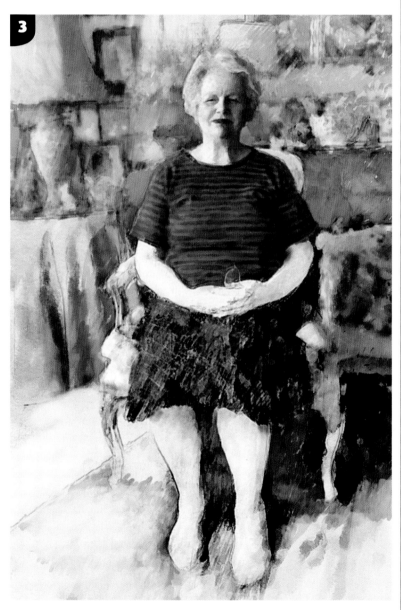

3 Here is the finished picture with the underdrawing and painted layers merged together. The underdrawing is on top with *Multiply Blend Mode* applied at an *Opacity* of 24%, so the painting shows through. The effect is subtle—the drawing suggests some detail without overwhelming the overall picture.

I created this charcoal-like effect at *Filter>Sketch>Torn Edges*, with the following settings in *Torn Edges*: *Image Balance* 46, *Smoothness* 14, and *Contrast* 22. This technique produced an approximation of a charcoal effect that I could customize as much as I wished. This drawing would work well with a very loose painting treatment.

⇒• **Pattern Stamp Tool** see pp. 48-49

Simulated Medium
Oils

Simulated Support
Artists Canvas

Application
Painter

○ CHECKLIST

Brush type	Size/Opacity
2B Pencil—Pencils	1.9/15%
Thick Wet Camel—Oils	4.5/100%
Thick Wet Camel—Oils	3.9/100%

Pointilization is the process of rendering an image in dots or small brushstrokes of color. It refers back to Pointilism, an art style associated with the Post-Impressionists and, particularly, with the work of Georges Seurat. Some experts argue that the aim of Pointilism is to create soft and lustrous gradations of color and value that more truly reflect the way we see and the subtlety of what we see. Others maintain that the chief intention is to get colors to mix in the mind's eye rather than on the canvas or palette.

The careful geometry of composition is distinctive in Seurat's work, with strongly defined shapes helping his pictures to read more clearly. Indistinct shapes are often more difficult to discern in a Pointilist painting. Seurat did not, in fact, use only dots, but a variety of small brushstrokes, including dabs, circles and short strokes. Nor did he use only primary colors—he experimented with many different color approaches, including complementary colors, to achieve the color vibration that is so significant in his work.

Painter and Photoshop offer a number of different tools to achieve Pointilized effects. In Painter there is a Seurat Brush in the **Artists' Brushes** category that can either be applied by hand or through the *Auto-Painting* feature. In the example below, I created a Pointilized version of an existing painting using Painter. You could use Photoshop just as well.

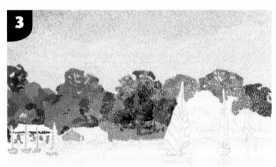

1 I began by making a drawing to guide my brushstrokes. I scanned in an original painting and used it to trace a contour drawing onto a cream background—the cream would help to unify the picture. I used **Artists Canvas** as my support, filling the canvas with a cream color with the *Paint Bucket Tool*, and using a 2B Pencil from the *Pencil* category at *Size* 1.9 and *Opacity* 15%, with a *Grain* of 44%.

2 Starting with the sky, I selected a blue from the scan of the original painting. I chose not to use the *Mixer Palette* but I could easily have done so. Instead I created a **Color Set** from the scanned painting, used swatches from it, and customized colors as I saw fit. I used a Thick Wet Camel Brush from the *Oils* brush category, *Size* 4.5, *Opacity* 100%, with *Impasto* off. I continued painting until the sky had one all-over application

of blue strokes. An alternative approach to painting large areas like sky entirely by hand is to select an area you have painted, *Copy* it, and *Paste* it in place. You can then move it to an unpainted bit of canvas. If working in Photoshop you could use the *Clone Tool (Tools Panel> Clone Stamp Tool)*. Once you have *Copy/Pasted* a number of painting fragments, you can merge them together by selecting all of the relevant layers and going to *Layers>Collapse*.

3 After the first application of color to the sky I made a start on the trees. The key thing to remember with trees is that, like clouds, they are generally brighter on top and in shadow below.

4 Here is a close up of an area to show the brushwork in greater detail. You can see that the Thick Wet Camel Brush was actually quite bristly. This gave a softer, more painterly effect than working with blobs of paint. My application method was a dabbing motion with no dragged brushstrokes.

➤ Artists' Brushes see pp. 20–21 ➤ Artists Canvas see Expressing Texture pp. 30–31 ➤ Color Set see pp. 70–71

5

6

7

5 Next I painted in the mid and foregrounds. The great thing with this technique is that if I misjudged hues or values, I could easily make corrections. Occasionally I reduced the *Size* of the brushstroke to 3.9 for detailed areas, but the aim was to keep to one size stroke as much as possible.

6 Here is a detail from the finished painting showing the application of layers in the sky. You can see how the paint jabs create lights over darks and darks over lights. This variety keeps the eye interested.

7 This close up of the foreground shows the painting's quite complicated tonal and color value changes, which were made just with jabbed brushstrokes.

8 You can Pointilize any image in this way, but if you do this to a plain photograph the result may not be very satisfactory; you will merely have a photograph made of up dots. To give it a more painterly effect, simplify it first and make sure you dab on the paint using a bristly brush. Alternatively, you can make a full Pointilist painting using dabbed color adventurously so that the intended hues and their values are formed in the viewer's eye.

8

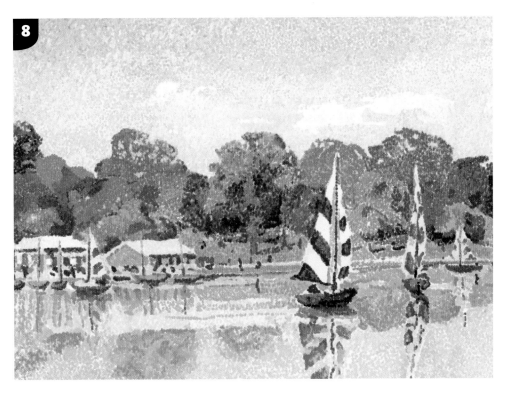

Simulated Medium
Watercolor

Simulated Support
Hot Pressed Paper (Smooth)

Application
Painter, Photoshop

○ **CHECKLIST**

Brush type	Size/Opacity
Watercolor Heavy Pigments	42/100%
Watercolor Heavy Pigments	18/100%

A Runny Wash is a type of paint application made in a watercolor painting. A wash is used to fill an area of paper with a color without showing any brushmarks; a Runny Wash floods the paper with color and will form rivulets if the paper is held near vertically. It is also used in the **Wet-in-Wet** watercolor technique.

Runny Washes in real watercolor painting can be hard to control; ordinary washes, which are made with less water in the brush, are preferable. These are used to make gradated areas of color either in relation to value change (as in dark blue to light blue sky) or color (as in blue sky to the red tint of evening along the horizon). Fringes can occur at the edge of wet areas where the pigment has dried out.

Runny Washes have gained more meaning in the context of digital painting because they are a type of brush in Painter's **Watercolor Brushes** category. There are six types: Runny Bleach, Runny Airbrush, Runny Wash, Runny Wet, Smooth Runny, and Soft Runny. These all create slightly different effects. The thing to remember with these brushes is that when you use them you are adding water—with or without color—to whatever is already on the paper. It is, in fact, the watercolor layer that is doing the work with Painter Watercolor brushes, but it is helpful to think of the brushes as adding liquid.

On this page are combinations of brush variants that illustrate how the wetness of the stroke can affect the overall image. First, a Runny Wet Camel on another Runny Wet Camel.

A Runny Wash Camel on another Runny Wash Camel. Note the relative absence of fringing (dried pigment).

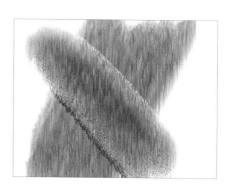

A Runny Wet Camel on a Runny Wash Camel. See how the Wet fringe appears even on top of a different Runny variant.

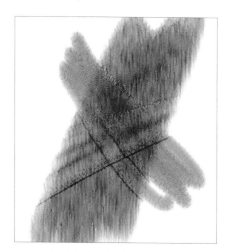

A Runny Bleach (with and without color) on a Runny Wash Camel.

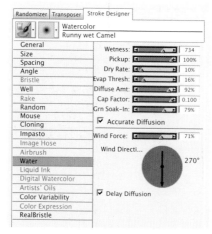

From these examples you can see that the *Wet* brushes are adding more water (and therefore fringing) than the *Wash* variants, and that the water is descending down the paper as it dries. The wetness and the direction and speed of liquid movement are controlled in the brushes' *Water* settings.

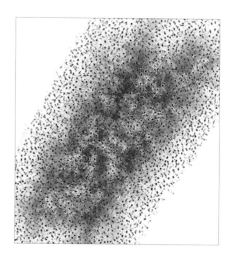

Change the direction of the arrow and the drying paint will also move in that direction. Cut the *Wind Force* to 0% on the Runny Wet Camel and the paint does not move in any direction but takes on a mottled look, with the watery paint remaining static.

➤ Wet-in-Wet see pp. 110–111 ➤ Watercolor Brushes see pp. 28–29

1 Photoshop does not have the sort of Runny brushes you would find in Painter, but it is possible to simulate quite wet washes. The easiest way is to load the *Wet Media* brush category in the *Brushes* palette, pick a brush, and check in the *Brushes* palette that *Wet Edges* is selected, *Spacing* and *Texture* are set to 0, and in the *Tool Options* bar that *Flow* is at a high setting like 75%. I created a **Pattern** from a photo and added a blank white filled layer above the background layer (the starting photograph), then selected the Watercolor Heavy Pigments Brush, set its *Opacity* to 100%, *Texture* to 0, and *Flow* to 75%. Painting into the white layer created a very wet-looking, generalized version of the pattern.

2 I duplicated this layer and changed the *Blend Mode* to *Soft Light*. This detail shows how wet the paint application appeared.

3 Having merged the *Soft Light* and *Normal* layers, I added the *Pattern Overlay* granulation effect that I made for **Granulated Wash** to enhance the appearance of a very wet wash on rough paper. You may need to adjust the scale of the granulation pattern to fit the picture. I also added another wash of paint to the new merged top layer, but this time at a reduced brush size.

4 On the same layer, with *Flow* at 100%, the paint was more pushed around than brushed, achieving a loose treatment. I added a little more detail with the same brush at a smaller size, and also the drips that I made for the pages on **Scanning** in Chapter 1, using the same *Pattern Overlay* method, not forgetting to change the *Blend Mode* to *Color Burn* for the drips layer.

5 This detail from the finished picture shows the loose watercolor treatment.

➡ Pattern see Pattern Stamp Tool see pp. 48–49 ➡ Granulated Wash see pp. 72–73 ➡ Scanning see pp. 52–53

Simulated Medium
Acrylics

Simulated Support
Artists Canvas

Application
Photoshop, Painter

○ CHECKLIST

Brush type	Size/Opacity
Sargent + Grain 26%	15.6/60%
Sargent + Grainy Hard Cover	18.3/24%
Sargent + Grain 14%	9.6/60%

Scumbling is used mainly in oil and acrylic painting. A coat of paint is applied loosely, roughly, or unevenly to a dry coat below in such a way that the undercoat can be seen through the new coat in patches. The aim is to create a new color and color value by mixing two coats of paint in the viewer's eye.

Scumbling usually involves the adding of a lighter, generally translucent or semi-opaque color over a darker one. But it is also used to modify the underlying color for other reasons. The base color can be warmed or cooled, made to come forward or recede, or enlivened by the addition of its complementary color, animating the flatness of a single value. It is created in many different ways using real media—from brushes to fingers—and doesn't follow any one kind of stroke application. The examples on this page were all made in Photoshop, but the same processes work in Painter, and the walkthrough on the facing page was made in Painter.

Here Scumbling lightened a dark blue, using the Swirl Brush with 38% *Opacity*, *Texture* on, *Spacing* set to 66%, with the brush loaded with a lighter blue.

This example of lightening used the Texture 6 Brush with *Spacing* set to 60% and *Opacity* set to 50% .

This lightening application was done with large semi-opaque brushstrokes using an Oil Heavy Flow Dry Edges with *Spacing* set at 5% and *Opacity* set at 38%.

This Scumble used red to warm up some blue, using a Dry Brush with *Spacing* set at 1% and *Opacity* at 40%.

A warm brown cooled by some blue using the Dry Brush, with the same settings as the previous example.

A Scumble using near complementary colors but in a highly stylized treatment, with different brushes and both colors creating a vivid look.

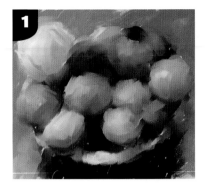

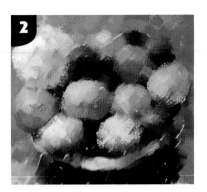

1 In this demonstration of Scumbling, I set a photograph up in Painter in **Clone Color Mode** and filled the clone layer with a light gray brown using the *Paint Bucket Tool*. With the Sargent Brush at a *Strength* of 60% and *Grain* of 26%, I then blocked in the forms. Because of the brush's lower opacity, this produced a low saturation image to serve as an **Underpainting**.

2 I began to add color using a large grainy version of the Sargent Brush that used the same **Dab** *(Captured)* as the Sargent, but substituted *Cover* for the *Method*, and *Grainy Hard Cover* for the *Subcategory*. The Artists Rough Paper added texture to the brushstrokes, giving the broken color associated with Scumbling.

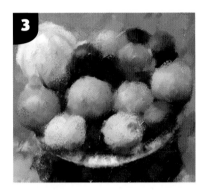

3 I added more Scumbled brushing using the customized grainy Sargent variant at progressively smaller sizes: 26, 16.9, and 8.8.

4 This close up illustrates the way the color strokes were applied, the broken strokes revealing the underlying color.

5 For the final picture, I added a little more color saturation *(Effects>Adjust Colors>Saturation: 7%)* along with some sharpening *(Effects>Focus>Sharpen)* to help the picture read clearly. The Rough Artists Paper helped the brushstrokes to appear as though they had caught the tops of the teeth of the paper, giving an effect similar to **Dry Brush**.

➡ Clone Color Mode see pp. 44–45 ➡ Underpainting see pp. 106–107 ➡ Dab see Painter Brushes Basics pp. 18–19 ➡ Dry Brush see pp. 62–63

Simulated Medium
Oils

Simulated Support
Artists Canvas

Application
Painter, Photoshop

☉ CHECKLIST

Brush type	Size/Opacity
Sargent (P)	7.5/34%
Eraser Oil Small Tip (PS)	8/75%
Eraser Oil Small Tip (PS)	4/75%

Sgraffito, meaning "scratched," dates back at least to the Middle Ages. It is particularly associated with pottery decoration, but is also used in painting. A surface color is removed to reveal the original ground—for instance white canvas—or the color coat below, producing different effects on wet and dry paint. This difference is especially noticeable in watercolor, where scratching wet paint will often fail to produce a white paper mark because the wet pigment bleeds back into the scratch. But scratching dry paint is an important method in watercolor of revealing white paper to produce highlights or other lightening effects. Done well, it produces more satisfactory white areas than the addition of opaque white. It is possibly less significant in oil painting because the addition of white is not uncommon in that medium.

In digital painting you can easily get back to white (or any other color), and the use of layers makes the notion of removing color to reveal a color below quite intuitive. But to make convincing Sgraffito effects you need to pay particular attention to how scraped areas appear in real life. There are three things to remember. First, the ground will almost certainly show more surface texture than the painted areas adjoining it because of the diminished thickness of paint. Second, the scraped area will often not be pure white because of the staining effect of paint previously there. And third, the scraped area may have textured edges because the scratch removes the over-paint unevenly.

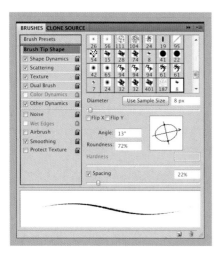

To demonstrate Sgraffito in Photoshop, I created a new document, filled it with a mid warm green color, then created a layer above and filled that with a khaki color. My intention was to make a scratched-looking sketch of some long grass by removing paint from the lighter layer to reveal the darker layer below, using the *Eraser Tool* but with Oils Small Tip selected as the Eraser Brush. (*Wet Edges* and *Color Dynamics* were unavailable because the brush was being used as the *Eraser*.)

1 For the main Sgraffito demonstration, I used a photograph of a painted rattan chair. My plan was to derive an overall background for the chair, and then use the *Eraser* to reveal the white and gray of the subject through the background. First, I opened the photo in Photoshop and used the **Topaz Simplify** plug-in to remove a little detail—this also added more color saturation. (If you don't have Topaz Simplify, applying the *Dry Brush* filter would do.)

Using the *Eraser Tool* at various opacities and small sizes, I added brushstrokes as blades of grass. In effect, I was scraping away the khaki color at different opacities to reveal the green below. (You could use more than one color in this process.) The finished sketch might look like a drawing, but has actually been made by the removal of a color layer, not by its addition.

➡ Topaz Simplify see pp. 34–35

 2

 3

2 Opening the image in Painter, I created a background from the wall that was behind the chair in the photo, and **Clone Colored** it with a Sargent Brush to make it less photographic. By hand, I painted in some imaginary dead leaves and grass to the area under the chair using a Hard Round Brush, *Size* 13, *Opacity* 95%. My intention was to scratch into this background to reveal the chair.

3 Back in Photoshop, I added the image as amended in Painter as the new top layer, above the layer showing the whole simplified chair seen in step 1. In order to show some texture and unevenness when the top layer was scratched out, I used the *Eraser* with the Oils Small Tip Brush at an *Opacity* of 75%. I removed paint from the brown background layer above the chair image layer and set the *Opacity* of the top layer to 80% so I could see where to scratch. Notice the mottled surface, which avoided too precise a scratch.

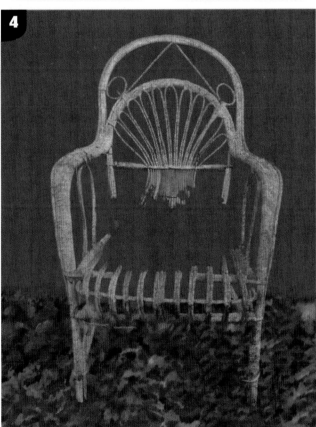 **4**

 5

4 At this stage I had finished scratching out the chair.

5 The plants and the box on the chair were still too bright, so on their layer below the top one, I selected them using the *Lasso Tool*, simplified them and lowered their color saturation using Topaz Simplify, and then scratched them in. Here you can see the garish "before" image.

 7

 6

6 And here is the more harmonious "after" image.

7 The picture was slightly ghostly and insubstantial and the red flowers were too dominant. For the final image I added a little more *Contrast* and some *Unsharp Mask* (*Amount* 25%, *Radius* 1.7 pixels, *Threshold* 0) to add a little punch. Not conventional Sgraffito, but an interpretation that uses the extra capabilities of digital painting software.

➡ Clone Color see pp. 44–45

Simulated Medium
Watercolor

Simulated Support
Hot Pressed Paper

Application
Painter, Photoshop

○ CHECKLIST

Brush type	Size/Opacity
Watercolor Splatter	8.8/80%
Customized Spatter 59	104/75%

This technique involves the controlled—or nearly controlled—application of paint onto a surface by flicking the paint from a brush. The aim of this method can be literal—to show the presence of small particles like snow, smoke, or sea spray—or expressive and abstract, adding energy and variety to a flat or static area. Jackson Pollock used Spattering among other techniques to apply paint to his canvases.

Spattering is in the same family as **Pointilization**. Like Pointilism, Spattering can break up forms, flat color, and hard edges, allowing them to be reassembled spontaneously, with new colors forming in the viewer's eye. Spattering can bring life and energy to a staid figurative picture if it is used selectively and with care.

In real natural media painting (particularly in watercolor), Spattering is a pretty high-risk technique, because if it goes wrong, it can be difficult or impossible to get the picture back to where it was before. This can make Spattering a technique of last resort, to be tried if a painting needs "something" but the artist is not sure what. The great thing about digital painting is that the software provides the *Undo* button and multiple layers to work on, so you can experiment as much as you like until you find the right approach.

Painter provides for Spattering with a number of brushes, primarily **Watercolor** as you can see on this page. On the facing page I outline some of the Spattering methods available in Photoshop.

1 Here is an example of the Spatter Water Brush in Painter's *Digital Watercolor* category. A beautiful effect.

2 There are also two Splatter (yes, "Splatter" rather than "Spatter") brushes in Painter's *Watercolor* category: above, the Splatter Water, and above right, the Bleach Splatter.

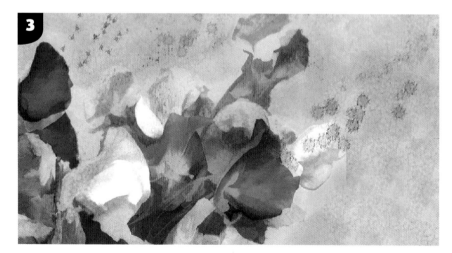

3 In this close up detail of a digital painting of some flowers, you can see the Watercolor Splatter brushes in action. The *Randomness* and *Spacing* between brush **Dabs** can be changed in the *Brush Creator*, and can also turn some other brushes into Spatter-like applicators. To use this technique, you need to be able to control both *Randomness* and *Spacing*, and the brush *Dab* types are the way to achieve this. *Dab* types that open both to you are *Circular, Static Bristle, Eraser,* and most of the *Liquid Inks*. All the pre-built Spatter and Splatter brushes use the *Circular Dab* type.

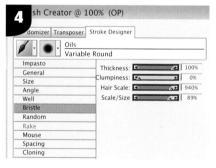

4 The Static Bristle makes a nice Spatter brush—or even a Pointilist-like brush—if you change the *Bristle* settings. You can get more distinct, rounded (but not translucent) spots of color by using the settings shown here. Note that the *Clumpiness* slider has no effect if the other sliders are all the way over to the right, and that part of the Spattery quality of these brushes comes from varying the *Color Value* (and even *Hue* and *Saturation*), which you can do in the *Color Variability* controls in the *Brush Creator*.

➡ Pointilization see pp. 90–91 ➡ Watercolor Brushes see pp. 28–29 ➡ Dab see Painter Brushes Basics pp. 18–19

1

2

3

1 In Photoshop, you can apply Spatter to a whole image, or part of an image, using a filter or a brush. To illustrate the options, I used a photo of a display dish.

2 Applying the *Spatter* filter *(Filter>Brush Strokes>Spatter)* to the whole image (with a *Spray Radius* of 25 and *Smoothness* of 15) did not produce a particularly interesting or evocative effect.

3 The effect did not bear much resemblance to one you would get from Spattering a surface with paint from a brush, but it does work quite well on fonts and other isolated images.

4

4 You can easily create good Spatter brushes in Photoshop. There are some already available, but they require tweaking. The key controls are *Brush Tip Shape*, which controls what the basic brushstroke looks like in cross-section, i.e., as a *Dab*; *Shape*

Dynamics, which governs what shape the brushstroke will have—if any; and *Scattering*, which sets the quality and location of the dabs or marks in a stroke. Here you can see marks made by a Spatter brush, and the settings I used.

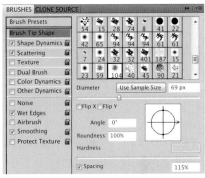

5

5 Here is a section of the display plate, this time painted with a Spatter brush in something of a Pointilist style.

Simulated Medium
Acrylics

Simulated Support
Basic Paper

Application
Painter

◯ CHECKLIST

Brush type	Size/Opacity
Loaded Wet Sponge	78/100%
Square Sponge + Grain 35	52/26%
Square Sponge + Grain 35	23/60%
Desnse Sponge	6.4/100%

In fine art, sponges are generally associated with removing paint and making corrections, particularly in watercolor, but also with acrylics when they are used with water. In this walkthrough, I have concentrated on sponges used for painting or applying color, rather than the corrective use of the technique. In real world painting, applying paint with a sponge is not unknown, but it is a hit and miss affair and is likely to be more effective on broader areas of color or, in figurative painting, for creating objects or parts of scenes that work with the particular characteristics of a sponge delivering paint. In landscape painting, for example, it can be used to create the impression of bushes or foliage, the broken coverage of a sponge suggesting light filtering through greenery. It can also be used for water spray and for clouds. Sponges can also be used for blending colors.

Photoshop and Painter both have Sponge brushes. Photoshop has a number of sponge brushes in the *Faux Finish* brush library—three examples are shown below. The brushes had *Spacing* set quite high as default because, sponges being what they are, the natural painting method is a dab rather than a stroke. Given the generic crinkled look of the sponge dab, you could easily use brushes like the Rolled Rag—Terry 120, or the Pastel Medium Tip as sponge brushes. Photoshop also has a *Sponge* filter in the *Artistic* filters range, which can be customized to give various effects looking rather like the *Dry Brush* filter. For the main walkthrough I used Painter.

Here are some examples of dabs and strokes made by a Photoshop Wet Sponge Brush.

And here is an example of the dab and stroke made by one of the Sea Sponges.

Here are examples of the dabs made by the three Stencil Sponges: Dry, Twirl, and Wet.

1 Painter has an entire category of Sponge brushes, which you will find in the *Brush Selector*. The Sponges use whatever *Texture* (Paper) you have selected, so *Texture* can dominate each dab or stroke if you wish. Some of the sponges change the angle of dabs randomly as you apply them. The Wet Sponges also have their own characteristics and all of them apply their dabs as you make a stroke.

2 For this walkthrough I used **Clone Color** and a number of Painter Sponge brushes. I simplified and added color saturation to the starting photograph of a spring woodland, with **Topaz Simplify**, which does both jobs. So much green is always a challenge, so I held back the color saturation of the rear curtain of foliage to help the foreground come forward. Next I set the picture up for cloning and cleared the clone layer to leave a white layer above the source image.

➥ Clone Color see pp. 44–45 ➥ Topaz Simplify see pp. 34–35

3 For more vibrancy, on the active top layer, I used the *Rectangular Marquee Tool* to add an undercoat of three roughly complementary colors: a purple for the top green half of the picture; a turquoise blue to complement the orange flowers; and a muted sand color to work against the purple and blue flowers.

4 I set the paper to *Basic Paper* as there was enough going on in this painting and any additional noise might distract the eye. I selected the Loaded Wet Sponge, set at *Size* 78, *Opacity* 100%, and no value to *Pull* and *Jitter*. Here you can see the effect as I began to paint over the background colors.

5 I covered more of the painting with this brush, not worrying too much about the gaps between the brush dabs.

6 The picture area needed to be covered further, but I took care not to cover the entire canvas with the new paint. I used a Square Sponge at a *Size* of 52, an *Opacity* of 26%, and with the *Grain* (*Texture*) set to 35.

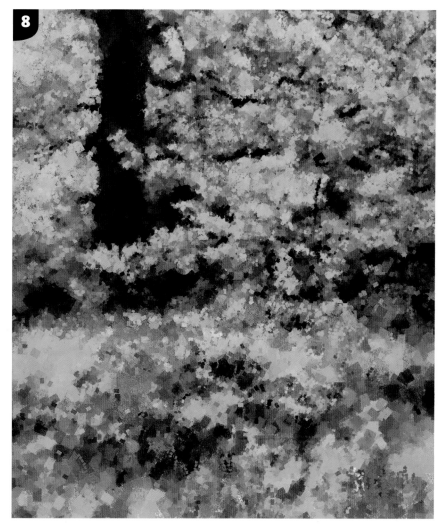

7 When this application was completed I moved on to a smaller version of this brush but at a higher *Opacity* (60%), and further refined the picture. You can see in this detail that there were still traces of the under colors showing through the Sponge dabs. I did not want to cover the whole area with the small brushstrokes and dabs; rather I wanted a variety of coverage to give the picture more energy and help to move the viewer's eye around the canvas.

8 I added some finishing small strokes using the Dense Sponge Brush, with *Size* set at 6.4 and full *Opacity*. I duplicated the final layer and added a little *Gel Composite Method* with some sharpening.

Simulated Medium
Oils

Simulated Support
Coarse Cotton Canvas

Application
Painter

○ CHECKLIST

Brush type	Size/Opacity
Soft Vine Charcoal 10	10/100%
Soft Diffused—Dig Watercolor	27.4/23%
Soft Diffused—Dig Watercolor	17/24%
Pointed Simple Water	8.8/13%
Soft Diffused—Diffusion 18	27.4/20%

It is unusual to be able to associate the genesis of a painting technique with a particular artist, but the entry of Stain Painting into the repertoire of fine art techniques is down to a single American artist: Helen Frankenthaler, and one particular work she painted in 1952, *Mountains and Sea*. Artists had used this technique before, but Frankenthaler is credited with adopting and developing it as a mainstream method. Stain Painting—or as she called it "soak-stain"—consists of applying diluted oil or acrylic directly on to an unprimed canvas so that the paint sinks into the weave of the fabric and is embedded in it, rather than onto its surface, giving it a stained look.

Frankenthaler and subsequent artists used implements such as coffee cans, hands, palette knives, and large brushes to dribble and loosely apply the dilute color. In the case of *Mountains and Sea*, the look Frankenthaler achieved was very much of transparent watercolor washes, and it has been suggested that this painting was influenced by the watercolors of Paul Cezanne. Frankenthaler was also said to have been influenced by Jackson Pollock.

You can use the Stain Painting technique any way you wish, but for this walkthrough, I created an abstract using a **Color Set** derived in Painter from a watercolor by Cezanne, *Château Noir devant la montagne Sainte-Victoire*, which has colors very similar to those in *Mountains and Sea*. I was not copying Frankenthaler's picture, rather creating something reminiscent of her style. For visual inspiration, I referenced some striking red oxide rock formations in Australia, but they were only a starting point; I did not intend to literally represent an actual scene. I kept the treatment light and airy, using different forms and linear marks to convey something of the iron oxide and undulating cliff faces, as well as the look of transparent watercolors (although simulating oils, and therefore on a canvas texture). I could have used Photoshop, but for this session I chose Painter and the brushes from the **Digital Watercolor** category.

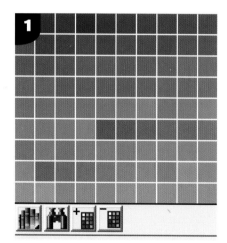

1 I began by creating a new document with a landscape orientation. I made my Color Set by opening the Cezanne reproduction, clicking on the small right hand arrow next to the title *Color Sets*, and then selecting *New Color Set* from *Image* in the drop down list. This produced a grid of color swatches. (If you have *Grid* selected in the drop down list, and you want to increase the size of the swatches, go to the drop down list again, select *Swatch Size*, and pick a different size.) I used the *Coarse Cotton Canvas* as support—Frankenthaler used Cotton Duck canvas—and colored the new document with some off-white. Then I duplicated the new color-filled layer in place.

2 It is crucial that the paint does not appear to sit on top of the canvas for this technique to be effective; it needs to appear to be actually in the fibers of the canvas. Normally, I would simply paint with grainy brushes or apply texture all over at the end of the painting process, but there are a couple of things to consider here. First, there are no brushes in the *Digital Watercolor* range that will apply grainy color in the prominent way required. Second, I would need to paint with the canvas apparent as I went. For this reason, I applied texture to the upper layer. The controls for the texture needed to be set carefully so that it would show through the paint clearly but harmoniously.

3 Size, brightness, and contrast of canvas can also be altered from the *Paper* palette. (Judge by eye whether the canvas texture will look to scale with the subject and style of your picture.) With the canvas texture applied to the upper layer, I changed *Composite Method* to *Multiply*, and the *Opacity* to 35%. If needs be, I could also make adjustments to the texture at the end of the process.

➤ **Color Set see pp. 70–71** ➤ **Digital Watercolor Brushes see pp. 28–29**

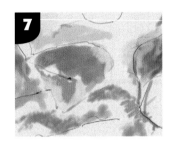

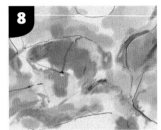

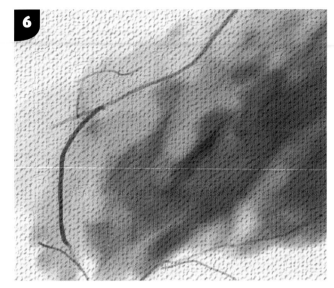

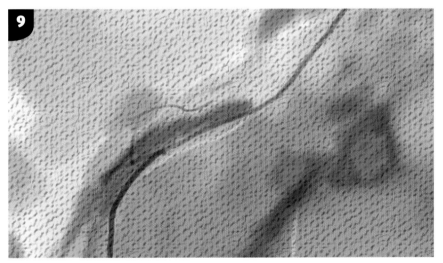

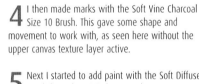

4 I then made marks with the Soft Vine Charcoal Size 10 Brush. This gave some shape and movement to work with, as seen here without the upper canvas texture layer active.

5 Next I started to add paint with the Soft Diffuse Brush from the *Digital Watercolor* category; I set its *Diffusion* to 18 and its *Wet Fringe* to 0. I brushed in the paint and began to work on the color and value relationships.

6 Here is a close up look at how the diffusion worked with the canvas texture to embed the color in the canvas.

7 I continued to add in more color using the Soft Diffuse Brush and the Pointed Simple Water at various sizes.

8 Here I added some more flat passages of color and more linear elements. I used the Diffuse Water Brush, still with *Diffusion* set to 18, to add some more of the fuzzy effects needed to convey the illusion of paint seeping into the canvas weave.

9 The appearance of the canvas texture top layer could be adjusted later, but it was useful to have it present at this stage to get some idea of the effect it was having.

10 With the exception of some accent colors, I stuck pretty closely to the original color palette. Getting the canvas texture and paint diffusion right were my main challenges. The only thing left to do was to finalize the texture. Here is the finished picture with a little *Sharpening* (1.77%).

Simulated Medium
Water Soluble Ink

Simulated Support
Rice Paper

Application
Photoshop, Painter

⊘ CHECKLIST

Brush type	Size/Opacity
Thin Bristle Sumi-e	20/38%
Thin Bristle Sumi-e	20/50%
Thick Blossom Sumi-e	8.8/40%

Sumi-e is a stylized form of brush painting with water-soluble black ink. It began in China and was later adopted in Japan, where its Japanese name emerged. The style of painting most associated with Sumi-e is of precisely and economically placed brushmarks applied to form high contrast black and white images with subtle shading, typically of bamboo, blossom, flowers, and other East-Asian landscape scenes.

Contemporary Sumi-e artists are extending the subject matter and style of their paintings, with greater tonal and color range. The common factor is the painting equipment itself. The brushes come to fine points and are made from many different types of hair, usually held in bamboo handles. The support is generally rice paper (actually made from bamboo pulp), because most watercolor papers are insufficiently absorbent. Traditionally conceived Sumi-e paintings use as few brushstrokes as possible and have a quiet elegance, but there are many pictures now made more spontaneously with Sumi-e equipment, in a more Western watercolor style, from light to dark, using background washes.

Photoshop does not have any Sumi-e brushes as such, but it does have a *Sumi-e* filter among its *Brush Strokes* filters. The filter adds darkened outlines and slanted, blurred edges with *Stroke Width*, *Stroke Pressure*, and *Contrast* being adjustable—probably best with black and white images. Painter has an entire *Sumi-e* category of brushes, which I used for this walkthrough, focusing on one aspect of traditional Sumi-e: the high contrast, black and white image. I used Painter's **Clone Color** function—which has no contour lines and no background washes—and intermediate tones sparingly so that the eye would concentrate on the black and white elements and fill in missing tones in the imagination.

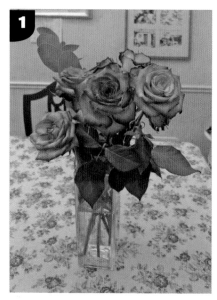

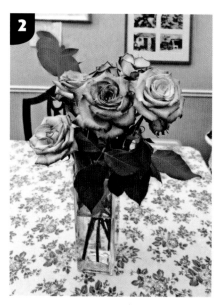

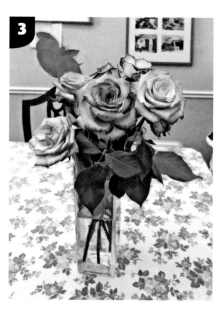

1 The starting photograph had a busier composition than might usually be seen in traditional Sumi-e paintings, but the various elements tied together well, providing a modern interpretation of a traditional theme.

2 I opened the photo and desaturated it in Photoshop. Next I needed to add some *Contrast*, but I did not want the already dark rose leaves to become black masses. So I increased *Contrast* less on them by duplicating the desaturated image and adding *Contrast* with a value of 18; then duplicating the original desaturated image again and adding *Contrast* with a value of 76; and then swapping the images around so the one with less *Contrast* was the top layer. Once that was done, I removed all of the details of the top image except for the rose flowers by selection and hand erasing, and then merged the images.

3 This was still a little stark for my Sumi-e treatment. To soften it, I opened it in **Topaz Simplify** and apply the *BuzSim* filter with a little of the *Detail* added back in the controls, to give it a gentler shading effect. I then opened the treated image in Painter.

➡ Clone Color see pp. 44–45 ➡ Topaz Simplify see pp. 34–35

4 Next I had to decide which brushes to use. The important point about Painter Sumi-e brushes is that their *Method (Brush Selector>Show Brush Creator>General>Dab>Stroke Type>Method)* is nearly always *Build-Up*. This means that as a stroke has other strokes applied on top of it, the tone rapidly goes to black, which is slightly unforgiving for the novice. You may want to consider changing the *Method* of Sumi-e brushes you use to *Cover* and increasing the *Opacity*. *Cover* is more forgiving of inexpert brush technique and will allow you to recoat ink without mid-tones immediately turning to black. For my painting I aimed to keep the same character of stroke but with just a little more room to maneuver.

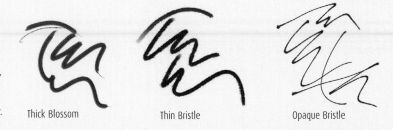

Thick Blossom Thin Bristle Opaque Bristle

One other thing to remember is that a number of the Sumi-e brushes are not useful for Clone Color painting because they simply play back the source image to you. You will want to select your own brushes to use, but the variants used for this painting were customized versions of the Thick Blossom Sumi-e, Thin Blossom Sumi-e, and the Opaque Bristle Sumi-e.

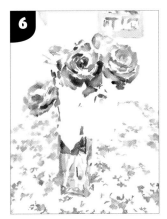

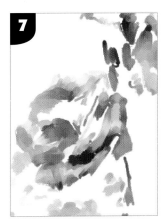

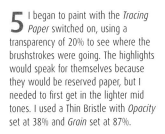

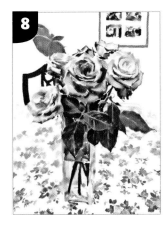

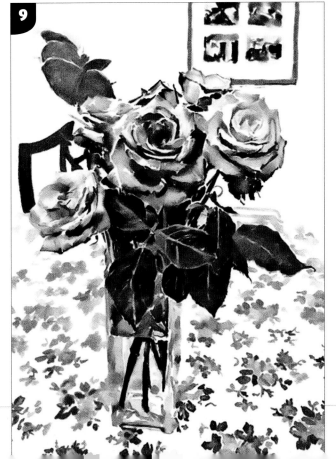

5 I began to paint with the *Tracing Paper* switched on, using a transparency of 20% to see where the brushstrokes were going. The highlights would speak for themselves because they would be reserved paper, but I needed to first get in the lighter mid tones. I used a Thin Bristle with *Opacity* set at 38% and *Grain* set at 87%.

6 Next, I duplicated that layer and moved on to the medium values, increasing *Opacity* to 50%.

7 The important thing here was to leave plenty of highlights.

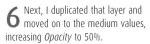

8 For the darker areas, I used the Thick Blossom Brush at an *Opacity* of 40% and a small size so as to keep its application neat. The picture needed softening so that it looked more liquid. To do this, I used the *Neat Image* noise reducer plug-in for Photoshop. (You can also use other noise reducers like *Blur* and *Median*.) I removed the bottom of the picture frame in the top left of the image and lightened the values of the chair and top right picture so they did not overwhelm the roses.

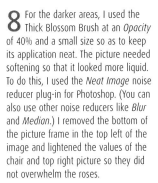

9 To give the paper a more absorbent look, I used the **Granulated Wash** paper I made earlier as a *Pattern Overlay* in *Soft Light Blend Mode* at an *Opacity* of 45%. I also gave the image a little more punch by duplicating it to a new layer and turning it into a Photocopy with *Blend Mode* set to *Multiply* and *Opacity* set to 44%, and then adding some more *Contrast*. You can make more elaborate adjustments to contrast using *Levels* and *Contrast* if you see fit.

⇒ Granulated Wash see pp. 72–73

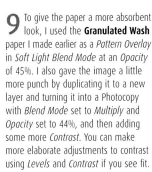

Simulated Medium
Oils

Simulated Support
Artists Canvas

Application
Photoshop, Painter

⊙ CHECKLIST

Brush type	Size/Opacity
Sargent + Grain 100%	10/100%
Sargent + Grain 100%	7/100%
Glazing Round—Oils	8.2/8%
Detail Blender 5—Bldrs	6.4/21%

Underpainting was originally a technique in which an image's values were painted first, usually in monochrome, before colors were added in glazes. The Underpainting color might be a burnt umber or gray, but could also be a warm or cool color that would show through the transparent glaze and add luminosity to the final color effect. Today, Underpainting takes many forms. It can be produced in oils and acrylics, be a detailed tonal study or simply a rough guide to the main forms and composition. It may show through the final picture as a combined effect of the under color and glazes, or be deliberately left to stand on its own in some areas. It may even be completely covered by subsequent layers of paint.

The use of Underpainting as a tool to sort out compositional issues is as relevant to freehand digital painting as it is to real world oils or acrylics, and there is ample scope for underlayers of color to be part of a finished digital painting. Particularly in Clone Color painting, different colored versions of the same image can be played into the painting process so the artist can see possibilities of color combinations as the work progresses. Whether painting freehand or with Clone Color, there are also other approaches to experiment with. The most direct is to either paint your Underpainting from scratch, or from a treated photograph that stands in for an Underpainting in the Clone Color method. For those with more stamina, you can make a Clone Color painting that approximates what you want in the finished piece and treat it as an Underpainting after developing its coloring and values. This was the process that I followed on the facing page.

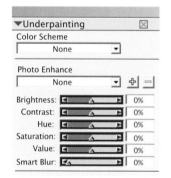

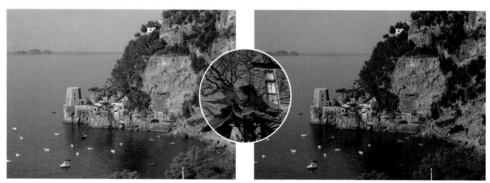

For automated help in Painter, Painter 10 offers the second iteration of its *Underpainting* feature, which now includes color borrowing in addition to other controls.

The Painter *Underpainting* feature allows you to prepare images for painting in a number of ways, with the color feature probably being the most interesting. This allows you to take the colors from one picture and apply them to another. The color changes are a little hit and miss, but once you have made the

transposition you can tweak the other *Underpainting* controls to refine them. Here you can see the color borrowing method at work. On the left, the target image to be changed, then the source image, and finally the resulting hybrid image, all controlled from the *Color Scheme* window.

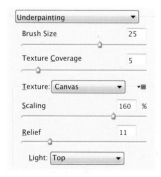

Photoshop has a filter devoted to Underpainting at *Filter>Artistic> Underpainting*.

The effect of the Photoshop *Underpainting* filter is to simplify by softening edges and add texture from a short list of texture options, or from one of your own. The idea is to make a

simplified version of an image in the style of an Underpainting. In the example here, I made a photograph of a bicycle sepia and then ran it through the Photoshop *Underpainting* filter.

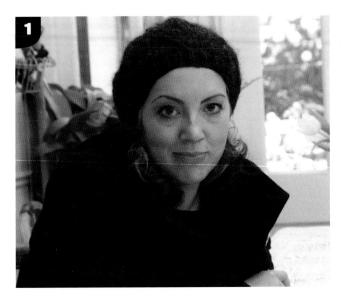

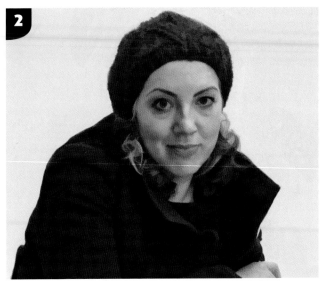

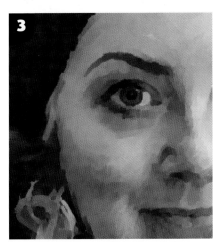

1 Here is one approach to producing an Underpainting and then a finished picture from using the technique. First, here is the starting photograph.

2 I prepared the photo for painting in Photoshop. I needed two versions—the first a simplified one made with **Topaz Simplify**, with which I could begin the **Clone Color** process, and another with no simplification, that would be used later for the glazing treatment. Here is the simplified image.

3 In Painter I used the Sargent Brush from the **Artists'** library with *Strength* and *Grain* set to 100%, so no color already in the image would be dragged along in a brushstroke, and only clone color would be applied. I wanted a fairly loose treatment.

4 Here is the painted image treated to act as an Underpainting using the *Adjust Colors* controls at *Effects>Tone Control>Adjust Colors*. The overall hue of grayish brown would be an effective support for the additional glazed color and fine detail added later.

5 Using a Glazing Round Brush from the *Oils* category, at an *Opacity* of 8%, and still in Clone Color Mode, I subtly added color to the hair and face and brought back detail. I wanted a delicate treatment that did not replicate the exact same amount of color as the original image. Finally, using the Round Blender Brush from the *Blenders* category (*Size* 15.6, *Opacity* 17), and following the forms of the subject, I gently blended rough areas to keep the look soft but not lose feature definition. Overall the picture was enhanced by the classical coloring used for the Underpainting.

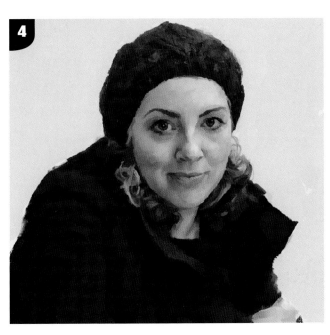

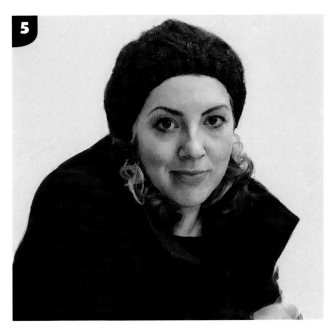

➤ **Topaz Simplify** see pp. 34–35 ➤ **Clone Color** see pp. 44–45 ➤ **Artists' Brushes** see pp. 20–21

Simulated Medium
Watercolor

Simulated Support
Cold Pressed Paper

Application
Painter, Photoshop

⊙ CHECKLIST

Brush type	Size/Opacity
Custom Watercolor (P)	78/18%
Custom Watercolor (P)	25.3/16%
Airbrush Soft Round (PS)	72/32%

Vignettes are pictures that, at their best, appear to emerge from the page. Rather than extend the whole way across a page, Vignettes fade into the background color at the edges. Usually they are centered, with the edges dissolving into an ellipse or some less regular shape. They are commonly associated with the faded, sepia-tinted portraits of early photography, but they can also be created successfully in natural media or digital painting. Vignettes very often present sentimental or decorative subjects and while they are generally pictures of people, they also work well with landscapes. That said, subjects do need to be strong enough to cope with being the center of attention in a blank canvas.

Vignettes can simply be pictures whose edges fade gradually to white, but using the off-white highlights in the picture—a portrait sitter's skin color, for example—as the page color will better create the illusion of the image growing out of the page. There are some marvelous examples of this style in the series of landscape etchings made after watercolors by J. M. W. Turner for Samuel Rogers's poem "Italy," published in 1830. These are of modest subjects—a tree, a stone bridge—but they seem to grow out of the page in quite an effective way.

1 Using this painted picture of a child as the source image, I created a simple portrait Vignette using an elliptical shape. To begin, I opened the picture in Photoshop, added a blank layer above the background, and filled it with white. I then duplicated the background layer and dragged it to the top of the stack.

2 For this treatment, I needed more clearance around the figure, so I added some width and height around the picture by resizing the canvas *(Image>Canvas Size)* adding two inches all around. I made sure to select the *Relative* option so that all sides were resized equally. I then painted or *Clone Stamped* over the white boundaries using the adjacent colors from the image. The objective was to give a little more room for the elliptical selection to clear the child's hat and knees. When I had finished this phase, I duplicated the layer and make an elliptical selection with the *Elliptical Marquee Tool* (found at the top left of the *Toolbox*), dragging the tool across the figure and over the area of the picture I wanted to keep.

3 I clicked on the *Add Layer Mask* button at the bottom left of the *Layers* palette. The little layer mask thumbnail appeared in the active layer and all of the painted area outside the ellipse was cut from the image.

4 Next I clicked on the *Layer Mask* icon in the active layer, and adjusted the radius of the blur *(Filter>Blur>Gaussian Blur)* to achieve the fade effect I wanted, using a radius of 21.4 in this instance.

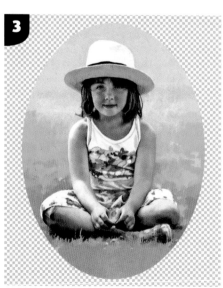

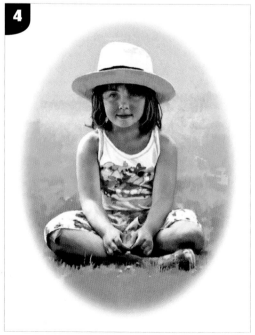

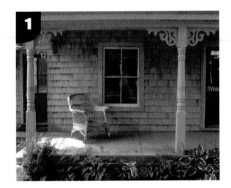

1 To create a Vignette of an exterior view, I needed to prepare the photo depicted here in Photoshop, paint it in **Clone Color Mode** in Painter, and then open it in Photoshop again to create my final image.

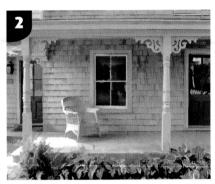

2 Although the lighting was interesting in its own way, I wanted to lighten the photo for my Vignette. I duplicated the background layer and, after increasing the lighting and simplifying the detail with **Topaz Simplify**, opened the picture in Painter.

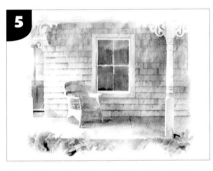

3 I set the picture up in Clone Color Mode, selected a light oat color from the image, and filled the blank clone layer with this color. I then selected a customized variant brush from the **Watercolor** library, built on a Watercolor Camel Hair Dab—you can see its *Water* page in the *Brush Creator* above.

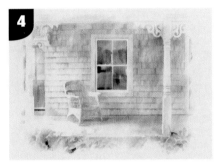

4 I used this brush at a very large *Size* (78) and low *Opacity* (18%) to get as even a wash effect as possible, making sure that the wash did not extend all the way to the edge of the paper and that a reasonable border was left so I could weave the picture into the background. After a little brushing, I finished the Painter phase and opened the picture back in Photoshop.

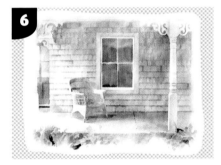

5 I added a little *Watercolor* filter *(Filter>Artistic> Watercolor)* to give the picture a little more mass, and lightened its values to make it more interesting.

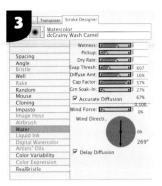

6 I cleaned up the edges where the painted image was ragged using an **Airbrush** Soft Round and painting lightly with the background color (the light oat). Then I created a *Layer Mask* as I did for the portrait Vignette.

7 As before, I added some *Gaussian Blur* to the edges and a new layer below the painted one, which I filled with the light oat color. Using the original background layer, I duplicated it and, with Topaz Simplify and the *Sketch_hardPencil* preset, created a light pencil sketch to add to the painted image. The addition of pencil lines to some of the contours, such as the porch chair, helped these boundaries read more clearly, and the drawn lines around the bottom foliage made the transition from background color to subject seem more natural. Finally, I flattened the layers, duplicated the new merged layer, and applied *Multiply Blend Mode* at a low *Opacity* to the top layer, adding more body to the picture.

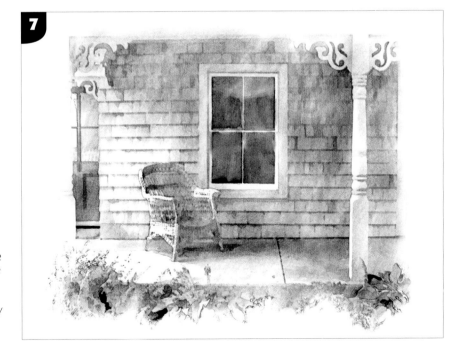

➺ **Clone Color Mode** see pp. 44–45 ➺ **Topaz Simplify** see pp. 34–35 ➺ **Watercolor Brushes** see pp. 28–29 ➺ **Airbrush** see pp. 114–115

Simulated Medium
Watercolor

Simulated Support
Cold Pressed Paper

Application
Photoshop

⊙ CHECKLIST

Brush type	Size/Opacity	
Custom Soft Round 45		
42/100%		
CSR45—Texture Depth 148%	23/100%	

Wet-in-Wet is primarily a watercolor technique, although it can also be used in acrylics and oils. It involves delivering paint to an area of existing paint that is still wet and, with the minimum of brushing, letting the two merge together, with the paint, and not the brush, doing the work. The merging of colors is a little unpredictable; lovely effects happen by accident, but there can be occasional disasters too. In real watercolor painting, you plan carefully, dampen the paper, and work fast to make Wet-in-Wet work for you, but these are not limitations in digital painting.

Any subject with shadows and **Soft Edges** is a good candidate for the Wet-in-Wet technique, but it is particularly good for physically soft looking subjects like skies, clouds, and flowers. However, you will rarely make a painting with only Wet-in-Wet paint application; that would mean few, if any, **Hard Edges** and little definition. It is normal to use some dry brushwork or painted and drawn lines to help the picture to read clearly. The considerations in using Hard and Soft Edges are very relevant to this technique.

You can make Wet-in-Wet simulations in both Painter and Photoshop. You can see how I created and used a Photoshop Wet-in-Wet brush on the facing page, but first, let's look at this method in Painter.

Diffuse Camel

Diffuse Grainy Camel

There are two good default brushes for Wet-in-Wet in the Painter **Watercolor** range: the Diffuse Camel and Diffuse Grainy Camel. There are other interesting *Watercolor* brushes that create different effects, but the Diffuse brushes come closest to making Wet-in-Wet-like stroke mixtures. You can also find Wet-in-Wet brushes in the *Extras> Brushes>Wet on We*t folder on the Painter X installation disk—the Simple Diffuse and Impressionistic brushes are worth a try. Note that all the *Water* and *Well* controls are important to controlling this technique, and quite small changes can have large effects on the brushstrokes.

Painter also has the **Digital Watercolor** brushes. These are simpler and more intuitive to use than *Watercolor* brushes but have consequential limitations. It is not as easy to produce a watercolor effect in which colors actually merge as they do in the *Watercolor* category. They can blur and soften, but there is no apparent mingling of pigment in the same way. However, once you understand the principles, reasonable Wet-in-Wet brushstrokes can be achieved.

Because you are creating an illusion of actual watercolor, it is helpful to see some of the grain (texture) that is so typical of real Wet-in-Wet. There are three key controls in the *Digital Watercolor* range: *Graininess*, *Diffusion*, and *Wet Fringe*. In Wet-in-Wet, you want plenty of *Diffusion*, little *Fringe*, and more *Graininess* to help the appearance of the technique. Less *Diffusion* makes for clearer *Fringing*, and less *Fringing* makes for more extreme color spreading (*Diffusion*). So if you want a paint application to look really wet, use lots of *Diffusion* (12+) and plenty of *Graininess*.

New Simple Water Brush used to make adjacent colors with no *Diffusion* but plenty of *Grain*.

New Simple Water Brush used to make adjacent colors with maximum *Diffusion* and no *Wet Fringe*.

One last thing to look at in Painter is the Wet-in-Wet technique in fully opaque media like oils. Wet-in-Wet painting in oils depends so much on the thickness of the paint and how much mixing medium—like turpentine—is used. Thick wet oil application is a quite different technique, in which inadvertently mixing the colors and ending up with a brown sludge is to be avoided. This form of Wet-in—or rather Wet-on—Wet (minus the sludge) is not difficult to simulate using **Artists' Oils**. For painting with runny, diluted oils, you can use *Blenders*.

New Simple Blender set for maximum *Diffusion* and *Grain*. This is not strictly Wet-in-Wet, but it is a good approximation of the technique. Remember that *Diffusion* will not happen over a selected area, so if you need a Hard Edge in an image, that's one way to get it.

Colors applied with the Wet Brush from the *Artists' Oils* category. To blend the two colors along the lower join, I used a Just Add Water Brush from the *Blenders* range. There are some *Blenders* among the *Artists' Oils* category, but the *Just Add Water* tools bring a delicacy to the mixing.

➤ **Hard and Soft Edges see pp. 64–65** ➤ **Watercolor Brushes see pp. 28–29** ➤ **Digital Watercolor Brushes see pp. 28–29** ➤ **Artists' Oils Brushes see pp. 24–25**

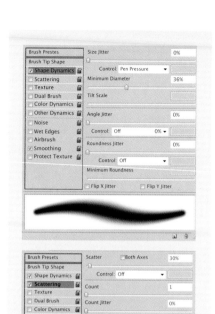

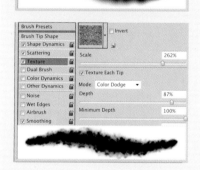

1 Once I had created my Photoshop brush, I opened the photo I wanted to work with and defined it as a pattern. The photo was then available from the fly out menu on the *Tool Options* bar when the *Pattern Stamp Tool* was active, and I could paint with the photo as its source. I had to keep my pen in contact with the tablet unless painting with *Flow* set to 100; if I didn't, subsequent brushstrokes would not merge into the old ones, but rather would sit on top of them, forming unwanted Hard Edges. I also made sure that the Impressionist option in the *Tool Options* bar was selected, otherwise the program would not tweak the brushstroke in the desired painterly fashion. I shuffled the brush around the image rather than sweeping it in brushstrokes so that the dabs hung together nicely.

2 For the next phase, I used another *Pattern Stamp* watercolor brush—the same as the one I had already made but with less texture—adding substance to the image.

3 Here you can see the same area from the finished picture.

4 You will see that the final picture is not all Wet-in-Wet. There are many passages with strong contour creation and Hard Edges outlining shapes, adding variety and making the final image easier to read.

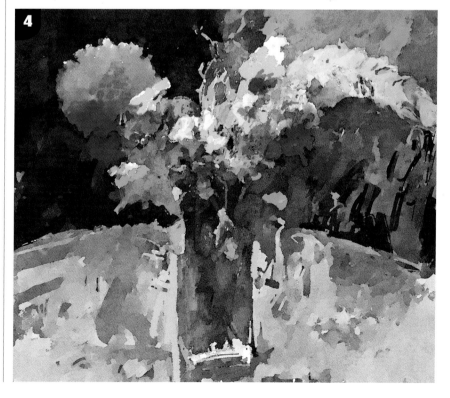

To demonstrate Wet-in-Wet in Photoshop, I needed to make a special brush. Photoshop only has a rudimentary armory of brushes useful for mixing wet paint with other wet paint, but it does have two good tools for creating Wet-in-Wet watercolor simulations: the **Pattern Stamp Tool** with a customized brush, and the *Healing Brush*.

To make a Wet-in-Wet brush to use with the *Pattern Stamp*, I started with a default one—a Soft Round 45 pixels. I selected *Shape Dynamics* and *Smoothing*, making sure the *Minimum Diameter* for the shape was more than 0. This is important if you are using *Pen Pressure*—a setting of around 36% is good. Next I added *Scattering*, and then *Texture*—I used the **Granulated Wash** texture made earlier and *Color Dodge* for the *Mode*. The *Mode* options make a big difference to the appearance of the brushstroke, they can give you marvelous rough paper textures as you paint. Lastly, I activated *Wet Edges*. It might take some time to create the right brush, but it is essential for good Wet-in-Wet simulation.

➥ **Pattern Stamp Tool see pp. 48–49** ➥ **Granulated Wash see pp. 72–73**

Other Digital Painting Techniques

This final chapter looks at some of the real-world fine art techniques that do not rely on the use of brushes. The aim of this book is to reproduce real-world techniques as straightforwardly as possible in digital painting, so while we are focusing on non-brushed techniques here, it is sometimes the case that these effects are most effectively achieved in digital painting through the use of brushes. While this may seem a little confusing, you will soon see what I mean. For example, one does not use a brush to Airbrush in the real world, but the most effective way to reproduce this result in digital painting is through the use of a digital brush with a spray effect. Similarly, Graffiti is described here because it is typically achieved with spray paint in the real world, but in digital painting the effect is reproduced with a brushed technique.

Some real world techniques involve both brushed and non-brushed approaches. For example, Chiaroscuro and Counterchange refer to more general techniques for using light in a particular way and can be achieved using a variety of approaches. Similarly, Masking can be achieved using brushed techniques, like with rubber for example, or non-brushed techniques, with tape or wax for example. Mezzotint also uses a mixture of brushed and non-brushed techniques, as it is primarily a printing process that can be carried out with a variety of tools.

As in some of the techniques described above, Montage is included in this chapter because it involves both brushed and non-brushed techniques. Similarly, Mixed Media is a general term for a technique that makes use of more than one media, and those media may or may not be mixed with the use of brushes. For example, marker pens and ink work, or ink and airbrush are examples of non-brushed Mixed Media combinations. Stippling is another general technique, which involves changing the density of dots to create shading effects in a form and can be achieved with any number of tools.

To complicate matters further, some real-world non-brushed techniques have a wider, brush-like application in the digital world. For example, real-world Smudging is generally limited to finger-painting, but in digital painting the Smudge Tool can be used as a brush as much as a tool, and actually has a specific "finger painting" setting reserved for the term's traditional application. In the same way, Painter's Palette Knife library has brush variants that may be used as brushes, while other brushes like Artists' Oils and Sargent can leave marks that look like palette knife smears.

As you can see by now, the digital tools described in this chapter are versatile and it pays to experiment with them. We all have tools and techniques that we are particularly fond of, and through experimentation, you will develop your own techniques and refine your own approach to achieving the exact result you are looking for.

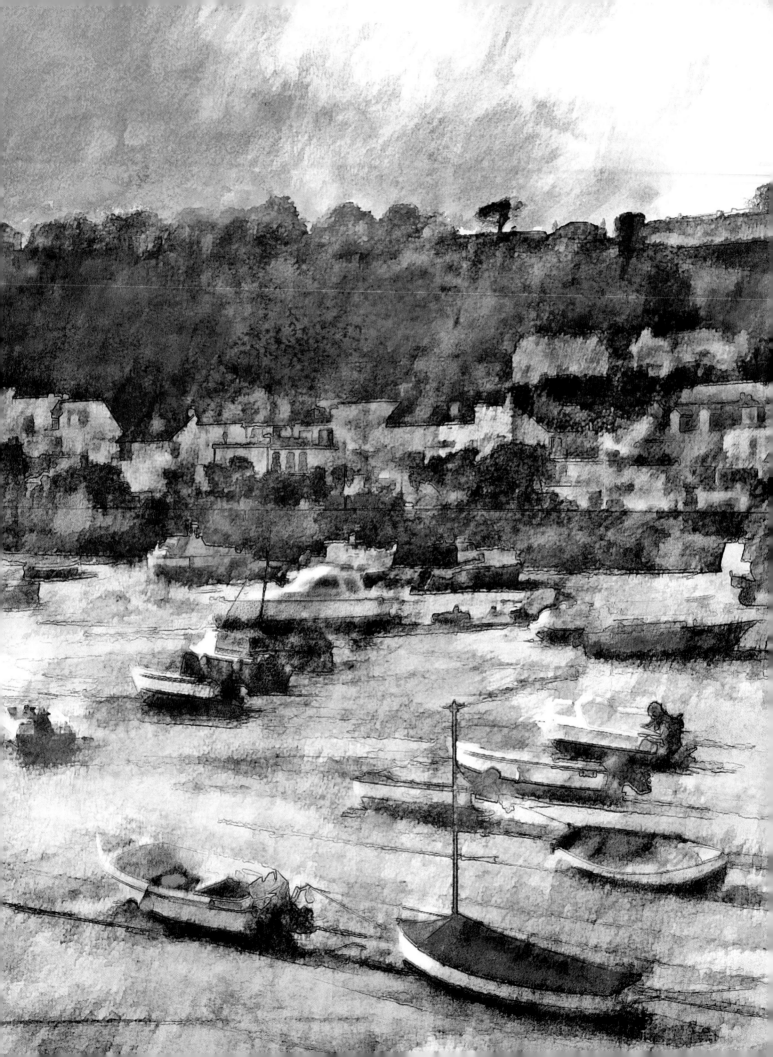

Simulated Medium
Airbrush

Simulated Support
Hot Pressed Paper

Application
Photoshop

⊘ CHECKLIST

Brush type	Size/Opacity
Oil Small Tip	8/48%
Airbrush Soft Round	100/100%
Airbrush Soft Round	100/23%
Airbrush Soft Round	13/26%
Airbrush Soft Round	35/56%
Spray	32/56%

While we may associate Airbrushing with its modern applications, the process has quite a history! The 30,000-year-old negative handprints in France's Chauvet cave are among the earliest recorded examples of air painting. These paintings were probably made by the artist using their hand as a stencil while blowing a mouthful of pigment onto the cave wall

Today, physical Airbrushing is done with a special tool that applies paint in a fine mist, propelled by compressed air. The technique is used in everything from car manufacture and decoration, to illustration and graphic design. We are probably most aware of Digital Airbrushing in the context of photo retouching or in science fiction and fantasy art, but its application is much broader than that.

Painter has a library of brushes dedicated to different Airbrush effects and Photoshop's comparatively smaller arsenal is vastly extended through brush customization. The thing to remember about Painter and Photoshop's Airbrushes is that they apply paint in a cone formation, and tilting them changes the way the paint appears on the canvas. Tilt the brush dramatically and you have an elliptical deposition of paint; hold it upright and it you get a circle of paint. When you add *Angle* into this, there are endless possible effects. If you add a **Wacom Intuos Airbrush** pen to the mix, there isn't anything you can achieve in real-world Airbrushing that can't be simulated in Photoshop and Painter.

Photoshop's many default Airbrushes can all be customized: Airbrush Hard Round, Airbrush Pen Opacity Flow, Airbrush Soft Round, Airbrush 75 Tilt Size and Angle, and Airbrush Dual Brush Soft Round. When you go into the *Brush* palette controls you will notice a number of options under *Shape Dynamics* and *Scattering*. If you have a Wacom Airbrush pen, *Stylus Wheel* is useful for controlling paint flow and stroke diameter. *Tilt* is important for determining the shape of the stroke as you paint. You will also notice a selectable *Airbrush* icon in the *Tool Options Bar*—this option is the same as the *Airbrush* setting in the *Brush* palette and subtly softens the edge of a brush. You can also make customized airbrushes in Photoshop that act like coarse spray brushes. The one on the right is made from the Airbrush Soft Round and gives a spray effect with added texture.

The Wacom Intuos Airbrush stylus makes it possible to adjust tilt angle, bearing, pressure, and ink flow. It has a fingerwheel that can be used to control brush size without affecting the paint's opacity. You can change the size of the brush with the fingerwheel, while making opacity changes with tip pressure.

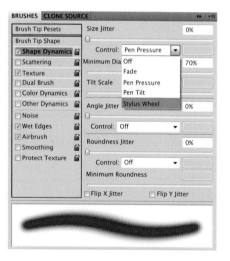

Painter has a whole library of Airbrushes, and all the variants are fully equipped to take advantage of the Wacom Intuos Airbrush. However, good Airbrush effects are also achievable with an ordinary pen tool. There are three dedicated **Dab** types: Airbrush, Pixel Airbrush, and Line Airbrush. These form the basis of all of the *Airbrush* variants in Painter. There is also a special *Airbrush* control, which allows you to independently change the spread and flow of the ink. There are also the usual *Expression* controls for these brushes, one of which you can see opened in the *Airbrush* window of the *Brush Creator* in the image above.

➥ Wacom Airbrush see Digital Pen Stylus pp. 14–15 ➥ Dab see Painter Brushes Basics pp. 18–19

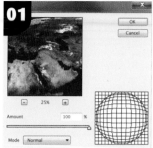

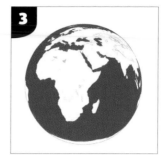

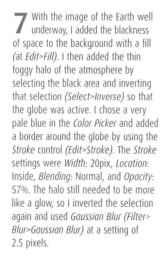

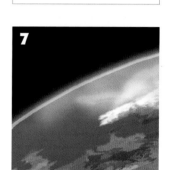

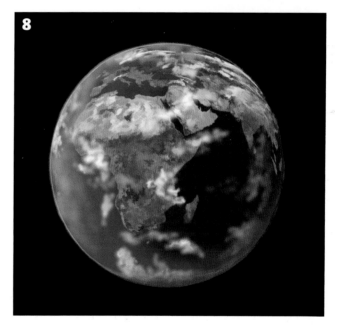

1 A ball shape with highlights and shadows requires the subtle gradations of tone so characteristic of Airbrushing and will be a good demonstration of the techniques involved. In this Photoshop demonstration, I used the *Selection* tools on this picture of the Earth. First, I took a flattened, projected map of the world and applied the *Spherize* filter *(Filter>Distort>Spherize)* to it at 100%.

2 Using the spherized image of the Earth as a guide, I made a freehand drawing, using an Oil Small Tip Size 8 Brush at an *Opacity* of 48%.

3 Next, I selected the ocean areas and Airbrushed in a deep blue starting color using the Airbrush Soft Round at a *Size* of 100 pixels and at 100% *Opacity*.

4 Here, I continued to Airbrush in the other colors in the picture, starting with the darker tones.

5 After blocking in the color for the continents, the picture needed some lighting to bring it to life. The sunlight falling on the globe came from the top left, so everything to the right of that point should be in shadow. First, I darkened the Indian Ocean using the same size Airbrush at a much lower *Opacity* of 23%. You can see that by just introducing this small area of darker blue, the Earth already looks more spherical.

6 Next, I added in some clouds, using the same Airbrush Soft Round at *Opacities* between 20% and 60%, and *Sizes* between 12 and 40. The Airbrush was essential to suggest the wispy cloud cover. Note that I also used *Spray* at 56%—with the *Airbrush* control active—to add brighter, more delineated clouds.

7 With the image of the Earth well underway, I added the blackness of space to the background with a fill (at *Edit>Fill*). I then added the thin foggy halo of the atmosphere by selecting the black area and inverting that selection *(Select>Inverse)* so that the globe was active. I chose a very pale blue in the *Color Picker* and added a border around the globe by using the *Stroke* control *(Edit>Stroke)*. The *Stroke* settings were *Width*: 20pix, *Location*: Inside, *Blending*: Normal, and *Opacity*: 57%. The halo still needed to be more like a glow, so I inverted the selection again and used *Gaussian Blur (Filter> Blur>Gaussian Blur)* at a setting of 2.5 pixels.

8 In order to strengthen the spherical effect of the Earth, I needed to enhance the highlights and shadow effects. I dimmed the light halo on the lower right-hand side. Then I intensified the middle blue arc in the lower right of the picture to create the impression of reflected light bouncing back onto the Earth. Lastly, I added some thin cloud on the top left of the picture to highlight where the sun strikes the Earth.

Simulated Medium
Oils, Watercolor

Simulated Support
Hot Pressed Paper

Application
Photoshop

○ CHECKLIST

Brush type	Size/Opacity
n/a	n/a

Chiaroscuro is a technique that uses dramatic lighting to enhance the 3D quality of forms in a picture. It was developed in the Renaissance period and has been used to great effect by artists like Caravaggio, Velasquez, Rembrandt, and Sargent. Primarily employed for portrait work, the technique uses high contrast lighting—often with an almost theatrical, spotlight effect—to make subjects stand out from their background and give them a sculptural presence. Today, the term is used to describe almost any dramatic lighting that has strong dark and light contrasts. Counterchange is a related technique and is often used to create the illusion of distance or visual recession by increasing contrast between different planes of a picture. The idea is to make the foreground stand out more than the middle ground and the middle ground more than the background. But it is also very useful for creating clarity and energy in a picture.

Chiaroscuro and Counterchange are close relations as they both rely on high tonal contrasts. But creating contrast is not only about tonal variation; it can also be achieved by color juxtapositions and by using **Hard and Soft Edges**. Any way you ultimately achieve the effect, Chiaroscuro and Counterchange are primarily about value oppositions.

Digital painting programs have one or two tricks up their sleeves that make creating high contrast effects much easier than real-world painting. These include the various value controls like *Curves*, *Levels*, and *Brightness/Contrast*, and combinations of *Blending Modes* (or *Composite Methods* in Painter). There are the photographic aids—the *Dodge* and *Burn* tools—that brighten and darken, and you can decide exactly where and how much value change you want to add using a brush. There are also the lighting effects—particularly spotlighting—that enable you to introduce the concentrated and directed lighting you find in many Chiaroscuro portraits. Photoshop has its lighting effects at *Filter>Render>Lighting*. Painter has its excellent lighting feature at *Effects>Surface Control>Apply Lighting*. The approach is similar but Painter is a little more intuitive.

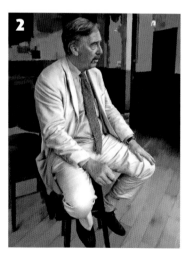

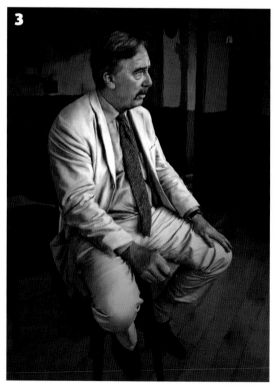

1 Here is the starting image.

2 In Photoshop, I simplified the photo using **Topaz Simplify**, then opened it in Painter and duplicated it using *Select All>Copy>Paste in Place*. I wanted an upper right corner light source, so I blocked in the background windows.

3 At *Effects>Surface Control>Apply Lighting* I chose the *Plain Light* source with settings

Brightness .47, *Distance* 1.41, *Elevation* 20 degrees, *Spread* 29 degrees, *Exposure* .89, and *Ambient* .89. I duplicated the image twice and darkened the new, upper layer image using the *Gel Composite Method*. I dropped the top layer (*Composite Method* to *Default*), and used the *Gentle Bleach Eraser* on the new top layer to lighten the man's face. This new high contrast image was ready for painting.

➥ Hard and Soft Edges see pp. 64–65 ➥ Topaz Simplify see pp. 34–35

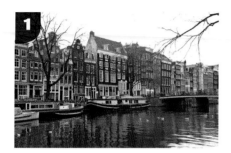

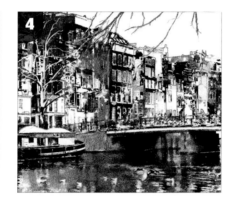

1 To illustrate the Counterchange technique, I used a photograph of a canal scene in Amsterdam. This was a good starting subject, but the detail of the image was indistinct and the picture rather flat.

2 I made a black and white drawing from the photo using Photoshop's **Pattern Stamp Tool** (with a Pencil Brush), and went for a high contrast approach with lots of additional white passages, complete with some line drawings for interest.

3 The eye is now led into and through the picture by the succession of white and black passages. This detail from the left hand foreground shows how Counterchange has been applied to the tree and buildings.

4 My aim here was to make the image more dynamic, not to reduce detail. In this close-up, you can see how the white strip along the bridge, with the parade of buildings beyond, force the eye around the picture. When the image is looked at as a whole, the high contrast treatment and the areas left undefined make for a stronger picture.

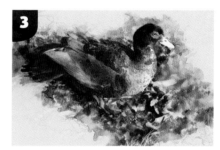

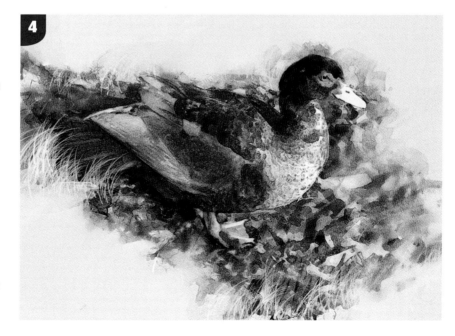

1 For this walkthrough, I used both Chiaroscuro and Counterchange to give the subject more impact and create interesting areas of value change. I used Photoshop's Pattern Stamp Tool as a brush.

2 The duck was camouflaged by leaves, so I created a new layer and filled it with a light sand color. Then, with a few pencil marks on the blank image to indicate some preliminary drawing, I created the *Pattern* from the original image and painted into a new blank layer, careful to leave a lot of white space around the subject.

3 I painted in some dark tail feathers to balance the composition, and lightened the area round the duck's head so that it stood out more.

4 Some Counterchange would help to give perspective and a sense of space. I painted some sunlit grass against the tail feathers and some foreground shadow. I also lightened the area around the duck's head more. Finally, I lightened the image in *Levels* to suggest the bright sunlight and added some warm filter at *Image>Adjustments>Photo Filter*.

➡ **Pattern Stamp Tool** see pp. 48–49

Simulated Medium
Oils

Simulated Support
Canvas

Application
Photoshop, Painter

❍ CHECKLIST

Brush type	Size/Opacity
Oil Small Tip	8/34%
Pattern—Soft Round—Wet Edges	61/84%
Pattern—Soft Round—Wet Edges	45/90%

Craquelure refers to the web of fine cracks that occur in old oil and tempera paintings. The web of cracks takes many forms, depending on the medium and the type of support used. Craquelure is a characteristic sign of aging and is a useful technique should you want to digitally simulate an old painting.

It would be a laborious job to create the detailed net of cracks by drawing them by hand. Fortunately, Painter has a wide range of papers that simulate networks of cracks, found in the additional libraries on the installation disk (not in the default library). The papers can be applied directly to the surface of a painting or made into a pattern and used elsewhere. Photoshop has a *Craquelure* filter at *Filter>Texture>Craquelure*, but there are more effective ways of achieving this effect.

For this technique I took an existing digital painting of Venice, Italy, aged it so it looked like the varnish had become dirty and brown, and added some Craquelure. I hardly used a brush at all.

1 Here is the digital painting I wanted to age.

2 I would be doing most of the work in Photoshop. I started by duplicating the picture twice and setting the *Blend Mode* of the top layer to *Multiply* with *Opacity* to 100%, making sure that the background (or bottom layer) was not active.

3 Next I began to brown the picture by adding some *Photo Filter* to the image's top layer at *Image> Adjustments>Photo Filter*, setting the *Color* to R:85, G:70, B:48, and increasing the *Density* to 70%. Then I merged the top two layers and duplicated the new top layer. I then added some more *Photo Filter*, this time using R:95, G:69, and B:31, with a *Density* of 83%.

4 I duplicated the top layer again and added another layer of *Photo Filter*, this time to warm up the brown tint. The *Filter* color was R:197, G:117, and B:5, with *Density* set to 90%. Next, I opened *Shadows/Highlights* at *Image> Adjustments>Shadows/ Highlights* and set the *Highlights* value to 31%, keeping the *Shadows* value at 0%. I reduced color saturation at *Image>Adjustments> Hue/Saturation* to -37. The aim of all this was to gradually increase the browning effect, while decreasing contrast and color saturation, to mimic the effects of dirt and aging.

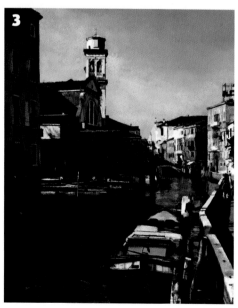

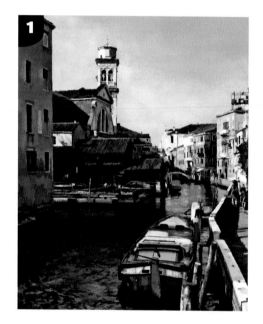

Creating the Craquelure effect

To create the Craquelure effect, I opened a new document in Painter with the same dimensions as the picture I was working on in Photoshop. Then, from the Painter installation disk, I loaded the paper I needed (Light Crackle) from the *Crack Textures* library. I loaded it by opening up the *Paper* palette (click on the *Paper* thumbnail in the *Tools* palette) and then opening up the flyout using the small top right arrow. I selected the *Paper Mover* option in the flyout list, clicked on *Open*, and browsed to the *Extras* folder on the *Additional Papers* on the installation disk. In the list of papers, I highlighted *Crack Textures>Papers* and clicked on *Open*. This loaded the papers from this library into the *Paper Mover* window.

I selected the Light Crackle paper there (highlighted in red in the image above) and dragged it into the left hand window of *Paper* in the open box.

Light Crackle was now loaded in the list of papers in the *Tools* palette. I needed to get this texture into an image, so I selected *Effects>Surface Control>Apply Surface Texture* and the window above appeared.

The Light Crackle texture can be seen close up above. I clicked *OK*, and the document was covered in this web-like crack texture.

5 After creating the Craquelure effect and applying it to my painting, I also wanted to make a web of white lines, so I inverted and saved the cracks image. Then, I needed to convert the Craquelure images into *Patterns* that could be used as overlays, so I went to **Edit>Define Pattern** and saved the documents as *Patterns*. Back on the main image document I clicked on the small icon below the layers that enabled me to "Create new Fill or Adjustment Layer." I okayed the *Pattern Fill* dialog box, and the new black lines pattern appeared at the top of the layers stack as a *Pattern Fill*. I set the *Blend Mode* of the new *Pattern Fill* layer to *Multiply* and its *Opacity* to 34%, leaving me with a Craquelure applied to the whole picture.

6 I did the same thing with the white cracks pattern but used an *Opacity* of 46% and the *Screen Blend Mode*. I wanted to warm up the image a little, so I added some more *Photo Filter*, this time using the *Warming Filter (LEA)* from the drop down list at a *Density* of 25%. I duplicated the color layer directly before the brown layers and moved it so it was just below the top layer. Then I reduced the *Opacity* of the top image layer to 70%. This brought back a hint of color into the picture, particularly some unsaturated blues, which enhanced the muted color effect of an old painting.

➥ Edit>Define Pattern see Photoshop's Pattern Stamp Tool pp. 48-49

Simulated Medium
Spray Paint

Simulated Support
Brick Wall

Application
Photoshop

❂ CHECKLIST

Brush type	Size/Opacity
Calligraphic Flat	15/100%
Customized Cal. Flat	15/100%
Calligraphic Flat	15/100%
Airbrush Soft Round	45/37%

There is nothing new about Graffiti. The art form may have experienced a recent surge of popularity, but Graffiti has been practiced in many parts of the world for thousands of years. Indeed there are surviving examples that date back to Ancient Greek times!

For the purposes of this book, the first thing to note is that Graffiti, in the context of art, is different from **Sgraffito**, which was covered in Chapter 2. Sgraffito is scratching through a layer of paint to reveal an under layer of color; Graffiti comprises stylized pictures or words (or both) applied to walls or other public structures and surfaces. The former is widely regarded as a fine art technique, the latter as vandalism. Graffiti has become more accepted as an art form in the last ten years, though it is still illegal to deface public buildings, no matter how expertly done!

In this section, I made a simulation of some Graffiti in Photoshop using an image of a wall and some text with a suitably subversive message.

1 It is important to apply Graffiti to a flat, textured surface. Without some surface texture to show through, the Graffiti text will look as though it is just pasted on. A brick wall works well. Photoshop does have a Brick texture at *Filter>Texture>Texturizer*, but this does not give the image of a brick wall, merely the texture of one, so it is best to use a photograph or a painting as your starting point. In the photograph I used, I retained a little of the pavement, some of the weeds, and a metal access cover in the wall to better give some scale to the picture.

2 To create the text, I made a new document in Photoshop—about 5" x 2.5" with a resolution of 300ppi. It was important to create a high-resolution text image; this would help to reduce any pixilated effects in the Graffiti drawing and could be scaled later to fit the final image. I used the brushes described below to make an angular, stylized text. This may take you some time, but that's fine—save the image often, or develop the work on different layers as the drawing progresses so you don't run the risk of spoiling your work.

3 To add color to the lettering and increase its coverage, I duplicated the layer in the layer stack, and selected the black lettering using the *Select>Color Range>Shadows* command. With black selected, I chose a mid green, and added a border to the text using the *Stroke* control with the following settings: *Width* 12px, *Location Outside*, *Blending Mode Normal*, and *Opacity* 100%.

For the Graffiti text, I used several brushes from Photoshop's *Calligraphic* brushes range to draw the text freehand.

Flat 10pix Brush from the *Calligraphic* brush range, used at full *Opacity* and at various sizes—shown here at 56pix.

Customized Flat 10 Brush. I changed the angle of the tip in the *Brush Tip Shape* control in the *Brushes* palette to make it flatter. Shown here at 56pix.

Flat 15pix Brush, which gives another more vertical brushstroke. Shown at 56pix.

Real Graffiti is generally made with spray paint, sometimes using stencils. To convey the look of spray paint, I would be using the *Gradient Tool*, adding some hand Airbrushing here and there. I duplicated my top layer and made the *Gradient Tool* active in the *Toolbox*. This would allow me to choose the type of *Gradient* style and color scheme. I picked a default orange-yellow-orange *Gradient* and selected the central focus button on the far right-hand side of the options shown here.

I wanted to use a red rather than an orange in the *Gradient* colors, so I opened up the color controls by double clicking on the *Gradient* color swatch in the *Toolbar*. I adjusted the outer colors of the *Gradient* by double clicking on the small arrows along the *Gradient* colors and changing them to the desired values.

➡ Sgraffito see pp. 96–97

5

6

7

8

9

10

5 Next I duplicated the top layer, selected the black lettering of the text again, and applied the *Gradient Tool* to it, positioning the yellow in the middle of the text. With the black text still selected, I sampled the yellow and (with an Airbrush Soft Round 45 at an *Opacity* of 37%) added in a little more yellow to the middle of the text.

6 To give the Graffiti more impact, I wanted to add a bright, light turquoise border around the text. I duplicated the top layer and selected the text's outer green border with the *Color Range Tool (Select>Color Range Tool)*, using its *Eye Dropper* to sample the green. Then I created a 7px stroke border around the green using the turquoise color.

7 Graffiti often has a drop shadow, so I duplicated the image and selected the white background using the *Color Range Tool*, then erased this at *Edit>Clear*. Now the Graffiti text was on a transparent layer. I right clicked on the layer in the layer stack and selected *Blending Options*. In the *Blending Options* window, I selected *Drop Shadow* from the left hand *Options* list, and set the *Blend Mode* to *Multiply*, *Opacity* to 100%, left the *Angle* at 30 degrees, set the *Distance* to 10px, the *Spread* to 0, the *Size* to 5pix and set the *Contour* to the top right one in the *Contour* drop down list.

8 I wanted to give the text more of a sprayed-paint quality. To achieve this, I duplicated the top layer, selected *Filter>Blur>Gaussian Blur*, and set the *Radius* to 1.4pix. Then at *Filter>Sharpen>Unsharp Mask*, I set the *Amount* to 62%, *Radius* to 250pix, and *Threshold* to 16 Levels. This darkened the image and gave it more impact.

9 It was time to bring the Graffiti and wall together. The photo of the wall was smaller and had a lower resolution, so the scales of the two images didn't match. I opened the photograph of the wall and copied it as a new top, duplicate layer. Then in the Graffiti image layer stack, I made sure the top layer was active and dragged it on to the wall image's top layer.

10 To resize the Graffiti image to fit the image of the wall, I selected *Edit>Transform>Scale* and dragged a diagonal handle until the Graffiti was reduced to the right size. I changed the *Blending Mode* for the Graffiti layer to *Overlay*; this allowed the brickwork to show through. I duplicated this top layer again, but this time with *Darken* as the *Blend Mode* and an *Opacity* of 85% to give the text a more solid look. I duplicated the wall layer and moved it to the top of the stack, changed its *Blend Mode* to *Soft Light*, and gave it an *Opacity* of 44%. This bedded down the Graffiti on the brick wall.

Simulated Medium
Acrylic

Simulated Support
Artists Canvas

Application
Photoshop

⊙ CHECKLIST

Brush type	Size/Opacity
n/a	n/a

The standard way to create **Hard Edges** in real-world painting is by using self-adhesive Masking Tape on a dry canvas or underpainting. It is very easy to make hard-edged geometrically-shaped lines using the selection tools in Photoshop and Painter. Using Photoshop for this walkthrough, I focused on the *Rectangular Marquee Tool*, to mimic the shape of Masking Tape. This tool is at the top left of the *Toolbox*.

The *Rectangular* and *Elliptical* tools both operate by dragging the cursor diagonally across the area you want to select. The *Elliptical Marquee Tool* enables you to make elliptical and circular selections by holding down the *Shift* key while dragging the tool to create your shape. The *Single Column* and *Single Row Marquee* tools make it easy to create straight lines. The *Rectangular Marquee Tool* lets you make rectangular and square shapes. If you need to make triangular selections, use the *Polygonal Lasso Tool*, which is just below the *Marquee Tools* in the *Toolbox*. Once this is active you just drag it from A to B in the document, then click once on the mouse at B, drag on to C and click at C, and so on. When you are back to your starting point, double clicking the mouse deactivates the tool, leaving the selection active.

All selections can be moved by clicking in the selected area and keeping the mouse button depressed as you drag the shape. Note that this only moves the selection shape, not the image inside the shape's boundaries. Material inside a selection can be moved in two ways: copy and paste a selection and then, having clicked the *Move Tool* in the *Toolbox*, and with your cursor in the new pasted area and mouse button depressed, drag the pasted copy selection to its new location; or make the selection, then click the *Move Tool* and drag the selected area without using copy/paste—this literally moves the selected area of the active layer, and as you drag away your selection, the layer below will show through.

Marquee Tools

Lasso Tools

Above are the *Marquee* controls. The four buttons on the left are important. Select the first and you make a new selection with whatever *Marquee Tool* you are using. Select the second and your new selection will be added to one already present in the document. The third button subtracts your new selection from one that's already there, and the fourth limits the new selection to the area covered by the previous selection.

The *Feather* control determines how soft the edge of the selection will be. If you need to blend a selection from one document into another, adding some *Feather* will help to make the addition seamless. Then there are three options under *Style: Normal* means the selection remains as you make it; *Fixed Ratio* gives the selection a specific size ratio, like 1:1 (square); and *Fixed Size* sets the exact dimensions you need for the selection.

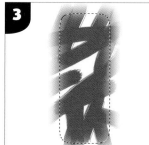

1 To demonstrate how the *Rectangular Marquee Tool* can replicate Masking Tape, I created a document in Photoshop and then made a rectangular selection in it. Then with a large brush and a color selected, I brushed over the selection. As you can see, the color was only applied within the selection.

2 If you invert the selection, the selected area becomes the whole document outside the original selected area. When I applied paint, it only appears on the paper outside of the rectangle. This is how Masking Tape operates in the real world and you can use it in the same way in digital painting, creating straight borders anywhere and switching between paint being applied inside and outside the selected area.

3 It is interesting to see the effect that *Feathering* has on Hard Edges. I made the same rectangular selection but this time set *Feathering* to 45 so the effect would be obvious. The value was so strong that it not only created a fade around the edges of the selection, it also rounded the corners of the selected area itself.

➡ **Hard Edges see pp. 64–65**

1 In this walkthrough in Photoshop, I made an abstract picture influenced by Paul Klee using the *Rectangular Marque Tool*, the *Stroke* command, the *Gradient Tool*, and the *Elliptical Tool*. First I created a new document, filled it with a light bluish-green and began to make rectangles with the selection tool. Each rectangle I made needed to have a thin black border, so I made these with the *Stroke* command. I set the *Stroke* to *Width* 2px, *Color Black, Location Outside, Blending Normal*, and *Opacity* 100%.

2 The *Stroke* command is only available when a selection is active, so immediately after making each rectangular selection, I had to activate the *Stroke* command. This effect produced the illusion of visual recession.

3 With the *Linear Gradient Tool* (from the *Tool Options Bar*) I selected a dark bluish green (R:76, G:130, B:114) as the foreground color and the existing light green as the background color. Then I dragged the cursor across each rectangle so that the outer side always appeared to be in shadow as you can see from this detail.

4 When I had finished laying in all the *Gradient* colors, the image looked like this.

5 The picture was nearly complete but it needed some focus, so I added a small black circle using the *Elliptical Marquee Tool*. I also needed to slightly build up the values and colors, which I did by duplicating the image and changing the *Blending Mode* of the top layer to *Multiply*, with an *Opacity* of 70%.

Simulated Medium
Watercolor

Simulated Support
Rough Paper

Application
Photoshop

◯ CHECKLIST

Brush type	Size/Opacity
Customized Wax Resist	35/100%
Customized Wax Resist	18/100%
Soft Round Wet Edges	40/84%

Wax and rubber can both be used for masking, as neither substance absorbs liquids. This means that they can be used to reserve white paper or areas of dry paint by preventing paint absorption in those areas. They are, however, deployed a little differently. Liquid rubber is used—particularly in water-color—to keep high value areas (such as clouds or sea spray) white and is scraped off the paper when the over-wash has dried. Wax is applied by a candle or a wax crayon, and when it is covered in paint, forms a broken texture because the paint is only absorbed between the wax strokes. So while both techniques involve Masking, wax is used more for its visual effect and rubber is used as a means to keep white paper white.

Between them, Painter and Photoshop completely provide for Masking. Painter has some resist brushes in the *Liquid Ink* library of brush variants, which can be used as erasers or to prevent paint absorption. You can see the effect in the image above, where I used a number of *Liquid Ink* ordinary variants and resist variants. There are no general purpose resist Painter brushes, however, and applying a *Watercolor* variant brush wash over a *Wax Crayon* variant has no effect.

Photoshop has some brushes that, with the right texture, give a nice paint over wax effect. These are not resist brushes, but with a little tweaking the effects of these default brushes are not unlike watercolor over wax. Above is a customized Heavy Smear Wax Crayon brushstroke.

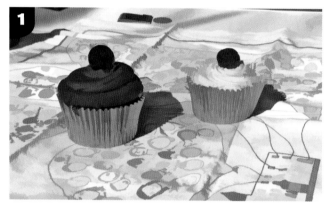

1 For this demonstration in Photoshop, I used the Masking with Rubber technique. After some preparation, which involved some simplification and the addition of contrast and color saturation, I arrived at this picture. I intended to restore a few details later, but this gave me a bright, crisp image to work from. I made it into a **Pattern** and created a new top layer filled with white. I then got to work with the Wax Resist Brush.

2 I set the texture to the **Granulated Wash** pattern made in Chapter 2 and the *Blend Mode* to *Multiply*. *Scattering* was at 190%, *Control* was off, and the *Count* was 2, with no *Jitter*. I used the Wax Brush on the areas surrounding the subject (not following the tablecloth lines), to create a broken texture effect.

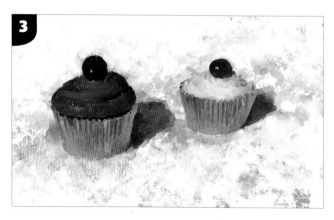

3 The wax resist look is, of course, only one element in this picture and the finished image includes detailed work on the small cakes themselves. But the broken texture effect helps to set off the strong shapes of the buns and adds contrast and interest to the overall composition.

➡ Pattern see Photoshop's Pattern Stamp Tool pp. 48-49 ➡ Granulated Wash see pp. 72-73

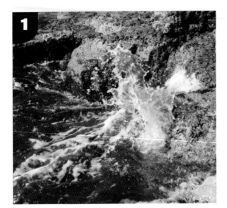

1 Masking with Rubber is easily simulated in both Painter and Photoshop. To reserve areas where no paint penetrates, you can either draw in selections around the areas to be reserved, or auto-select them using color as a criteria for selection. Once you have made your selection, simply invert it so that any paint you apply—in one or more layers— only sticks to the image outside the selection. In this Photoshop walkthrough, I mimicked rubber Masking, using this photo as a starting point.

2 I duplicated the image, simplified it in **Topaz Simplify**, and created another duplicate of the background layer, which became the new top layer. I then needed to select all the lightest spray areas in this top layer so that they wouldn't be affected by any washes. I used the *Color Range Selection Tool* and chose *Highlights*. Then I inverted the selection, added a new blank layer, and filled it with white. You will see that the selection I made is still visible on the blank layer. Using the Watercolor Brush—Heavy Medium Tip—for the *Pattern Tool*, I began to add in the background to the picture.

3 The selection allowed me to keep nice clean edges for the white spray while using quite a loose style of brushstroke for the picture.

4 Gradually, I added more paint to the picture, retaining the selection throughout. I then added some *Color Saturation*, a little *Texture*, and some *Sharpening* at *Effects>Focus>Sharpen*.

➡ **Topaz Simplify see pp. 34–35**

Simulated Medium
Print

Simulated Support
Paper

Application
Photoshop

● CHECKLIST

Brush type	Size/Opacity
n/a	n/a

Mezzotint is a printing process known for its deep blacks and its smooth tonal gradations. The technique was invented in Holland during the 17th Century but was most widely used in England, especially for portraits. The subtle tonal variations, the glowing quality of the values and characteristically smooth blacks, made this a popular process for transferring paintings into print.

The technique uses a copper plate that is first scored all over with a "rocker" tool to create a uniform, scored surface in a process called "grounding." The tiny holes made by the rocker holds ink well, and if no other treatment were applied to it, a grounded plate would print as solid black. The Mezzotint treatment therefore involves working from dark to light, and the lightest areas are made by scraping and polishing the raised burrs of the pitted plate to varying extents. For color images, an additional plate for each of the primary colors is necessary.

The nature of the technique—working from dark to light—results in images that have very dark backgrounds with carefully lit foregrounds and middle grounds. Indeed, the lighting is particularly important—often dramatic—and needs to be carefully considered in the planning of the picture. The overall effect is that the subject often appears to emerge out of a dark background, with contours marked by gradations of tone, making for a distinctively glowy look.

Making real Mezzotints is a demanding process, and many an artist has experienced untold frustration with the technique. Indeed, it provides the source for the expression "off your rocker" (meaning crazy), presumably because of the difficulty and tedium of treating the plates.

Here I show you how to achieve the effect of Mezzotint in Photoshop, a process that I hope will not drive you off your rocker! Remember, we are after the look of a Mezzotint, not a replication of the process. Mezzotints were very often created as reproductions of paintings, so I used a digital painting as a starting point, in this case a vase of flowers. Although Photoshop has a *Mezzotint* filter, I will run through an alternative method that offers a more subtle result.

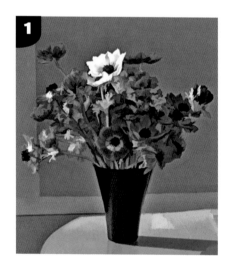

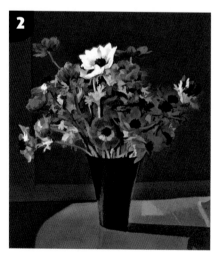

1 Here is the original painted picture. This became the background layer in Photoshop, which I then duplicated.

2 I selected background with the *Magic Wand Tool* and reduced the image's brightness by 81. I duplicated this layer twice so they became layers 3 and 4, then set the *Blend Mode* for the top layer to *Soft Light* and merged layers 3 and 4 using *Layer>Merge Visible*. (Make sure you only have the top two layers active before you do this.)

3 I duplicated the new (merged) top layer twice and named these Photocopy 1 and 2. The layer stack now looked like this.

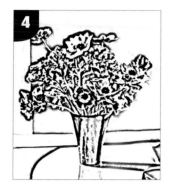

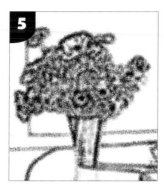

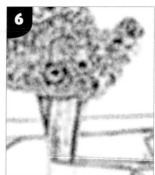

4 It was time to begin making the wide tonal gradations around the forms in the picture. I made sure the *Color Picker* had black set as its foreground color. Then on the Photocopy 1 layer I selected *Filter>Sketch>Photocopy* and changed the *Photocopy* settings to *Detail* 9 and *Darkness* 37. I cleaned up the table and the background so they were white.

5 I duplicated the *Photocopied* image and called it PC1 Spatter, then selected **Filter>Brush Strokes> Spatter** and changed the settings to *Spray Radius* 8, *Smoothness* 1.

6 I duplicated PC1 Spatter and blurred the image at *Filter>Blur> Gaussian* with a value of 2.8 pixels.

7 I changed the *Blend Mode* of the blurred image to *Multiply* and made sure there were no active layers between the blurred image and the image that resulted from the *Soft Light* blending, located immediately below Photocopy 1.

8 Next I went through an almost identical process for Photocopy 2, except I used a yellow foreground color instead of black. For the *Photocopy* filter the settings were *Detail* 5 and *Darkness* 11; for the *Spatter* filter the settings were *Spray Radius* 11 and *Smoothness* 1; and for the *Blur* the value was 1.3. I set the layer *Blend Mode* to *Multiply*. This warmed the image a little.

9 I needed some dark depth, so I duplicated the *Soft Light* blended layer and moved it to the top of the layer stack, then changed its *Blend Mode* to *Multiply*.

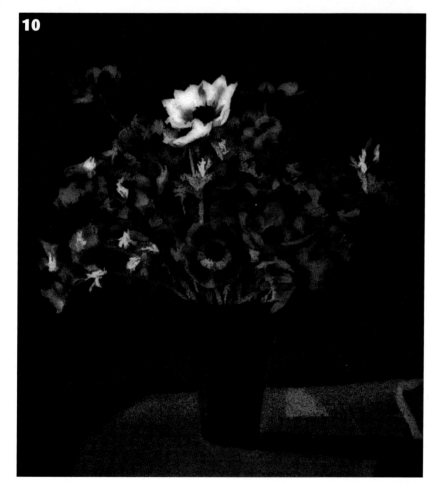

10 The image needed to be more saturated to suggest the effect of a plateful of color, with some grain applied. I copied the top layer and created a *Spatter* effect as before, but this time with *Spray Radius* set to 23 and *Smoothness* set to 1. I applied a heavily saturated red *Photo Filter* to the resulting image to make it more dramatic. Finally I set the *Blend Mode* to *Soft Light*, and *Opacity* to 91%.

➠ Filter>Brush Strokes>Spatter see Spattering pp. 98–99

Simulated Medium
Oil and Chalk

Simulated Support
Artists Canvas

Application
Painter, Photoshop

○ CHECKLIST

Brush type	Size/Opacity
Customized Sargent	16.9/62%
Customized Sargent	9/69%
Square Hard Pastel	10/100%
Square Hard Pastel	8/100%

Mixed Media are combinations of natural media on one surface, like watercolor, oil, or chalks being used together. In the real world, there are some combinations that cannot be used together, or can only be used together in some circumstances. There are so many workable combinations that it would be impossible to list them all here, and the only way to find ones that suit your purpose is to experiment. As a starting point, there are many familiar old favorites such as pencil or pen and watercolor, opaque white (gouache) and transparent watercolor, watercolor and acrylic, and charcoal and oil.

Almost any sort of media combination is possible in digital painting. The only things that will stand in your way are software limitations. In Painter, *Liquid Inks* and **Watercolors** both have their own wet layers and other forms of media cannot be painted or otherwise applied to a wet layer. But once a Watercolor is dried and saved in a single layer you can apply whatever digital media you want to the saved image.

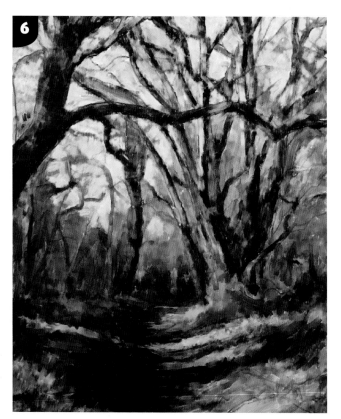

3 In Painter, I set the picture up for **Clone Coloring** and filled the blank *Clone* layer with a light blue—R:210, G:245, B:255. Next I chose the Tapered Artist Chalk variant from the *Chalk Brush* category, and set the color to a reddish dark brown. I set the paper to **Artists Canvas** and began to draw in the guide contours for the painting.

1 Mixed Media partnerships are possible in Photoshop and Painter, but I chose Painter for these two walkthroughs. In this first walkthrough, I started with this woodland scene.

2 I intended to develop the starting image with red chalk and oils, but it was too detailed to begin painting with. I simplified it using **Topaz Simplify** and then lightened it in Photoshop using *Levels*.

4 I began painting using the Wet Brush variant in the **Artists' Oils** library. The brush was set to a *Size* of 12.3, the *Opacity* was 59%, and the *Grain* was 10%. Here is a detail from an early stage in the process.

5 I painted in some detail using the Detail Oils Brush in the *Oils* library: *Size* 4.6, *Opacity* 89%, and *Grain* 82%.

6 Finally, I brought back some detail and reimposed the original chalk layer as the top layer with *Darken* as the *Composite Method*. I added some *Saturation* and *Contrast* in Photoshop.

⇒ Watercolors see pp.28–29 ⇒ Topaz Simplify see pp. 34–35 ⇒ Clone Color Mode see pp. 44–45 ⇒ Artists Canvas see Expressing Texture pp. 30–31 ⇒ Artists' Oils see pp. 24–25

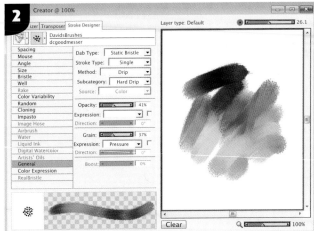

1 In this second Mixed Media combination in Painter, I created an abstract picture of a stream using a customized **Sargent Brush** and a Square Hard Pastel 25. I prepared the painting by bringing out some more detail, brightening it with *Shadows/Highlights* and adding some color saturation.

2 In Painter, I set the picture up for Clone Coloring, using a white fill for the blank clone image. I customized the Sargent Brush with a **Dab** type of *Static Bristle*, and a *Method* of *Drip*. The *Bristle* settings were: *Thickness* 49%, *Clumpiness* 0, *Hair Scale* 490%, and *Scale/Size* 24%.

3 Here is the picture after roughing in the paint with the Bristle Drip Brush at bristle thicknesses ranging from 49% to 79%.

4 I added in the detail gradually with the Square Hard Pastel variant brush from the *Pastel* library, with the *Grain* set to deliver obvious canvas texture (using the Artists Canvas paper). This detail shows the square cut marks of the Pastel brush.

5 I cropped the image to enhance the composition and added some color saturation. Using the Bristle Drip Brush I also added a little red to the foreground rocks and darkened the rocks at the end to help the visual recession. Lastly, I added some turquoise reflections in the left hand water area to better link the left and right parts of the picture.

➻ **Sargent Brush** see Artists' Brushes pp. 20–21 ➻ **Dab** see Painter Brushes Basics pp. 18–19

Simulated Medium
Oils

Simulated Support
Board

Application
Photoshop

✪ CHECKLIST

Brush type	Size/Opacity
Oil Small Tip	21/84%
Oil Small Tip	12/84%
Hard Round	9/43%

A Montage is an assemblage of images within a frame, with the images usually contributing to a theme or organized around a dominant or central starting image. Montages differ from collages in two important ways. In Montage the embedding of images in the overall picture is generally smoothly handled with none of the rough edges typical of collage. Also, the images in Montage are usually sourced from a single medium. So for example, a photomontage is—unsurprisingly—made up of photos, whereas a collage might be made from magazine and newspaper cuttings as well as photographs or paint.

Creating a painted Montage using original digital paintings is the same as with real media: there are no special considerations. But painting one using photographs requires a composition plan. You need to have some idea of how the final image will look, and how the individual components will contribute to the whole. A Montage can be about any subject you like, but in this case, it was constructed from photographs of separate views from a small garden. I was not trying to create an accurate view of the garden as a whole, nor give the picture an entirely realistic feel. What I wanted to create was an entirely new composite image of a garden, with the obvious feel of a Montage. For this walkthrough I used Photoshop.

My photos were taken with a compact 24-70mm camera; the 24mm wide view gives an attractively odd view of the world. Before preparing your photos—see step-by-steps—create a new blank document in Photoshop; mine was 13" x 10", resolution 300ppi. This was the frame and background. I saved each photograph at a size of approximately 8" x 5", resolution 150ppi. This left plenty of scope for playing around with the images in the frame.

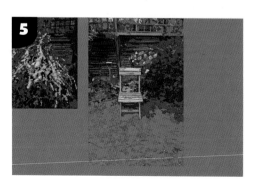

1 First I chose half a dozen or so pictures of the garden to use in my Montage. It's a good idea to create a new folder so you can keep track of your photographs.

2 It is also sensible to make a standard processing workflow for each photo. In this case, this meant using the standard auto tone, color, and contrast controls in Photoshop, and adding some filters.

3 I needed to give the pictures a little more punch, so I applied the *Cut Out* filter at *Filter>Artistic>Cut Out* using the following settings: *Number of Levels* 8, *Edge Simplicity* 4, and *Edge Fidelity* 3.

4 Then I applied the *Poster Edges* filter at *Filter>Artistic>Poster Edges*, using the following settings: *Edge Thickness* 2, *Edge Intensity* 1, and *Posterization* 2. Then I added more *Color Saturation*: +30.

5 It is best to treat all your images first, so you can concentrate on their placement in the Montage. Before I started moving the images into the frame, I sampled a grass green from one of the photographs and created a new layer filled with this color. This would be a sympathetic background and could stand in for grass while I arranged the images.

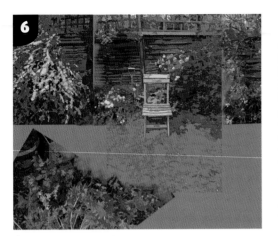

6 I wasn't too worried about scale here; the only rough rule was that flowers and other objects in the foreground should be larger than those in the background. But if I needed more pink, I simply enlarged the image with the pink flowers, or a selection from it. Getting the composition right is the most important thing at this point. Remember, there is a lot of trial and error in placing the photographs—and that's part of the fun.

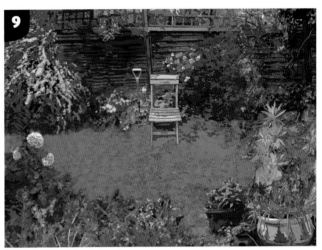

	Layer 18
	Layer 7
👁	Layer 8
	Layer 4
👁	Layer 14
👁	**Layer 15**
👁	Layer 3
👁	Layer 22
👁	Background copy
👁	*Background*

7 I blended the images together here and there, either by dropping *Opacity* in overlapping areas or adding painted color. You could use layer masks for *Opacity* changes, but this picture would have at least fifteen layers by the time I finished, so it was simpler to work directly on to the images. You can always import a copy of the starting image again if necessary.

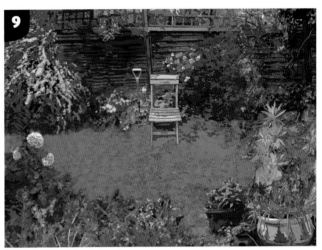

8 I filled in the remaining space in the Montage with more pictures.

9 There were a lot of minor tweaks required to ensure that the images did not sit too awkwardly together. In addition to *Blending Edges* by changing the *Opacity* of images where they overlap and adding paint to smooth joins, you will find the *Clone Stamp* and *Healing Brush* tools very useful for joining elements together and bringing in textures from one part of the picture to another.

10 I added a little BuzSim filter from the **Topaz Simplifier** to the final image and some final compositional tweaks, such as added shadows at the bottom of the chair and a clear path for the viewer to be led into the picture at the bottom right of the image.

➤ Topaz Simplifier see pp. 34–35

Simulated Medium
Oils

Simulated Support
Artists Canvas

Application
Painter, Photoshop

● CHECKLIST

Brush type	Size/Opacity
Loaded Palette Knife	58/100%
Loaded Palette Knife	15/100%

The Palette Knife was originally used for mixing oil paint pigments on a palette and for cleaning up un-wanted material, but it is now regarded as a primary tool for applying paint to a support. You can use a Palette Knife for painting in various ways—applying new paint over dry or wet paint in a butter-spreading motion, dabbing paint on, or dragging the knife across existing wet paint to create marbling effects. It almost always produces a thick texture and even large flat areas usually have visible texture at the edges.

It is possible to create Palette Knife brush effects in Photoshop—indeed there is a *Palette Knife* filter at *Filter>Artistic>Palette Knife*. But I have concentrated on Painter's Palette Knife Brush variants because they are readily available and designed for the job. As always, it's best to experiment with the tools to find out what they can and cannot do.

There are two things to remember about Painter's Palette Knives. First, only the Loaded Palette Knife variant adds new paint to the picture. All the other variants use existing paint on the support and push it around in various ways: smearing, softening, smudging, or marbling. The brushes may appear to deliver color in Clone Color Mode, but all they are doing is tweaking the existing source image as it is applied to the canvas. You must use the Loaded Palette Knife if you want to make a picture without a clone source.

Second, the *Value* setting at *Show Brush Creator>Color Variability>HSV* is important because it determines how stripey the Palette Knife strokes will be, and so affects how smoothly detail can be captured. As seen right, a low *Value* setting gives very little striping, while a high setting gives considerable striping. In this walkthrough I mainly used the Loaded Palette Knife at a middle *Value* setting, because I wanted it—and the Subtle Palette Knife toward the end—to provide a little subtle blending. To avoid an uncharacteristic Palette Knife look, I did not make the painting in Clone Color Mode.

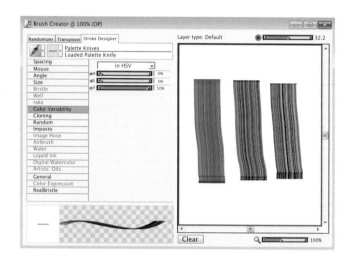

Palette Knife

Subtle Palette Knife

Here are some examples of the Palette Knife, Subtle Palette Knife, and Smeary Palette Knife used in non-Clone Color Mode, picking up existing color but adding none of their own.

Smeary Palette Knife

1 First I set up the prepared photograph in **Clone Color Mode** so that I could use the *Tracing Paper* feature to help me get the Palette Knife strokes in the right place. But I would not be using Clone Coloring itself; instead I would sample colors from the original photo as I went along.

➡ Clone Color Mode see pp. 44–45

3 I was ready to being painting back in Painter. I used the Loaded Palette Knife variant at a *Size* of 58 and an *Opacity* of 100%. Remember—using a Palette Knife at significantly reduced *Opacity* is not going to be very realistic, as paint is usually applied very thickly with a Palette Knife. I did not need to use the *Imposto* effect, but I did use a *Value* setting at the start that provided some striping in each stroke.

4 I continued to build the picture, making no effort to disguise the Palette Knife's rough treatment.

5 Here is the picture as I painted in the land and developed the sky and clouds further.

6 At this point I used a smaller sized Loaded Palette Knife Brush and started bringing in some finer detail, using a Subtle Palette Knife at *Size* 15 and full *Opacity*.

2 I prepared the photograph for painting in Photoshop, treating it with the auto settings for *Tone, Contrast,* and *Color,* then applying some *Shadows/Highlights*. To enhance the color, I took it through the **Tone Mapping** process for a single image in **Dynamic Photo HDR**, and cropped it to improve the composition.

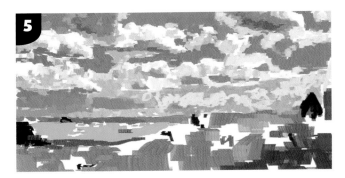

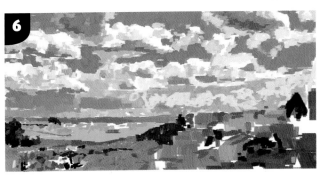

7 Here is the final image, which is a mix of Impressionistic detail and broad brushstrokes. It's a good idea to try not to fiddle too much with a Palette Knife painting, continually refining detail; you want enough detail for the picture to read effectively but you don't want to overwork the image and lose the bold Palette Knife marks in the paint.

➥Tone Mapping/Dynamic Photo HDR see Higher Dynamic Range Photographs pp. 36–37

Simulated Medium
Oils

Simulated Support
Canvas

Application
Painter

○ CHECKLIST

Brush type	Size/Opacity
Customized Smudge—Blenders	44.4/38%
Customized Smudge—Blenders	23/38%

In everyday life, Smudging usually means accidentally smearing paint in a picture, or ink in writing, and losing focus or detail as a result. But in fine art, Smudging is a recognized technique, often called "finger painting." As its name suggests, Smudging literally involves the application of paint by hand. It is a primitive way to make paintings but because of its tactile nature, it can be very satisfying. The technique is obviously not suitable for fine detailed work but good for more Impressionist or Expressionist styles.

In digital painting, Smudging has several uses and meanings, particularly in relation to Clone Color or on-photograph painting. There are at least four ways it can be used: as a blender to smooth edges between paint passages; as a way of making a clone image more natural before detail is brought back to create focus and interest; to make images more painterly by reducing detail in them without obliterating the image; or as a means of making highly smoothed versions of photographed subjects.

All of these techniques can be achieved in Painter and Photoshop. Painter has such a large library of *Blender* brush variants that it is difficult to speak generally about them. Most of the *Blender* brushes start their brushstrokes with the foreground selected color when in Clone Color Mode, provided that the *Grain* setting (where there is one) is sufficiently high. But there are other variants like the Diffuse Blur, Oily Blender, and the (mischievously titled) Grainy Blenders that don't have this effect. And there are brushes—like the Details Blender—that don't have a *Graininess* setting at all and yet still apply the foreground color at the start of their stroke. Though it can be confusing, if ever there was a category of brush variants with which you should experiment, this is it.

Above are some of the Painter *Blender* brushes working on previously applied paint, not in Clone Color Mode. From the top: Diffuse Blur, Just Add Water, and Smear.

Here is an example of a *Blender*—the Soft Blender Stump—used at an *Opacity* of 40% to blur edges.

1 Messing up an image before you clone it may seem like an odd thing to do, but it can be very helpful in producing looser Clone Color pictures, because there is less temptation to be guided entirely by the original photograph. The two simple steps here are an example of this technique, starting with a detailed picture of a flower-bed.

2 Here is the same photo treated with the Painter Coarse Oily Blender 30, with a *Size* of 30 and *Opacity* of 43%. This provides an interesting starting point for painting.

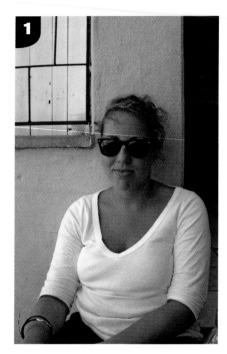

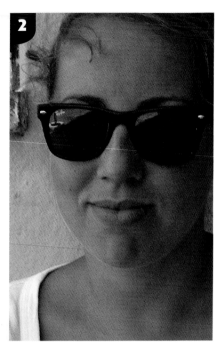

1 Here is an example of a photograph that has been simplified with a Blender to bring out the planes of the form rather than the contours. The painting is not completed, but it has been taken far enough that you can see the effect of simplifying the forms. Here is the starting photograph.

2 I would be using the Smudge Brush variant to smooth out the forms. In Painter I set the image up in **Clone Color Mode**, but I did not clear the clone version. I would be working directly onto the picture, so I did not need to limit the clone version's *Opacity*. It is very important to use a large brush, and the least number of brushstrokes necessary to cover the photo. You do not want the picture to look pecked-at. I set

the Smudge Brush to use a *Static Bristle* **Dab** type in the *Brush Creator*, and then set the variant's *Size* to 45, *Opacity* to 38%, and *Grain* to 100%.

3 As you can see from this close up of the subject's face, I blocked in the paint by following the form with the brushstrokes, only reducing the brush size to get into tight angles.

4 And finally, the Smudged picture, cropped to make a more interesting composition.

➤ **Clone Color Mode see pp. 44–45** ➤ **Dab see Painter Brushes Basics pp. 18–19**

Simulated Medium
2B Pencil and Ink

Simulated Support
Paper

Application
Photoshop

❖ CHECKLIST

Brush type	Size/Opacity
Cutstomized Hard Round	3/100%
Created Stipple Brush	162/100%

Stippling is related to—but not the same as—**Pointilism**. The difference is that Pointilism blends color optically in the viewer's eye, where Stippling conveys color or tone—often tone alone—by varying the density of identically sized dots. Historically, Stippling is associated with making black and white prints and pen and ink drawings, but today its principle—variable dot density—is also used by inkjet printers.

You can simulate Stippling by changing the tonal value of the dots rather than their density. Here, I demonstrate how to make a black and white Stippled version of a photograph using a single Photoshop brush, and then outline a color version using a specially-created Stipple Brush. There are default Stipple brushes in Photoshop, but these will not give the tone control required to produce this effect successfully. For the first approach, I will be making a Stippled pencil version of a vintage Rolls Royce drawing.

To make the Photoshop brush I would be using, I opened the *Brush* palette and selected the second brush—a Hard Round 3 Pixels. Then in the *Brush Controls*, I deselected *Shape Dynamics*, and selected *Scattering* with a *Scatter* of 31% and a *Count* of 2. This gave a painterly, smudged **Dab**. If you want a clean one, deselect *Scattering*. I would be using my black and white photo layer as a source image for my Stipple. The idea was to start with the darkest values and gradually work toward the lightest, using four tone values.

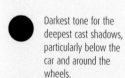 Darkest tone for the deepest cast shadows, particularly below the car and around the wheels.

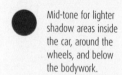 Mid-tone for lighter shadow areas inside the car, around the wheels, and below the bodywork.

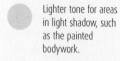 Lighter tone for areas in light shadow, such as the painted bodywork.

Lightest tone for areas in sunlight or other highlights, such as the reflective headlamps.

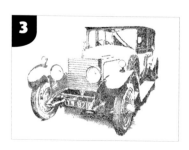

1 The source photo was approximately 11" x 8" at a resolution of 150ppi. The background had been simplified, but as I would not be using the background, this was not essential. I opened the photo in Photoshop and, in the *Layers* palette, created a new layer and filled it with white.

2 By reducing the *Opacity* of the blank white layer to around 23%, the photo underneath remained visible, and I began to dab dots of the darkest tone on the screen, following the forms of the photo. There is quite an art to judging relative values in a picture. If you make a mistake and make an area too light or too dark, you can easily correct it by painting it out with white, and re-applying your dabs. Keep flipping between having the top layer transparent and at full *Opacity* to check values and placements.

3 These handmade Stippled pictures take time. So it is important to enjoy the process for its own sake, as much as for the prospect of the finished picture. At this stage, I was well into the application of my second darkest value. The overall image was still very high contrast.

➛ Pointilism see pp. 90–91 ➛ Dab see Painter Brushes Basics pp. 18–19

4 In making this picture, I was not trying to create an exact representation of the source photo. Instead, I was making an impression of it, and limiting myself to four values helped to simplify the image. Here I had completed the third value: the car's painted bodywork and the windshield were now treated.

5 Here is a close up of the windshield and side windows, which shows the dabbed dots of value. No need to worry if all the dots are not perfectly placed and applied. A small random element—human jitter, if you like—makes the picture more lively.

6 With the application of the lightest tone and a few final touches (such as correcting the values of the license plate) the picture was complete. If you want a higher contrast image you can add *Contrast* or duplicate the top layer and set its *Blend Mode* to *Multiply* or *Soft Light*, with whatever *Opacity* you require. But be careful not to lose all of the subtlety of the intermediate values.

If you want a faster technique than this dot-by-dot approach, but don't want to use any filters, you can create a custom brush that covers large areas of the picture in a single dab. A custom brush can deliver color either in *Clone Tool Mode* or as a *Pattern Tool Brush*. This technique is closer to using a *Stamp Tool* than a brush, with each *Stamp* impression placed carefully next to its neighbor.

The first step is to make the brush. Select a Hard Round Brush at a *Size* of 5 pixels, with *Opacity* and *Flow* at 100, and with *Impressionist* turned off in the *Tool Options Bar*. Next, create a new document at 4" x 4", at 100ppi resolution. Then select a square of "2 x 2" on the new document and start dabbing on dots with the color black, making sure the dots are tightly packed and evenly spaced. When you have finished, save the brush as "Big Stipple."

Once you have created your brush, choose a picture for Stippling—I have chosen a digital oil painting of a vase. Create a new layer in your layer stack and fill it with a light gray-brown to help your dabbed dots read more clearly.

With the starting picture selected and visible, select the *Clone Stamp Tool* from the *Toolbox*, and choose your new "Big Stipple" brush from the *Brush* palette to act as your *Clone Tool*. Carefully place the brush in the top left hand corner of the picture, and with the *Alt* key held down, click on your mouse or pen tool to load that corner area into the *Clone Tool*. Reselect the light brown layer and place the *Clone Stamp Tool* in exactly the same place. When you click the mouse, the cloned area will

appear on the brown layer. As you move along the image, carefully butting up the edge of the *Clone Tool* to the previous cloned square, the next area of cloned image will appear. Carry on with the *Clone Tool* until the whole picture has been cloned.

Starting Brushes

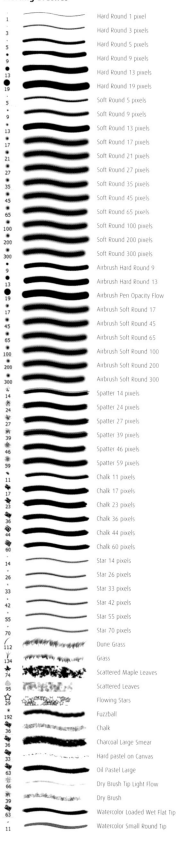

1	Hard Round 1 pixel
3	Hard Round 3 pixels
5	Hard Round 5 pixels
9	Hard Round 9 pixels
13	Hard Round 13 pixels
19	Hard Round 19 pixels
5	Soft Round 5 pixels
9	Soft Round 9 pixels
13	Soft Round 13 pixels
17	Soft Round 17 pixels
21	Soft Round 21 pixels
27	Soft Round 27 pixels
35	Soft Round 35 pixels
45	Soft Round 45 pixels
65	Soft Round 65 pixels
100	Soft Round 100 pixels
200	Soft Round 200 pixels
300	Soft Round 300 pixels
9	Airbrush Hard Round 9
13	Airbrush Hard Round 13
19	Airbrush Pen Opacity Flow
17	Airbrush Soft Round 17
45	Airbrush Soft Round 45
65	Airbrush Soft Round 65
100	Airbrush Soft Round 100
200	Airbrush Soft Round 200
300	Airbrush Soft Round 300
14	Spatter 14 pixels
24	Spatter 24 pixels
27	Spatter 27 pixels
39	Spatter 39 pixels
46	Spatter 46 pixels
59	Spatter 59 pixels
11	Chalk 11 pixels
17	Chalk 17 pixels
23	Chalk 23 pixels
36	Chalk 36 pixels
44	Chalk 44 pixels
60	Chalk 60 pixels
14	Star 14 pixels
26	Star 26 pixels
33	Star 33 pixels
42	Star 42 pixels
55	Star 55 pixels
70	Star 70 pixels
112	Dune Grass
134	Grass
74	Scattered Maple Leaves
95	Scattered Leaves
29	Flowing Stars
192	Fuzzball
36	Chalk
36	Charcoal Large Smear
33	Hard pastel on Canvas
63	Oil Pastel Large
66	Dry Brush Tip Light Flow
39	Dry Brush
63	Watercolor Loaded Wet Flat Tip
11	Watercolor Small Round Tip

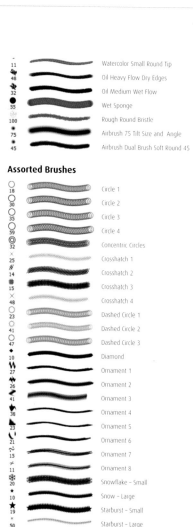

11	Watercolor Small Round Tip
48	Oil Heavy Flow Dry Edges
32	Oil Medium Wet Flow
55	Wet Sponge
100	Rough Round Bristle
75	Airbrush 75 Tilt Size and Angle
45	Airbrush Dual Brush Soft Round 45

Assorted Brushes

18	Circle 1
30	Circle 2
35	Circle 3
59	Circle 4
32	Concentric Circles
25	Crosshatch 1
14	Crosshatch 2
15	Crosshatch 3
48	Crosshatch 4
23	Dashed Circle 1
41	Dashed Circle 2
47	Dashed Circle 3
10	Diamond
27	Ornament 1
26	Ornament 2
41	Ornament 3
38	Ornament 4
23	Ornament 5
21	Ornament 6
15	Ornament 7
11	Ornament 8
20	Snowflake – Small
10	Snow – Large
19	Starburst – Small
50	Starburst – Large
28	Texture 1
28	Texture 2
54	Texture 3
28	Texture 4
36	Texture 5
32	Texture 6
9	Triangle
11	Triangle - Dots

Basic Brushes

1	Hard Mechanical 1 pixel
2	Hard Mechanical 2 pixels
3	Hard Mechanical 3 pixels
4	Hard Mechanical 4 pixels
5	Hard Mechanical 5 pixels
6	Hard Mechanical 6 pixels
7	Hard Mechanical 7 pixels
8	Hard Mechanical 8 pixels
9	Hard Mechanical 9 pixels
12	Hard Mechanical 12 pixels
13	Hard Mechanical 13 pixels
16	Hard Mechanical 16 pixels
18	Hard Mechanical 18 pixels
19	Hard Mechanical 19 pixels
24	Hard Mechanical 24 pixels
28	Hard Mechanical 28 pixels
32	Hard Mechanical 32 pixels

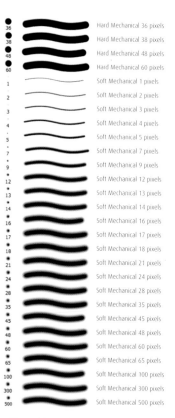

36	Hard Mechanical 36 pixels
38	Hard Mechanical 38 pixels
48	Hard Mechanical 48 pixels
60	Hard Mechanical 60 pixels
1	Soft Mechanical 1 pixels
2	Soft Mechanical 2 pixels
3	Soft Mechanical 3 pixels
4	Soft Mechanical 4 pixels
5	Soft Mechanical 5 pixels
7	Soft Mechanical 7 pixels
9	Soft Mechanical 9 pixels
12	Soft Mechanical 12 pixels
13	Soft Mechanical 13 pixels
14	Soft Mechanical 14 pixels
16	Soft Mechanical 16 pixels
17	Soft Mechanical 17 pixels
18	Soft Mechanical 18 pixels
21	Soft Mechanical 21 pixels
24	Soft Mechanical 24 pixels
28	Soft Mechanical 28 pixels
35	Soft Mechanical 35 pixels
45	Soft Mechanical 45 pixels
48	Soft Mechanical 48 pixels
60	Soft Mechanical 60 pixels
65	Soft Mechanical 65 pixels
100	Soft Mechanical 100 pixels
300	Soft Mechanical 300 pixels
500	Soft Mechanical 500 pixels

Calligraphic Brushes

7	Flat 7 pix
10	Flat 10 pix
15	Flat 15 pix
20	Flat 20 pix
28	Flat 28 pix
35	Flat 35 pix
45	Flat 45 pix
60	Flat 60 pix
7	Oval 7 pix
10	Oval 10 pix
15	Oval 15 pix
20	Oval 20 pix
28	Oval 28 pix
35	Oval 35 pix
45	Oval 45 pix
60	Oval 60 pix

Drop Shadow Brushes

1	Drop Shadow Round 1 pixel
3	Drop Shadow Round 3 pixels
3	Drop Shadow Round 3 pixels
3	Drop Shadow Round 5 pixels
5	Drop Shadow Round 9 pixels
9	Drop Shadow Round 13 pixels
13	Drop Shadow Round 19 pixels
19	Drop Shadow Square 8 pixels
8	Drop Shadow Square 11 pixels
11	Drop Shadow Square 13 pixels
13	Drop Shadow Square 15 pixels
15	Drop Shadow Square 19 pixels
19	

21	Drop Shadow Square 21 pixels
24	Drop Shadow Square 24 pixels
25	Drop Shadow Square 25 pixels
32	Drop Shadow Square 32 pixels
34	Drop Shadow Square 34 pixels
40	Drop Shadow Square 40 pixels
43	Drop Shadow Square 43 pixels
52	Drop Shadow Square 52 pixels
58	Drop Shadow Square 58 pixels

Dry Media Brushes

63	Pastel on Charcoal Paper
19	Pastel Rough Texture
2	Pencil
36	Soft Oil Pastel
60	Soft Pastel Large
10	Large Graphite with Heavy Flow
6	Wax Pencil
1	4H Hard Pencil
5	Charcoal Pencil
5	Conte Pencil
3	Graphite Pencil
6	Waxy Crayon
9	Permanent Marker
32	Permanent Marker Medium Tip
13	Charcoal Scraping Paper
28	Charcoal Flat
20	Heavy Smear Wax Crayon
5	Hard Charcoal Edge
6	Conte Pencil on Bumpy Surface
8	Small Pastel on Charcoal Paper
29	Pastel Medium Tip

Faux Finish Brushes

25	Mesh – Small
60	Mesh – Medium
119	Mesh – Large
40	Plastic Wrap – Dark 40 pixels
90	Plastic Wrap – Dark 90 pixels
40	Plastic Wrap – Light 40 pixels
90	Plastic Wrap – Light 90 pixels
20	Rolled Rag – Cotton 20 pixels
60	Rolled Rag – Cotton 60 pixels
120	Rolled Rag – Cotton 120 pixels
20	Rolled Rag – Terry 20 pixels
60	Rolled Rag – Terry 60 pixels
120	Rolled Rag – Terry 120 pixels
110	Sea Sponge 1
90	Sea Sponge 2
65	Stencil Sponge – Dry
65	Stencil Sponge – Twirl
65	Stencil Sponge – Wet
100	Texture Comb 1
95	Texture Comb 2
75	Texture Comb 3
75	Veining Feather 1
50	Veining Feather 2

Natural Brushes 2

50	Chalk – Dark
50	Chalk – Light
20	Dry Brush 20 pixels
60	Dry Brush 60 pixels
118	Pastel Dark 118 pixels
64	Pastel Dark 64 pixels
20	Pastel Dark 20 pixels
118	Pastel Light 118 pixels
64	Pastel Light 64 pixels
20	Pastel Light 20 pixels
25	Pencil – Thick
9	Pencil – Thin
20	Swirl Brush 20 pixels
60	Swirl Brush 60 pixels
49	Watercolor 1
50	Watercolor 2
41	Watercolor 3
50	Watercolor 4
20	Wet Brush 20 pixels
60	Wet Brush 60 pixels

Natural Brushes

12	Stipple 12 pixels
19	Stipple 19 pixels
21	Stipple 21 pixels
29	Stipple 29 pixels
43	Stipple 43 pixels
54	Stipple 54 pixels
12	Stipple Dense 12 pixels
21	Stipple Dense 21 pixels
26	Stipple Dense 26 pixels
33	Stipple Dense 33 pixels
46	Stipple Dense 46 pixels
56	Stipple Dense 56 pixels
14	Charcoal 14 pixels
21	Charcoal 21 pixels
24	Charcoal 24 pixels
34	Charcoal 34 pixels
41	Charcoal 41 pixels
59	Charcoal 59 pixels
14	Spray 14 pixels
26	Spray 26 pixels
33	Spray 33 pixels
41	Spray 41 pixels
56	Spray 56 pixels
68	Spray 68 pixels

Special Effects Brushes

69	Azalea
48	Scattered Roses
45	Scattered Daisies
9	Drippy Watercolor
45	Scattered Flowers Mums
45	Scattered Wild Flowers
117	Large Roses with Chroma
45	Ducks Not in a Row
84	Falling Ivy Leaves
35	Hypno Lines

50	Tumble Planets
35	Granite Flow
35	Petal Crystals
29	Butterfly

Square Brushes

1	Hard Square 1 pixel
2	Hard Square 2 pixels
3	Hard Square 3 pixels
4	Hard Square 4 pixels
5	Hard Square 5 pixels
6	Hard Square 6 pixels
7	Hard Square 7 pixels
8	Hard Square 8 pixels
9	Hard Square 9 pixels
10	Hard Square 10 pixels
11	Hard Square 11 pixels
12	Hard Square 12 pixels
14	Hard Square 14 pixels
16	Hard Square 16 pixels
18	Hard Square 18 pixels
20	Hard Square 20 pixels
22	Hard Square 22 pixels
24	Hard Square 24 pixels

Thick Heavy Brushes

111	Flat Bristle
111	Rough Flat Bristle
100	Round Bristle
104	Smoother Round Bristle
104	Rough Round Bristle

Wet Media Brushes

17	Rough Round Bristle
9	Drippy Water
39	Dry Brush on Towel
24	Heavy Scatter Flow
5	Heavy Stipple
13	Brush on Light Weave
19	Light Oil Flat Tip
55	Paint on Rough Texture
95	Paintbrush Tool Texture Comb
54	Rough Dry Brush
39	Rough Ink
14	Scattered Dry Brush
14	Scattered Dry Brush Small Tip
54	Large Texture Stroke
15	Oil Heavy Flow Small Tip
28	Brush with Thick Flow Medum Tip
74	Oil Medium Brush Wet Edges
8	Oil Small Tip
63	Brush Light Texture Medium Tip
41	Watercolor Heavy Loaded
22	Watercolor Heavy Pigments
42	Watercolor Heavy Medium Tip
65	Watercolor Fat Tip
45	Watercolor Textured Surface
42	Watercolor Light Opacity

Adobe RGB (1998): also referred to as aRGB, this is a set of color instructions created by Adobe that can be associated with an image to tell color devices like printers and scanners the color range (working space) in which that image was created. It is known as an ICC Profile (International Color Consortium)—its aim is to improve color management and consistency. aRGB is a larger color space than sRGB and is best used for print work. It was originally intended to include the colors achievable on CMYK printers.

Blending Modes (Photoshop): These are different ways that color pixels in Photoshop layers can react to each other and how painting tools like a brush, Pattern Brush, or Art History Brush affect painted areas already applied. The equivalent in Painter is the Composite Method.

Brush Libraries (Painter): A library is a group of default or saved categories. Categories are groups of default or saved brush variants (the brushes themselves).

Brush Method (Painter): The method of a brush variant describes its basic character—like "Eraser" or "Wet." For example, the Build Up method makes paint applied over other paint quickly become black—like a felt tip marker.

Brush Preset (Photoshop): A default or saved brush that has a particular brush tip and other specified characteristics, like Shape Dynamics and Scattering. Brush presets are saved into sets using the Preset Manager and sets can be loaded there too.

Brush Tips (Photoshop): The basic means of applying paint in Photoshop. They give brushstrokes their particular character. There are many brush tips and it is easy to modify or create your own—like capturing Dabs in Painter. You can even have a brushstroke that uses two brushstrokes—the Dual Brush setting.

Brush Variants (Painter): The brushes themselves—they are grouped in categories.

Captured Dab (Painter): The basic shape of a brushstroke derived by selection of a created or customized Dab or brush tip

Cold Pressed Paper: A watercolor paper with a medium rough surface.

Color Dynamics (Photoshop): Determine how the color of paint in a brushstroke alters during the brushstroke. Many variations of color attributes between the foreground and background colors are possible.

Color Management: The process you go through to ensure color consistency across the digital imaging world of monitors, cameras, and scanners. The aim is to ensure consistent handling of colors. The simplest advice on achieving consistency is to use the same color space for all the devices you have in the digital imaging chain. So, for example, you set your digital camera to work in sRGB and use this color space in Photoshop and Painter, and with images you send to your home printer or make for the internet. Color management is complicated and you will find long written advice articles about it on the web.

Color Sets (Painter): Collections of colors (color swatches). They can be created, customized, and copied from a photograph or other image. Useful for creating harmonious color schemes.

Color Swatches (Photoshop and Painter): Individual colors arranged in a Color Set.

Composite Method (Painter): Painter's equivalent of Photoshop's Blending Modes—not identical but similar. See Blending Modes.

Dab (Painter): The type of media application made in a brushstroke. There are over 20 Dab Types—made up of Rendered Dabs and Pixel Dabs. Rendered are continuous brushstrokes, whereas Pixel based Dabs are overlapped to form continuous paint deposition. Captured Dabs are pixel-based Dabs. Photoshop has Brush Tips as its equivalent of Dab Types and they can be manipulated in many ways.

Define Brush (Photoshop): This is the feature that allows you to make new brush tips and brushstrokes from them. It is in the Edit drop down menu and uses the selection tool.

Define Pattern (Photoshop): This enables you to set an image as a clone (confusingly called a "Pattern") source to use with the Pattern Stamp Tool (but again confusingly, not with the Clone Stamp Tool).

Digital Painting: Using software and computer hardware to create and manipulate images using many sorts of brushing and other application tools.

Digital Tablet: Also called Graphics Tablets. You draw on them with a plastic pen device (the stylus) and the picture appears as you make your marks on the computer's monitor. It's another form of input device—like your mouse. Some advanced digital tablets have built-in LCD screens that show your marks as you make them on the tablet. For sophisticated digital drawing and painting some kind of tablet is pretty much essential.

Dirty Brush Mode Tool (Painter): This tool lets you paint with colors mixed in the Mixer Palette. Dirty Mode is related and enables your brushstrokes to apply any pigment remaining after the last stroke in the following stroke. Both enhance painting realism.

Display: A generic name for your monitor screen—most people now have LCD (Liquid Crystal Display) screens but some people still do use, and prefer, CRT (Cathode Ray Tube) monitors. Wide Color Gamut LCD displays are becoming more common and whether or not they are right for you depends on to what digital use your work will be put. For example, if you are only showing your work on the web, sRGB (with its smaller color range) will probably suffice, but if you just want to look at your work at home or get it printed, Adobe RGB, and therefore a wider color gamut display, may be what you need.

Dual Brush (Photoshop): This combines two brush tips in a brushstroke. The second brush provides its texture to the first brush tip. The Dual Brush is very useful when, for example, simulating watercolor on rough paper.

Grain (Painter): Grain means texture—the texture of any surface on to which paint or any other medium is applied. Remember—the higher the Grain value, the less surface texture you will see in a brushstroke.

Graphics Card: Also called a display card, generates the images you see on your display. Their capability—including how much memory they have—has in the past not been a big issue for 2D image creation, but has recently become an issue with Photoshop version CS4.

HDR: Stands for Higher Dynamic Photography. It enables a greater range of light and dark to be seen in a photograph—particularly more detail in highlights and shadows.

Hue: The color we see and to which we give names—blue, red, purple, for example. Values are the degrees of light and dark in a color, and Saturation (Chroma) is how intense a color is.

Jitter (Photoshop and Painter): Setting a tool or feature, like brush roundness or color hue, to produce random variations, in the case of roundness and hue, during the course of a brushstroke. See Random for Painter too.

Method (Painter): Defines a brush's behavior at its simplest—examples are "Eraser" and "Wet." Sub-categories refine the basic behavior of a brushstroke so, for example, "Soft" feathers brushstroke edges, and "Hard" produces smooth strokes. There are many combinations of methods and their subcategories.

Other Dynamics (Photoshop): Determine how Opacity and Paint flow vary over the course of a brushstroke. Another tool to help make more realistic brushstrokes.

Pen Stylus: The other half of a digital pen tablet. It takes the place of a brush, pen, or pencil and you draw and paint with it on a digital tablet to make the marks that appear on your display. There are a number of different sorts of pen stylus.

Random (Painter): Introduces some unpredictability into brushstroke and clone color deposition using the Jitter control. Jitter does it for brushstrokes' grain and clone location variability. The Randomizer is a feature in the Stroke Designer of the Brush Creator that generates unplanned brush settings to create new brushes.

Saturation: The intensity, or Chroma, of a color hue.

Shape Dynamics (Photoshop): determines how variable are the marks that make up a brushstroke—it has controls like, Size, Roundness, and Angle Jitter.

Spacing (Photoshop and Painter): Determines distances between brush tips and dab style/types applied in the course of a brushstroke. Reduce the Spacing value in your brush controls to get a smoother brushstroke.

Tip Shape (Photoshop) and Brush Shape Profile, or Dab Profile (Painter): The look of a brush in cross section—as if you are looking at the brush from above after it has been sliced in two.

sRGB: The default working color space of the internet and of CRT monitors. Like aRGB its aim is to improve color consistency across color devices but it covers a slightly less wide color range than aRGB. However, sRGB is the default working space of the digital world and in general works well for most situations (except some printing ones).

Sub-categories: See Method.

Tone Mapping: A computer software process that translates HDR images into approximations that are viewable on LCD and CRT displays. The high dynamic value range of HDR images cannot be fully viewed on ordinary displays and tone mapping processes these images in such a way that they become fully viewable and without losing the additional image detail that is an important feature of HDR images.

Value: The darkness or lightness of a color or tone.

Water (Painter): The water controls affect how the wet layer created automatically when you use a watercolor brush reacts with the pigment applied in a brushstroke; for example, how far the color spreads (wetness), and how fast paint dries (Dry Rate).

Well (Painter): Determines how color is applied to a paper in a brushstroke. For example, how much color from previously applied color is picked up in a subsequent brushstroke, or how fast a brush runs out of paint.

Picture Credits

The author would like to thank the following for kindly allowing him to use their photographs as the starting point for some of the pictures in this book.

Henrietta Cole: Beach Scene (p. 2); Scottish Borders (p. 64); Positano, Italy (p. 106); Dorset, England (p. 113); Amsterdam Canal (p. 117); Woodland Path (p. 128); Garden Flowers (p. 134); Old Yellow Rolls (pp. 136–137)

Lucy Cole: Sailing Boat (p. 4); Salvador, Brazil (pp. 32–33); Ipanema Beach, Rio de Janeiro, Brazil (p. 38 and p. 40); Rio de Janeiro (p. 51); Jericoacoara (both pictures on p. 63); Evening on the Amazon (p. 73); Lucy and Georgina (pp. 76–77); Duck in Brazil (p. 117); Amazon Pool (p. 129)

David Hentschel: La Rochelle, France (p. 39); France (pp. 132–133)

Simon Hughes: Portland Bill, Dorset (p. 125)

Georgina Marling: Lucy (p. 135)

Judi Marling: Lucy in Scotland (p. 108)

Peter Stanton: Sophia (p. 29)

Sir David Cole: original painting—Sailing, England (pp. 90–91)

Steve Whitelegg: Sailing Boats at Chioggia (p. 11); Grand Canal, Venice (pp. 84–85); San Barnaba, Venice (pp. 86–87); Rio di San Trovaso, Venice (pp. 118–119)

First, I'd like to thank my late father for getting me started in watercolor painting. He was an accomplished watercolorist and used to take me on painting walks in the Surrey countryside when I was little. The evident pleasure he got from the small watercolors he made during our little expeditions made a big impression on me, and though I didn't of course realize it at the time, he sparked an interest in picture making that has stayed with me all my life. Thanks, Pa.

Next, I want to thank Henrietta, Lucy, and Tim, and my mother, for their support and encouragement before, during, and after the writing of this book. They helped in all sorts of ways—providing photographs for many subsequent paintings; sitting patiently for portrait photographs; giving me good critical advice on my paintings; helping me to see that mountains I encountered en route were really molehills; Henrietta's wonderful flower arrangements; and my mother's marvelous curries. All helped so much.

I need to thank too my fellow tunnelers in the RO, and my old friends elsewhere, for letting me take photographs of them and their belongings over the years with few groans—quite a number of the photographs have found their way into this book as paintings which I hope won't put them off letting me take more photographs of them for paintings. Particular thanks to Pete Stanton and Steve Whitelegg for many hours of productive discussion in the Hope—some of which was definitely about the book as far as I can remember.

Finally, thanks to ILEX Press for giving me the opportunity to write and illustrate this book, and to Nick for making the process as painless as these things can be.

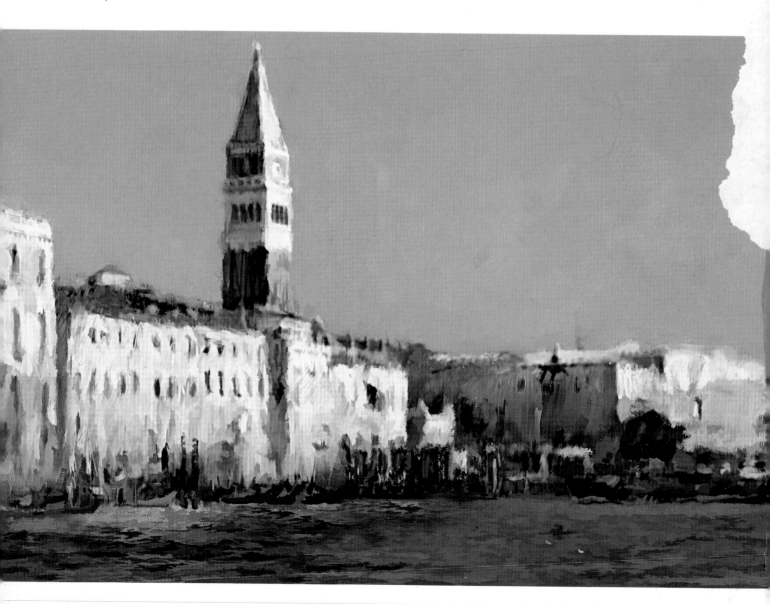